SUMMER IN THE CITY
NEW YORK BASEBALL

1947–1957

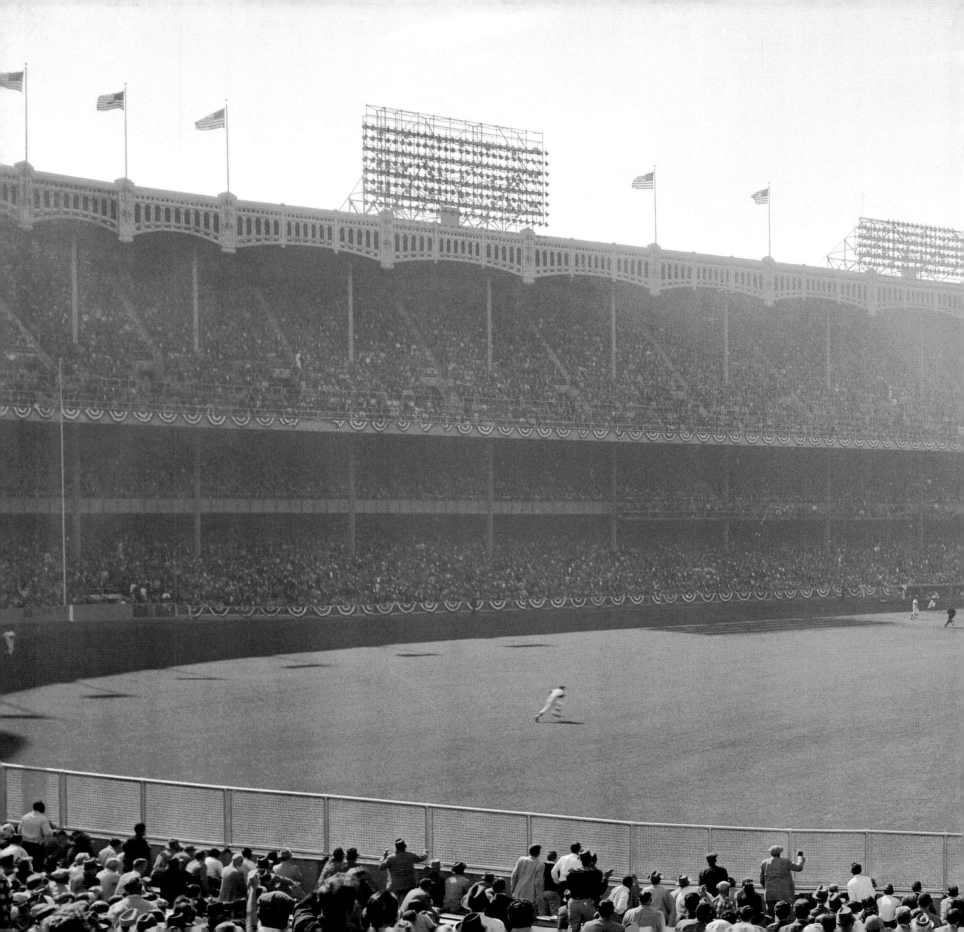

SUMMER IN THE CITY
New York Baseball 1947–1957

Vic Ziegel

Photographs from the New York Daily News edited by
Claus Guglberger

Annotations by
Richard Slovak

Harry N. Abrams, Inc., Publishers

1947 PAGE 12

1948 PAGE 30

1949 PAGE 40

1953 PAGE 106

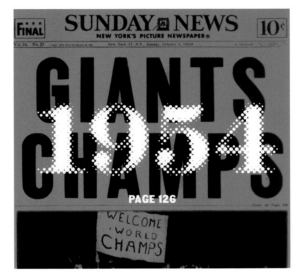

1954 PAGE 126

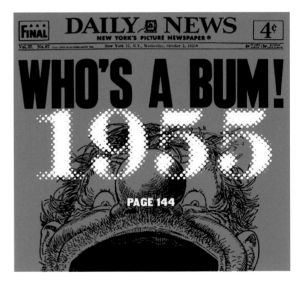

1955 PAGE 144

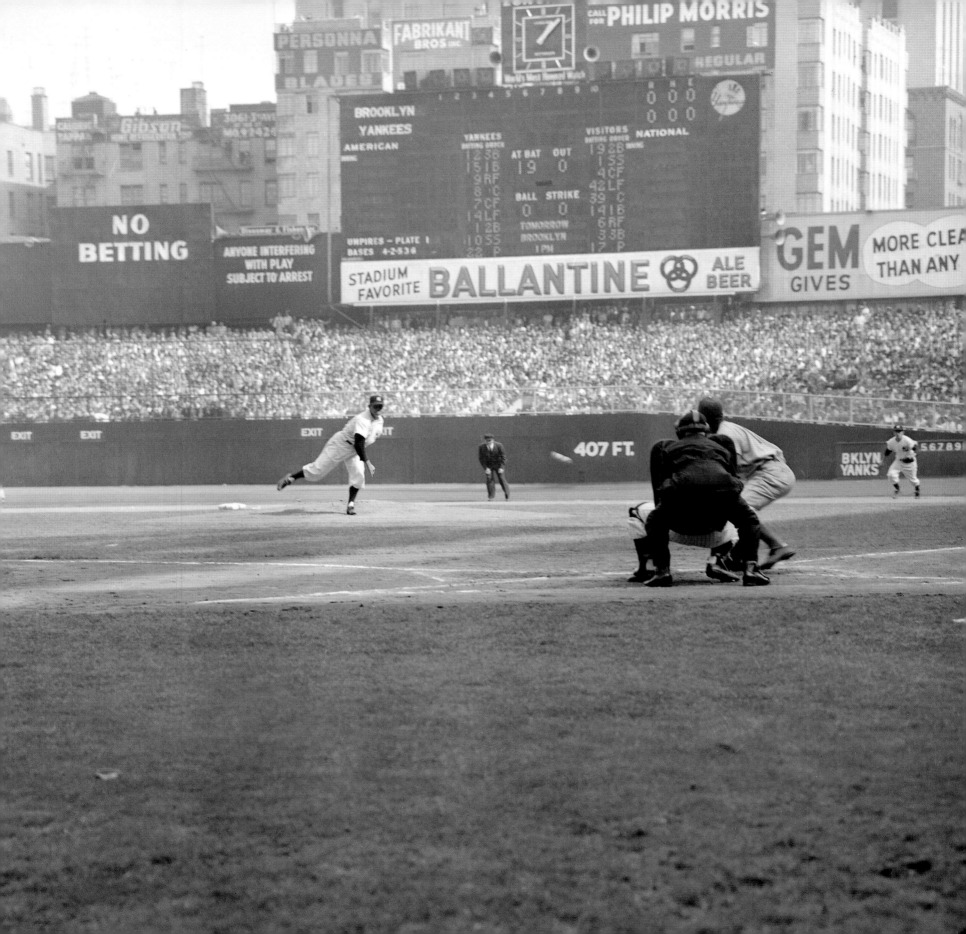

Vic Ziegel

INTRODUCTION

Red Smith covered sports all his life, covered sports without ever raising his voice, or losing his cool—a phrase he would never allow himself to use. Until October 3, 1951, when he rolled a sheet of copy paper into his typewriter in the Polo Grounds press box and reached for words that might describe the indescribable. "Now it is done" was the opening line of his column that gloomy Wednesday afternoon. "Now the story ends. And there is no way to tell it. The art of fiction is dead. Reality has strangled invention. Only the utterly impossible, the inexpressibly fantastic, can ever be plausible again."

Bobby Thomson had sent a ball into the old park's left-field stands, ending a game between his New York Giants and the Brooklyn Dodgers that will be remembered as long as baseball is played and argued about. And it doesn't matter, not even a little, that the Polo Grounds, and the teams on the field that day, no longer exist. The home run, a low line drive that traveled a mere 320 feet, smacked by a player with no other claim on our memory, was the standout moment in a remarkable collection of New York seasons that ran from 1947 to 1957.

Years later, looking back, Smith accused himself of swinging too hard, of reaching for the same fence Thomson had cleared. "If I wrote that today," he said, "I would have cooled it a little." But that would have been impossible back then, when New York was the baseball capital of the country and its primary port. New York owned the sport, and the city was owned by baseball in a way it never had, and never will again. Smith got it right the first time.

That era was a passionate and amazing time when baseball and October belonged, almost exclusively, to the Yankees and Dodgers and Giants, and their fans. When dreams came true. When a New York team was on view in all but one World Series. And for seven years in that magical span, when every Series game was available at the end of a subway ride.

September 30, 1953

Allie Reynolds of the Yankees at the start of Game 1 of the World Series, pitching to the National League Rookie of the Year, Dodgers second baseman Jim "Junior" Gilliam, who also led the league in triples. (Jackie Robinson had moved to left field.) The Yankees won, 9–5, and went on to take a record fifth consecutive World Series.

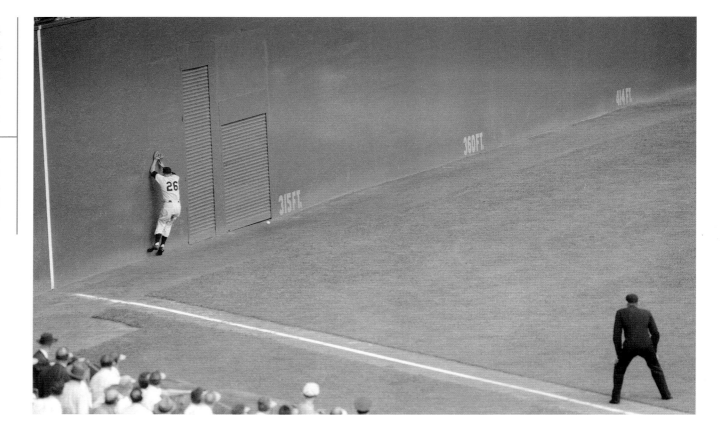

September 30, 1954
Dusty Rhodes crashes into the left field wall in an effort to snare pitcher Early Wynn's drive in the sixth frame. Ball bounced off wall and it went for a double. It was one of Cleveland's eight hits.
Fred Morgan

The ball's about six feet to his right, at the wall. Rhodes performed more heroic feats at the plate for the Giants in Game 2, and throughout the 1954 World Series against the Indians.

When the players worked in sunlight and newspaper photographers were allowed to share the field with them, crouching near home plate to catch the action. When it was the radio ratings that mattered, because the television picture was a shaky, black-and-white thing available only in the living room of your least favorite aunt. The *Daily News* circulation as that era began was more than 2 million, and people lined up at newsstands to wait for the first edition at 8 P.M. To see what that day's game looked like. For the photos they'd be talking about until the next afternoon.

If Thomson's home run was the highest mountain, there were several other peaks in that decade. Joe DiMaggio ended his remarkable career and was replaced by a failed shortstop named Mickey Mantle. The Yankees' lineup, a continuing collection of all-stars, won every World Series from 1949 to 1953. They didn't get there in 1954, when they had 103 wins and one wonderful excuse: Cleveland won 111. A year later, they were back where they belonged, but they lost the Series to Brooklyn after failing to score a run in the seventh game. Waite Hoyt, a former Yankees pitcher, offered this explanation: "The trouble with the Yankees is they don't have enough Yankees."

The Dodgers of that era sent four players into the Hall of Fame: the dynamic Jackie Robinson, the first African-American major leaguer; Duke Snider, the slugging center fielder; Roy Campanella, the brilliant catcher; and Pee Wee Reese, their captain and shortstop, a Southerner who, when Robinson was the target of vile shouts from a rival dugout, made it a point to place his arm around his teammate's shoulder. The message was delivered. During this period, the Dodgers played in six World Series and missed appearing in two others by a total of two games. Their only problem was timing, in regard to the other team on the field in every one of their Octobers. The Yankees were just a little too good for the Boys of Summer.

The Giants had been baseball's dominant team for the first quarter of the century. Until that Babe Ruth fella came along, in that grand new park called Yankee Stadium, hitting home runs and breaking into that comical trot of his. The Giants lost their hold on the city and spent most of the 1940s finishing out of sight. Nothing left for their fans to do but observe the etiquette of the day, which demanded that they root for the league's representative in the postseason. So there were the Giants, back home, hunting for varmints and such, finally able to smoke something besides the sponsor's cigarettes, waiting for next year, forcing their fans to swallow hard and cheer on the Dodgers. That seemed to be the Giants' fate until a new manager, the noisy Leo "the Lip" Durocher, and a subdued rookie, Willie Mays, would make them winners again. ("Willie Mays," Murray Kempton wrote, "was the only promise the rich ever made the poor and delivered on.")

There was no way of knowing, when the 1947 season began, what was on the horizon for New York's teams. Oh, the Yankees, who hadn't

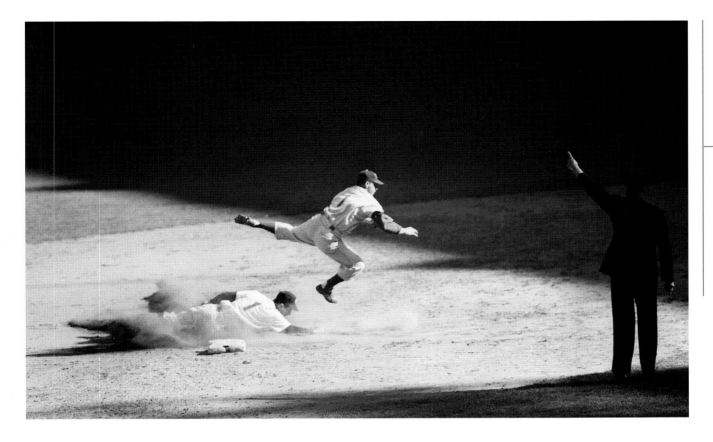

October 3, 1955
UP FOR THIS ONE
Reese takes to air to fire to 1st in vain attempt for DP on Berra bouncer in 7th. Martin plows Stadium real estate trying to break up play. Hodges took Berra's sock and threw to Reese.
Fred Morgan

That's Pee Wee Reese and Gil Hodges of the Dodgers, and Yogi Berra and Billy Martin of the Yankees. Although Game 6 of the 1955 World Series went through the motions, it was all over in the first inning. Whitey Ford came through for the home team by holding the Dodgers to just one run, in the fourth. With this 5-1 victory, the Yankees forced a seventh game.

won a Series since 1941, an unspeakable oversight, would probably be all right. People who hated the Yankees, or simply envied them, and were used to finding them at the top of the standings—so conditioned to it that they compared the Yankees to all-powerful U.S. Steel—expected them to win. As did their fans, of course. That's how it was with the Yankees. They had haters and fans, and nothing in between. The 1947 season was the beginning of yet another post-Ruthian dynasty. DiMaggio and Phil Rizzuto, comfortable in pinstripes again after three years of army duty, were about to be joined by a kid catcher with a body that matched his name: Yogi Berra. It was the right time to buy stock in U.S. Steel.

The Dodgers and Giants—identified in *Daily News* headlinese respectively as "Flock," because they were once the Robins, and the "Jints"—were sure of only one thing in 1947: their rivalry, the fiercest in sports, would continue. They played each other twenty-one times a year and slid into bases just a little harder and avoided angry pitches a lot more often in those games. And the beer tasted a little better if your team came out on top. There was something about their idiosyncratic ballparks—Ebbets Field in the Flatbush section of Brooklyn, and the Polo Grounds, across the street from Manhattan's Harlem River—that enhanced the rivalry. Yankee Stadium, by comparison, was a stately mansion. The House That Ruth Built had gone up on the Bronx side of the Harlem River, in time for the 1923 season, and it wasn't long before

people were calling it the country's most famous stadium. All these years, and one major renovation later, it's a description that still works.

Ebbets Field, the cigar-box stadium named for a former Dodger owner, opened in 1913. Casey Stengel, an outfielder on that team, was still in uniform, and managing the Yankees, when his team came into Ebbets Field to open the '52 Series. The manager decided to show his center fielder, Mantle, how to position himself for balls that bounced off the walls. Especially the pesky wall in right-center, the bottom half of which tilted up and away from the field until its midpoint, when it became straight. Imagine that, a wall that bent in the middle. And to make it just a little more confusing, a screen rose above the wall. Casey had worked in that same outfield forty years earlier. He knew about strange bounces. But the twenty-year-old Mantle had a hard time believing the old man standing alongside him, wearing a glove, lecturing him, had once been a major leaguer. "He thinks I was born sixty years old," Stengel said later.

Charming is a ridiculous adjective to apply to a ballpark. Sorry, but Ebbets Field was charming. It belongs in that sweet part of your brain with the first cramped apartment you called home. Or the time you walked down the steps into a small jazz club and heard someone playing magical notes. The Dodgers, in fact, had their own band, ragtag regulars who wore top hats and called themselves the Dodgers Sym-Phony. And stationed out in the bleachers was Hilda Chester, who

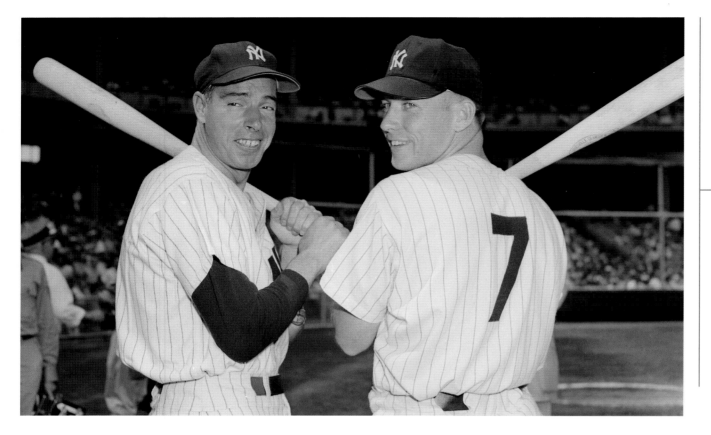

August 22, 1953
MASTER AND PUPIL
Joe DiMaggio, considered the greatest center fielder in Yankee history, makes his appearance with his successor, Mickey Mantle. In DiMag's last season as an active player, '51, Joe gave the Mick the benefit of his knowledge as hitter and fielder. Now it's up to Mickey.
Charles Hoff

The superstars posed together on Old-Timers Day. Joltin' Joe got the biggest hand of the forty-three past Yankees introduced before the two-inning exhibition game (and then the real one, in which the lowly Philadelphia Athletics "humiliated" the Yankees, 10–4—but the Yanks were still in first, by nine games). Mantle finished his third season with a .295 average, twenty-one home runs, and ninety-two runs batted in.

brought her leather lungs and cowbell to every game. The best time for her to clang was Opening Day of the 1947 season, April 15, when Jackie Robinson took the field at first base. Putting an end, Lawrence Ritter wrote, to "apartheid in major league baseball." The Dodgers won a pennant in Robinson's first season, and he spent nine more years in Flatbush, getting on base, edging away from the base, stealing second, sometimes stealing home, and always getting on pitchers' nerves. After the 1956 season, the Dodgers traded him to the hated Giants, and he said, in effect, "You can't trade me; I quit."

The Polo Grounds, where the Giants played, was Ebbets Field in a funhouse mirror. A U-shaped old barn, a bathtub fit for a mythical giant. The foul lines, though, were as close as a happy marriage. A left-field home run had to travel only 279 feet, and the same baseball hit to right field became a fan's souvenir after only 257 feet. At the same time, it was possible to lash the ball 460 feet in one direction—the wrong direction, if the ball stayed up long enough—because center field, the open part of the tub, never ended. It didn't often happen that a ball traveled that far, but on September 29, 1954, the first game of the Series, there were 52,751 witnesses to just such a happening. The game was tied in the eighth inning, but Cleveland had two men on base, and none out, when Vic Wertz came to bat. Wertz swung and, Roger Kahn wrote, "The ball was hit too far and too hard to be caught." But this was the only stadium with enough room, and the only center fielder with enough skill.

Take a look at Frank Hurley's memorable shot on page 126. Willie Mays is exactly where nobody expected him to be, and the ball is about to drop into his glove. Now look at the fans sitting in the bleachers above the screen. They might be as well be watching the third baseman pull down a foul ball during a game in May, their team too many runs behind. They aren't at all shocked by the center fielder's over-the-shoulder, back-to-the-plate, history-in-the-making catch. This was, remember, Willie Mays, doing what Willie Mays was forever capable of doing. Cleveland didn't score that inning, and became losers in the tenth inning on one of those 250-foot-and-something pokes by pinch hitter Dusty Rhodes. The Giants needed only four games to win their first Series in twenty-one years.

Casey's last year as a player, 1925, was Durocher's rookie season. Leo kicked around for a dozen years—good field, no hit, big mouth—until he joined the Dodgers, and his brash reputation became the taunt that grew in Brooklyn. Before a game against the hapless Giants, Durocher glanced across the field and spotted Mel Ott, the other team's popular manager and an acknowledged nice guy. "Nice guys finish last," sneered the anti-Ott, earning himself a place in Bartlett's Hall of Fame. He was the man Giants fans loved to hate. So imagine their shock, halfway through the 1948 season, over a baseball story so incredible it was carried on the front page of the city's dozen news-papers: "Lip Replaces Ott!" was how it looked in the *Daily News*. For Giants fans, like it or not, the Wicked Witch had become their Prince Charming.

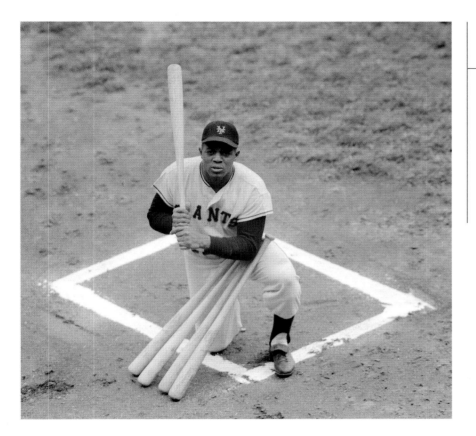

September 23, 1955
Tom Watson

Willie Mays poses with bats symbolizing the fifty-one home runs he hoped to have by the end of the last day of the season. He did it, tying a club record, in the first game of the doubleheader, with a shot off Robin Roberts into the left-field upper deck at the Polo Grounds. He also stole two bases in the game, which the Giants won, 5–2.

Suddenly, fierce was no longer the appropriate word for that rivalry. The Giants' new manager intended to make sure that fierce was replaced by something more than fierce. Durocher, loud and profane, was already in the history books for various crimes and misdemeanors. He's the guy who, when he was a young player with the Yankees, was said to have stolen the Babe's watch. He was banned from baseball for a year for, among other things, associating with gamblers. He was famous for his screaming matches with umpires. For kicking dirt on their wing tips. He married a film star, Laraine Day, and hung with the Hollywood crowd. Frank Sinatra was a pal. Before the game, Leo told hilarious stories, laced with profanity. Nine innings later, forget it, he wasn't available to sportswriters. He had someplace better to be. Maybe Sinatra was in town. But he pushed the Giants, and cussed just enough, to turn them into contenders and, finally, winners.

The 1951 season was the sweetest of all, thanks to the Giants' remarkable comeback—they were thirteen and a half games behind the Dodgers in mid-August—and Thomson's improbable home run. Which was the exclamation point at the end of another comeback, since the Giants had come into the ninth inning of that final playoff game three runs behind the Dodgers.

The great surprise of that decade belongs to the Yankees, whose unmatched and routine success made surprises almost unimaginable. Don Larsen wasn't much of a pitcher. Hard to say if he was a pitcher who drank or a drinker who pitched. He was traded six times, lost more games than he won, walked nearly as many as he struck out, never won more than eleven games in a season, once lost twenty-one, and when he was Stengel's choice to start the second game of the '56 Series, he wasted a six-run lead and was gone by the second inning. The Series was tied when Larsen got his second chance in Game 5. All he did was pitch a game that has never been equaled. The perfect game. They come along every once in a great while but never—never, ever—in a World Series. Larsen's perfecto was against a great Dodgers team on October 8, 1956: twenty-seven up, twenty-seven down. The one nervous moment came in the fifth inning when Mickey Mantle, running at full speed, made a backhanded catch of Gil Hodges's line drive. The last out of the afternoon—it's the answer to a trivia question by now—was Dale Mitchell's strikeout. "Casey," the manager was asked, "was that the best game you ever saw Larsen pitch?" Casey kept it perfect. "So far," he said.

At the end of the following year, the golden time was over. Oh, the Yankees were back in the World Series, but New York's National League teams were on the move. The Dodgers were next seen in Los Angeles, and the Giants turned up in San Francisco. Ebbets Field was razed in 1960 and the Polo Grounds four years later. They used the same wrecking ball.

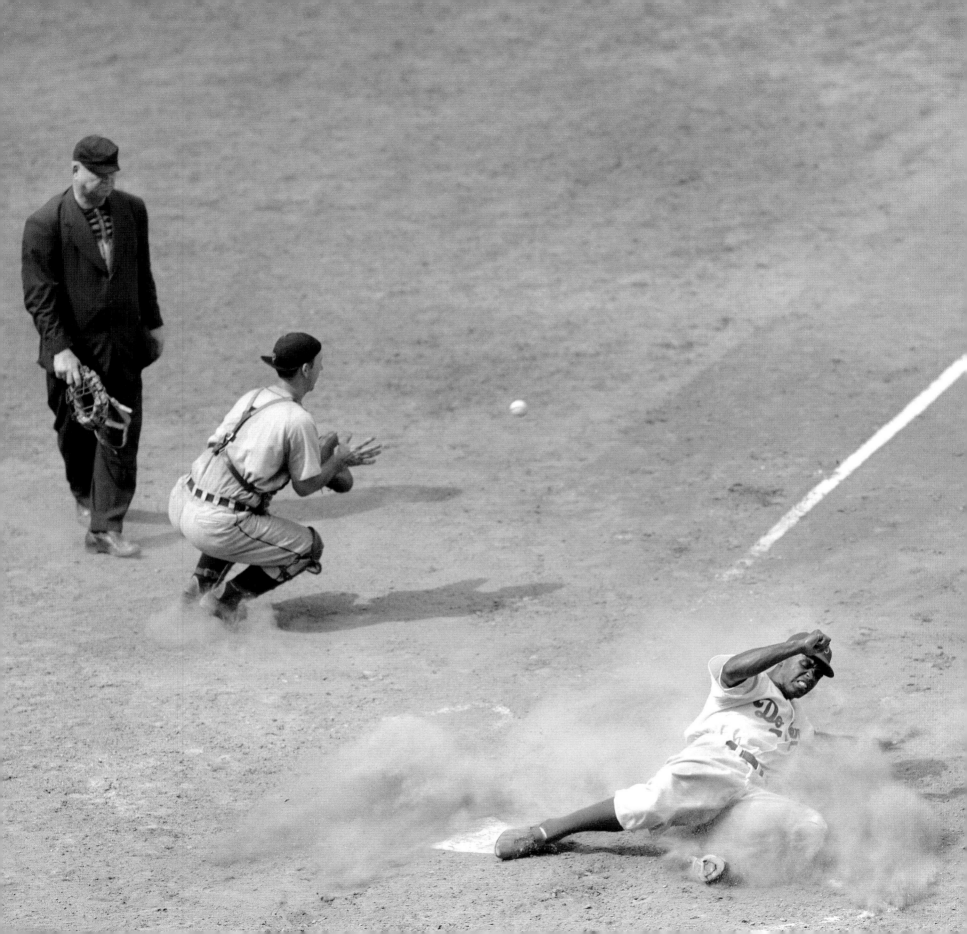

The Yankees hadn't won a World Series in three seasons, and if this was another lean year, it would be their longest drought in a quarter century. A couple of bridges away, in Brooklyn, the Dodgers were still waiting for their first taste of champagne. As it happened, both teams made it all the way to October, and they produced one of the most memorable of all postseasons—a fitting climax for a season that was already in the history books. On April 10, during the sixth inning of an exhibition game against their Montreal farm team, the Dodgers made the routine announcement that a Montreal player was being moved to their big-league roster and would begin the season in a Brooklyn uniform. His name was Jack Roosevelt Robinson, and he became the first black player to step on a major-league field in the twentieth century. It was known as the great experiment, but it was hardly that tentative. The same season, the Dodgers added a second black player, and so did two teams in the American League. The Dodgers had already made front-page news that exhibition season when the baseball commissioner, Happy Chandler, suspended their manager, Leo Durocher, for the entire year. He was replaced by the sixty-two-year-old Burt Shotton, who wore a business suit during games because, he said, he was too old to wear a uniform. Robinson batted .297, led the league with twenty-nine stolen bases, and was named Rookie of the Year. A strong case could have been made for the Giants' rookie pitcher, Larry Jansen, who won twenty-one games and lost five. But this was Jackie Robinson's time, and Jansen picked the wrong year for those sparkling numbers. The World Series went seven games and was highlighted by the performances of three unexpected players. In Game 4, Yankees pitcher Bill Bevens, who was a pathetic 7–13 during the season, and walked as many as he struck out, came within one out of pitching the first no-hitter in Series history. Pinch hitter Cookie Lavagetto, who might have been that out, poked a double, two runners scored, and the Dodgers were winners. Two days later, in Game 6, the Yankees were three runs behind in the sixth inning, with two men on and two out, and Joe DiMaggio at the plate. He hit a ball high and deep into left-center. A sure home run—until Al Gionfriddo, running hard, made the unexpected catch. On the radio, Red Barber called out, "Oh, Doctor," and the Dodgers won that game too. But the Yankees won the seventh game, the important game. The three players who made the biggest headlines that week—Bevens, Lavagetto, and Gionfriddo—would never again play in the major leagues.

August 25, 1947
FLYING HOME
Dodgers' Robinson slides across plate
safely in 4th as Pirate catcher, Howell,
takes throw from outfield.
Hank Olen

That's Jackie Robinson, of course, the Dodgers' rookie phenomenon. The outcome was "Brooks nosed Bucs, 11-10." Homer "Dixie" Howell was part of a five-player trade by the Dodgers in May for one Pirate, outfielder Al Gionfriddo—who would play a pivotal role in the World Series. Despite slugger Ralph Kiner, the National League home-run leader every year from 1946 to 1952, the Pirates wound up in a last-place tie with the Phillies. The Dodgers, on the other hand, went on to win the pennant (five games ahead of the St. Louis Cardinals) for the first time since 1941, and only the second time since 1920.

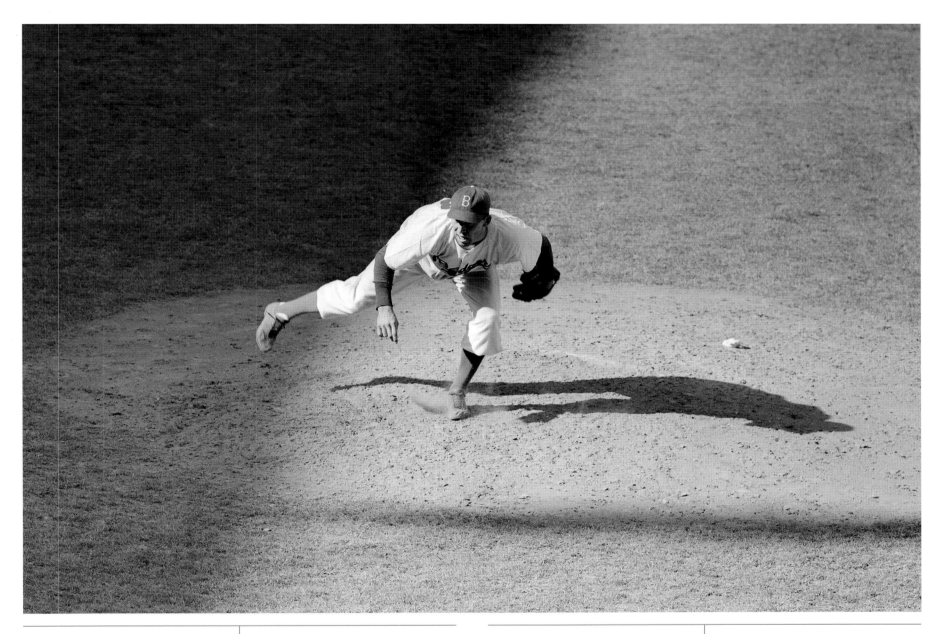

April 16, 1947
BLEACHING AGENTS
Of 39,344 that attended Yank opener at
Stadium (and saw home nine get
trounced, 6-1, by A's), thousands got in
some sunbathing in bleachers.
Paul Bernius

The Yankees, under three different managers,
had finished third in 1946. The Athletics,
in Philadelphia since 1901, had been a
dynasty in their earliest years and in the
1920s to early 1930s. But the A's came in
seventh or eighth—out of eight American
League teams—in most of their last twenty
years before moving to Kansas City in
1955 (and then to Oakland in 1968).

April 22, 1947
Hank Olen

The Dodgers' Hal Gregg, in action in the
ninth inning of his one-hit, 1–0 win over
the Phillies at Ebbets Field. However, his
lifetime record was only 40–48, and he
was the starter in the Dodgers' ill-fated
seventh game of the World Series against
the Yankees in 1947.

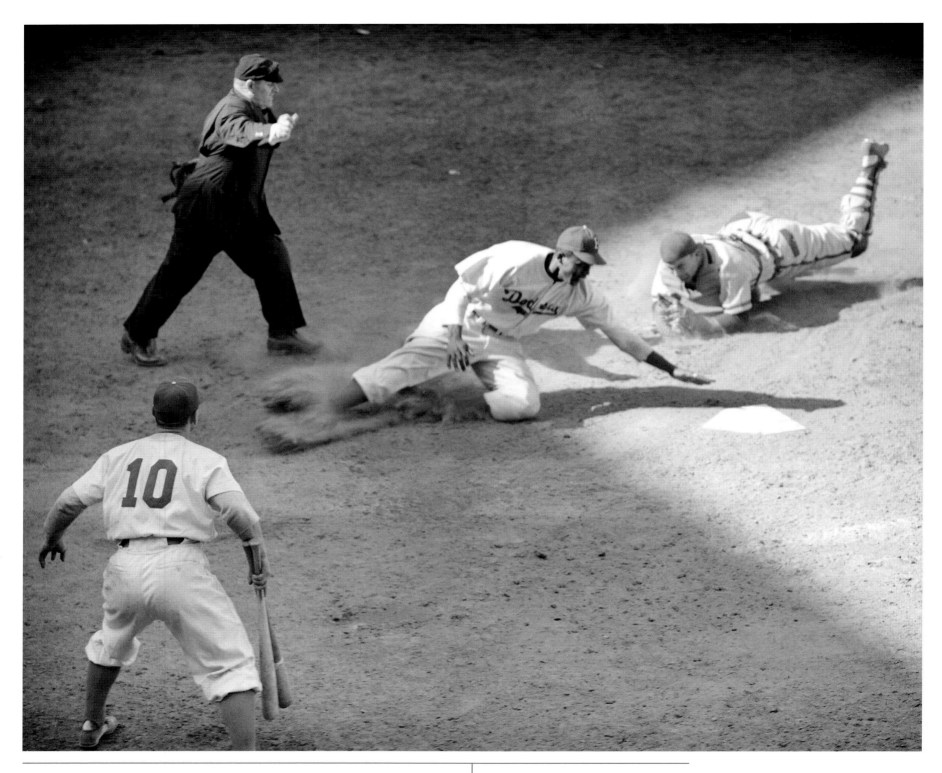

April 22, 1947
GESTURE
Jackie Robinson, nailed by Northey's peg, reaches for plate after Philly
catcher Andy Seminick tagged him out in 6th. Ump Stewart calls play.
Hank Olen

Right fielder Ron Northey caught a foul fly,
then threw out Robinson when he tagged
up at third. But the Dodgers' ever-aggressive
new star—ignoring racial slurs from the
Phillies' dugout throughout the game—
scored the winning run in the eighth inning.

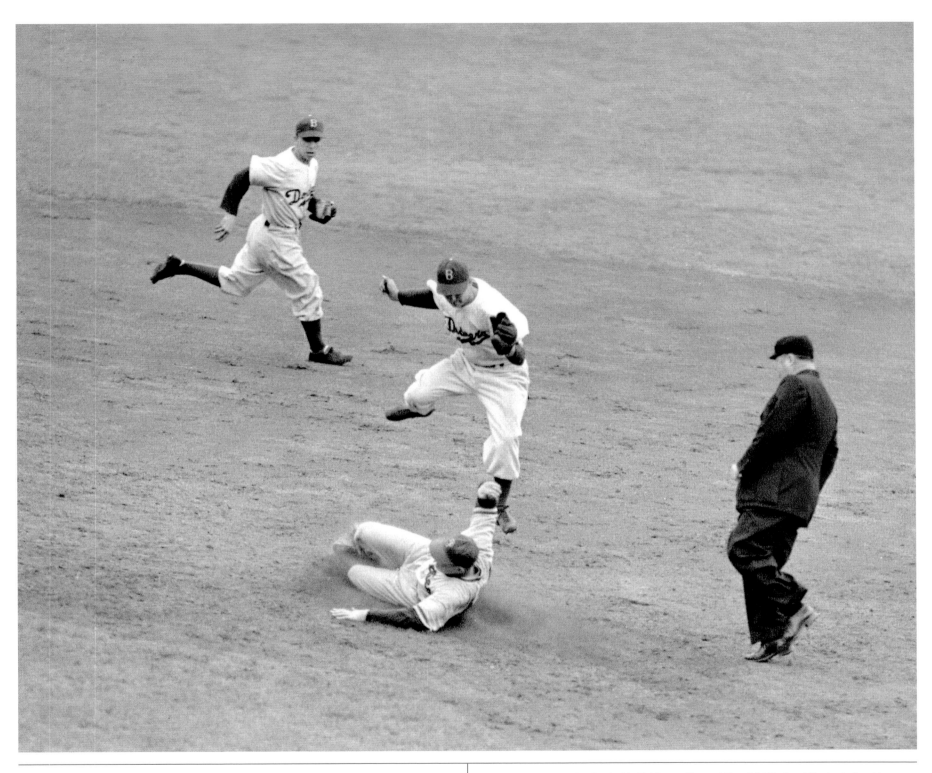

May 25, 1947
FAST NUMBER

As Del Ennis streaks into second feet first, Brooks' Ed Miksis steps high, wide and handsome to avoid Del's spikes. Yep, it was a stolen base in Phils' half of 5th. Pee Wee Reese backs up play. Dodgers won, 5-3, at Ebbets Field.
Walter Kelleher

It was just another day for Jackie Robinson: three of the eight Dodger hits, including his second home run. Reese, the Dodgers' Hall of Fame shortstop, was the captain of the "Brooks"—one of the team's nicknames in the *Daily News.* The Phillies, a mediocre team between its pennants in 1915 and 1950 (and then until 1976), ended up in a tie for last place, thirty-two games out of first.

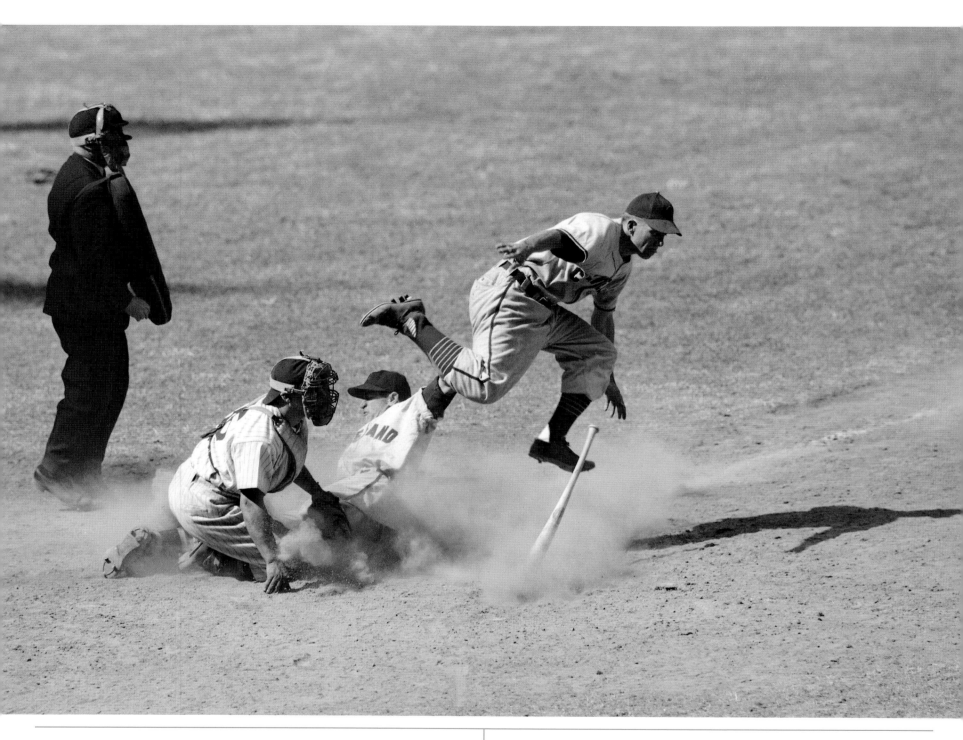

June 23, 1947

INJUNS NO HOLDUM POWWOW, INJUNS HEAP CONFUSED

Intent upon scoring a run that broke an 8th inning tie, Cleveland's George Metkovich, who broke for home with the pitch, slides in and nearly upsets teammate, batter Jack Conway. Jack, who singled at the same time, has to jump over Metkovich to get to first. Evidently the two visiting Indians got their signals crossed and were running when they should have been parking, or swinging when they should have been taking. Berra, the Yankees catcher, looks on in amazement. Yankees won the game anyway, 8-5.

Walter Kelleher

The Yankees moved into first place on June 20, had a nineteen-game winning streak (a league record) starting June 29, and weren't threatened for the rest of the season. (The second-place Detroit Tigers were twelve games back; Cleveland ended up in fourth, seventeen games out.)

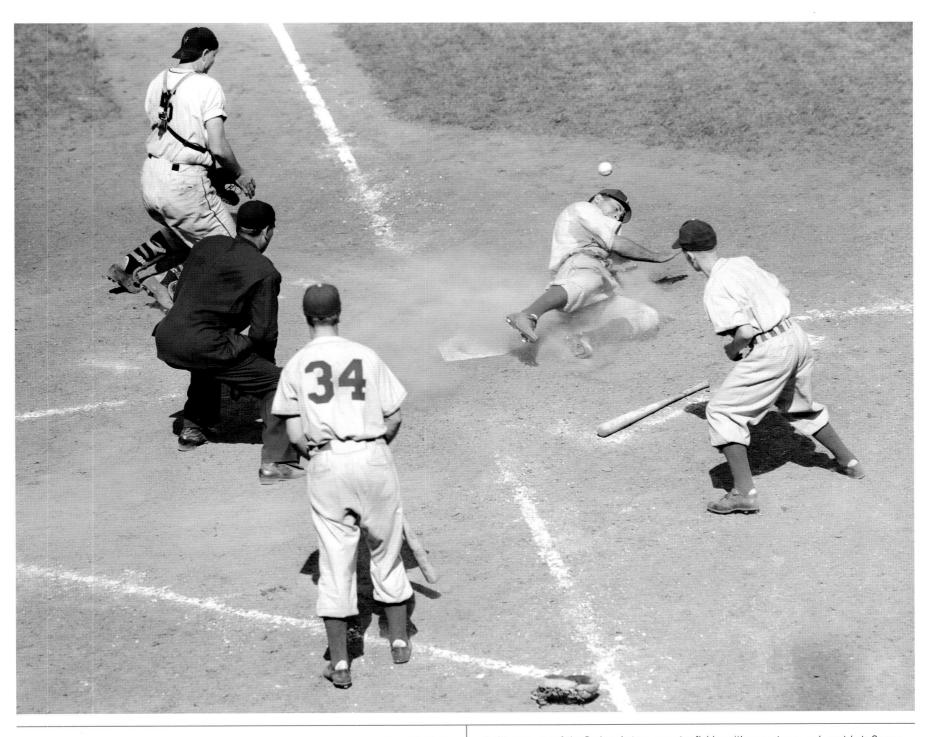

June 29, 1947

THE WAR'S ON

Throw-in, awaited by Giants' Walker Cooper, bounces off Carl Furillo as he scores on Jorgensen's single in 8th of first game. While pitcher Iott chased pill into dugout, Jorgensen scored too. But umps chased Jorgy back to third. After an en masse Dodger squawk, manager Burt Shotton let the game go on—under protest.

Walter Kelleher

Furillo was one of the Dodgers' stars, a center fielder with a great arm and great bat; Cooper was one of the Giants' top sluggers in 1947. That year, rookie John "Spider" Jorgensen played third base for the Dodgers, while Hooks Iott was a weak member of the Giants pitching staff. In this game, Jackie Robinson scored the winning run by singling, stealing second, and advancing on a sacrifice fly and then a single. He had five hits and three stolen bases in the doubleheader, though the Giants won the second game. The Dodgers and Giants were right behind the Boston (later Milwaukee, then Atlanta) Braves for first place. But, as usual since 1937, the Giants couldn't compete, winding up in fourth place, thirteen games back.

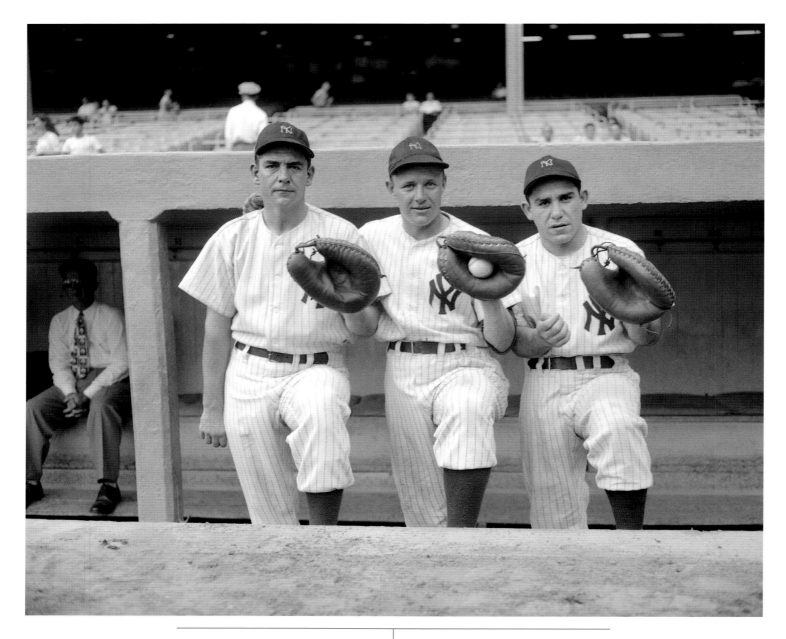

September 13, 1947
Hank Olen

Yankees catchers Aaron Robinson, Ralph Houk, and Yogi Berra (left to right), two days before the team clinched the American League pennant, in Bucky Harris's first season as manager. Robinson was soon part of a trade to the White Sox for pitcher Ed Lopat; Berra caught fifty-one games in his second season and also played some outfield (he didn't become the full-time Yankees catcher until 1949); Houk, a backup, is best known as the team's manager in most of the 1960s and the early 1970s.

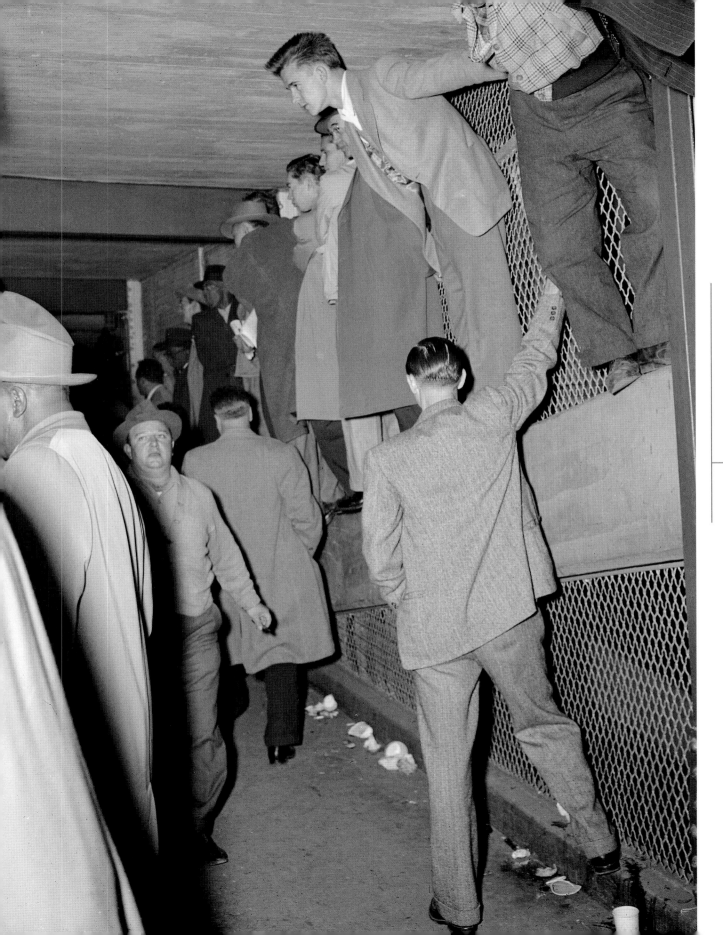

September 30, 1947
GRILL STAKE
Clinging tenaciously to their precarious perch outside second tier grillwork, these standees—at $4.00 per stand—seem to be enjoying the game as much as their reserved seat brethren. Of course, when the hot dog man came along, these fans were really up against it (what with their hands tied up this way).
Ed Jackson

The crowd of 73,365 for Game 1 at Yankee Stadium set a World Series attendance record—until 74,065 showed up for Game 6.

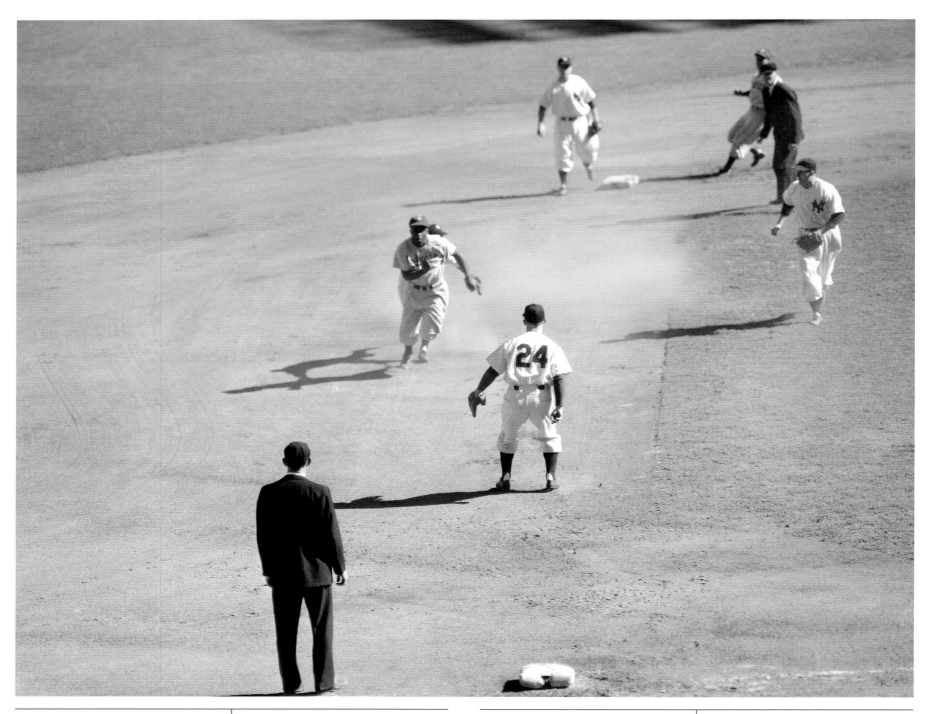

September 30, 1947
THAT RUNDOWN FEELING
Straying too far, Robinson is caught
off 2d on Reiser's rap to box and run
down and tagged by Rizzuto, who took
Shea's throw. Reiser pulls into 2d.
Walter Kelleher

Jackie Robinson had stolen second base
in the first inning of Game 1; although he
then got caught when "Pistol Pete" Reiser
hit the ball back to pitcher Frank "Spec"
Shea, Robinson spent so long avoiding the
tag (look for Phil Rizzuto's shadow, behind
Robinson's) that Reiser advanced—and
eventually scored. The Dodgers led 1–0—
until the disastrous fifth inning.

September 30, 1947
VICTIM
of Yankees power and his own wildness,
big Ralph Branca, shoulders slumped,
leaves dejectedly after getting hook in 5th.
Walter Kelleher

After four perfect innings, the Dodgers'
Branca (a twenty-one-game winner during
the season) started throwing too quickly. By
the time he was pulled, the Yankees had
scored five times. They won Game 1, 5–3,
and then took Game 2 at the stadium,
10–3—largely because of disastrous field-
ing in center by Pete Reiser. The onetime
phenom had played too hard and slammed
into too many walls making catches in his
stellar but injury-shortened career.

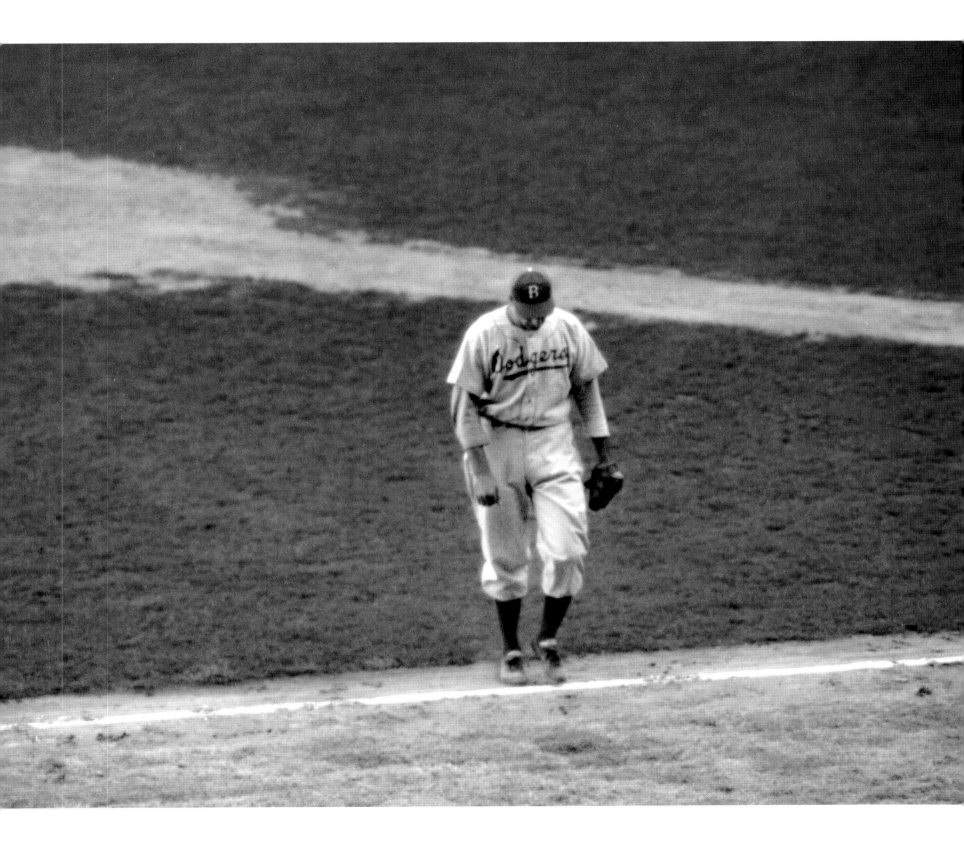

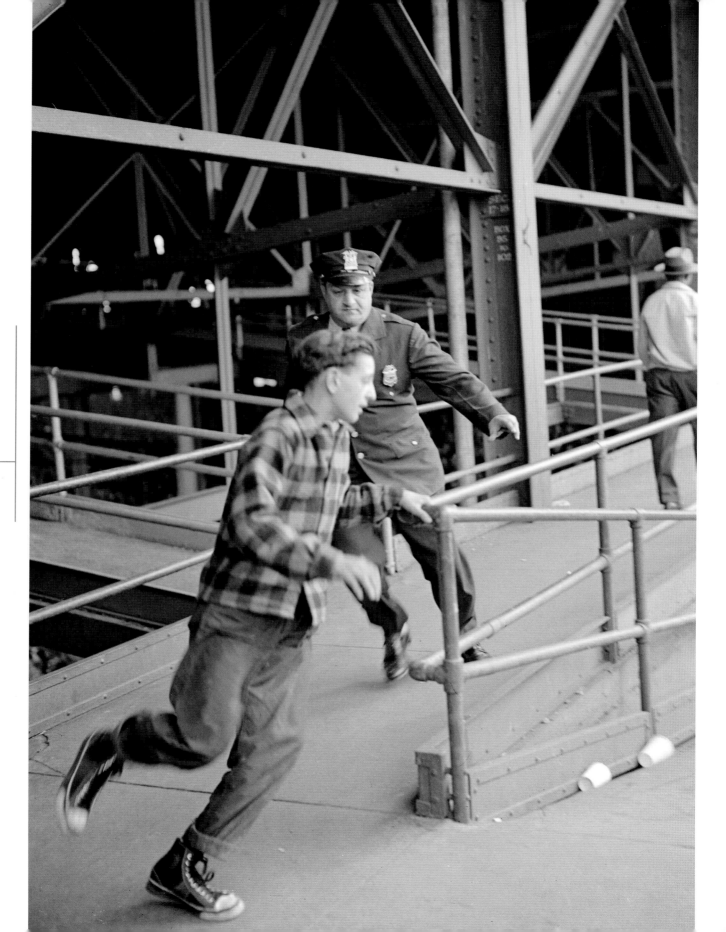

October 2, 1947
ANYTHING GOES . . . IN BROOKLYN
Slipping in the main entrance at Ebbets
Field, Maurice Savino led Special Officer
Teddy Rothenberg a merry chase around
tiers of stands all through the game. . . .
Yes, he was there at the finish.
Ed Jackson

Fan intensity was just as great for Game 3,
the first at the much smaller Ebbets Field;
attendance there was 33,098.

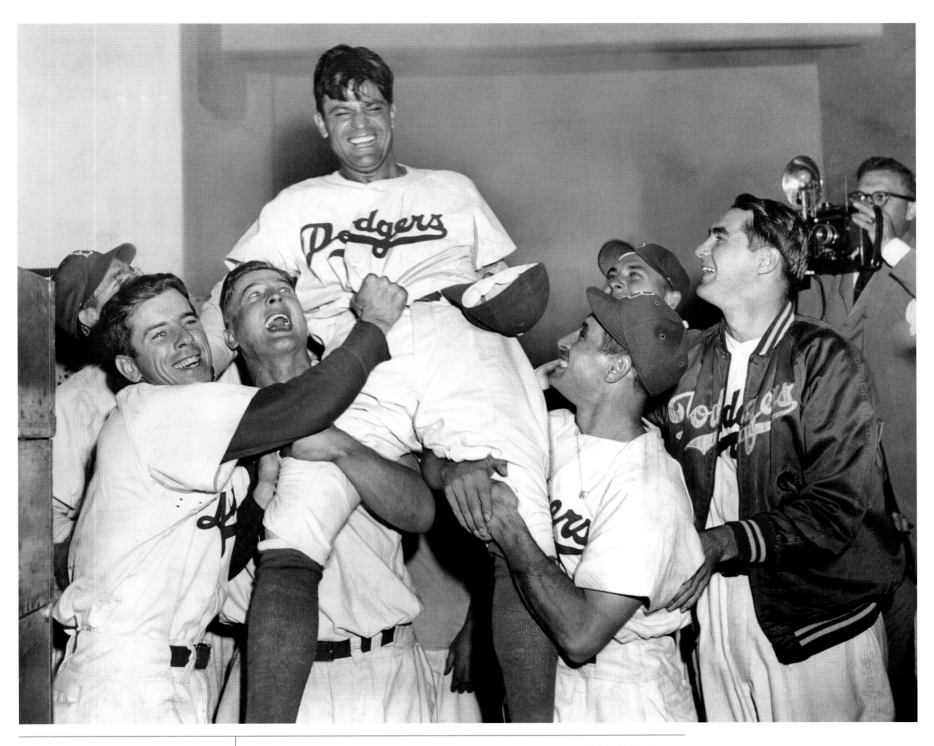

October 3, 1947
Riding high on the shoulders of his team-
mates, Cookie Lavagetto is carried into
Dodger dressing room after dramatic hit.
Bill Meurer

At home, the Dodgers had won Game 3, 9–8. In Game 4, also at Ebbets Field, the Yankees
were up 2–1 and Bill Bevens was an out away from a no-hitter, despite an unprecedented ten
walks, two of them in the ninth. Then thirty-four-year-old pinch hitter Harry Arthur Lavagetto
doubled them home, giving the Dodgers a 3–2 win and tying the Series. Hy Turkin of the *Daily
News* described the clubhouse hysteria: "After five mad minutes of kissing, cussing and slap-
ping, it was a disheveled Italian-American guy who was dumped in front of his locker, tears in
his eyes and a mile-wide grin on his usually impassive face." In the main *Daily News* article,
Dick Young called it "the greatest ball game ever played."

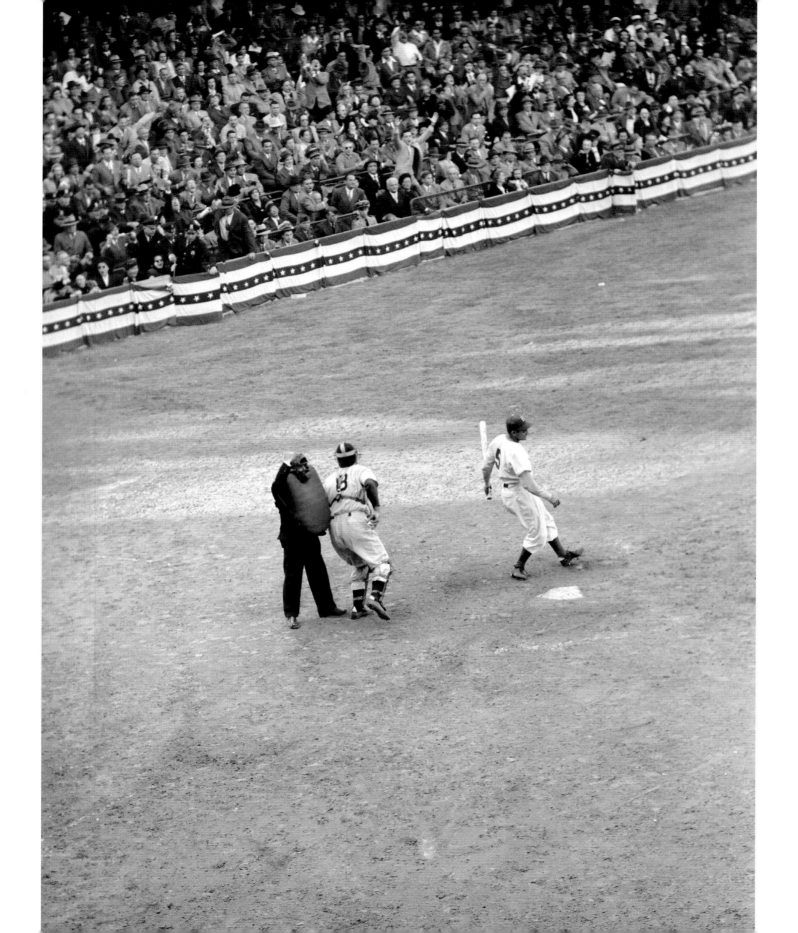

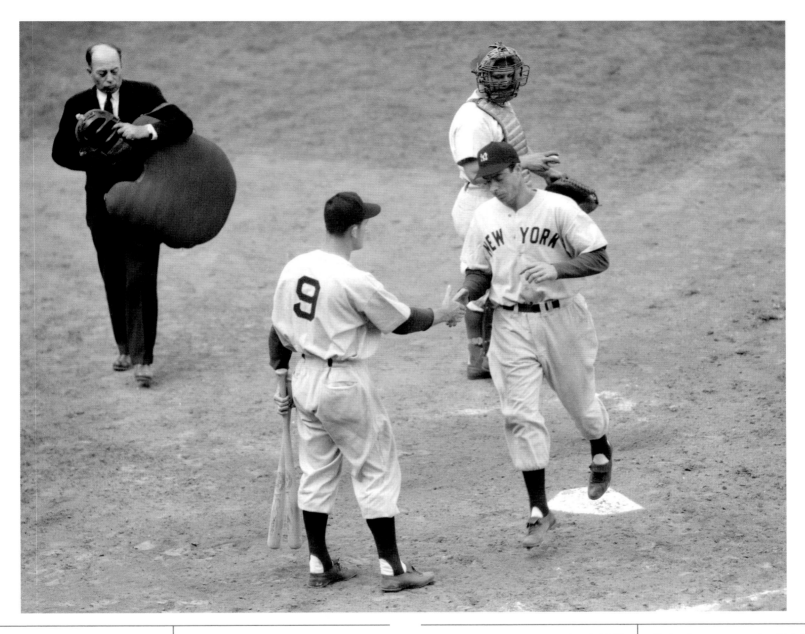

October 4, 1947

DEFLATED

hero Cookie Lavagetto, who busted up
Friday's game with a pinch double,
whiffs in the same role yesterday. Ball's in
Aaron Robinson's hand.
Ump McGowan makes it official.

Charles Hoff

Game 5: Once again, it was the ninth inning
at Ebbets Field, with the tying run at sec-
ond, but this time, on a full count against
Spec Shea, the mighty Lavagetto struck out.
The Yankees won 2–1 and moved back to
their home turf up three games to two. (Yogi
Berra later took over Robinson's uniform
number as well as his position.)

October 4, 1947

MIGHTA BEEN GOAT BUT WINDS UP HERO

With bases loaded and none out in first,
Joe DiMaggio fans ingloriously. With two
aboard in third, he whacked into woeful
DP. But with none on in the fifth, he
connected for game-winning homer, and
. . . he's being mitted by George McQuinn
(9) as he completes circuit.

Hank Olen

During the same game in which Lavagetto
was going from hero to goat, the American
League's Most Valuable Player was moving
the other way. It was DiMaggio's home run,
along with rookie pitcher (and Game 1 win-
ner) Spec Shea's four-hitter, that won the
day for the Yankees.

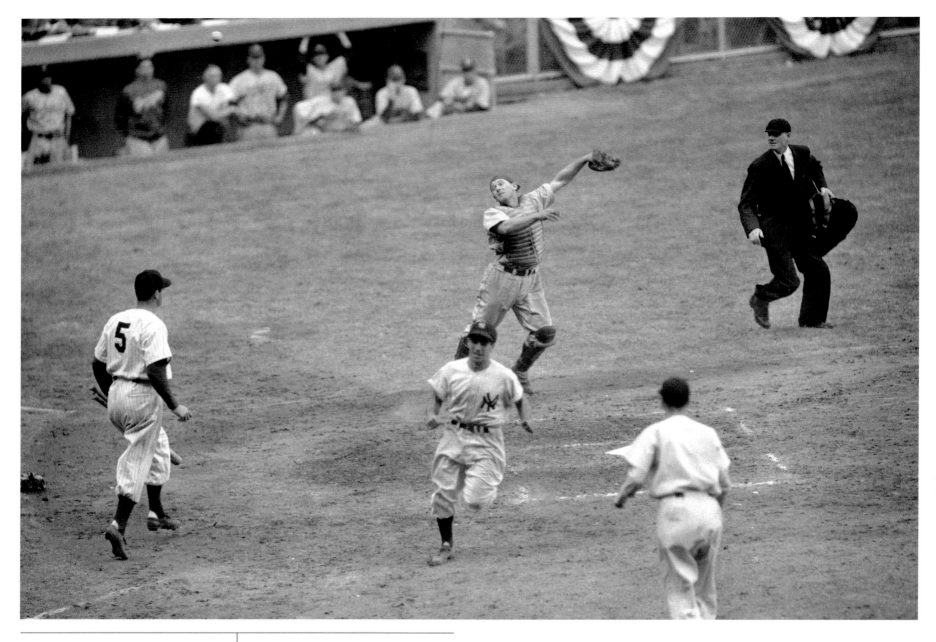

October 6, 1947
PAS DE DEUX?
Bruce Edwards could get time-and-a-half on the ballet stage for his gyrations as Furillo's throw gets past him in the 6th while Rizzuto scoots across on Clark's rap.
Hank Olen

Allie Clark's pinch-hit single delivered one of two insurance runs after the Yankees took the lead in the fourth inning of Game 7. The Dodgers had forced a Game 7 with an 8–6 win the day before—the game in which Al Gionfriddo caught what should have been Joe DiMaggio's three-run, game-tying home run. But in the finale, after scoring two runs in the second, the Dodgers were held by Joe Page, pitching his fourth Series game in relief, to one hit in the last five innings.

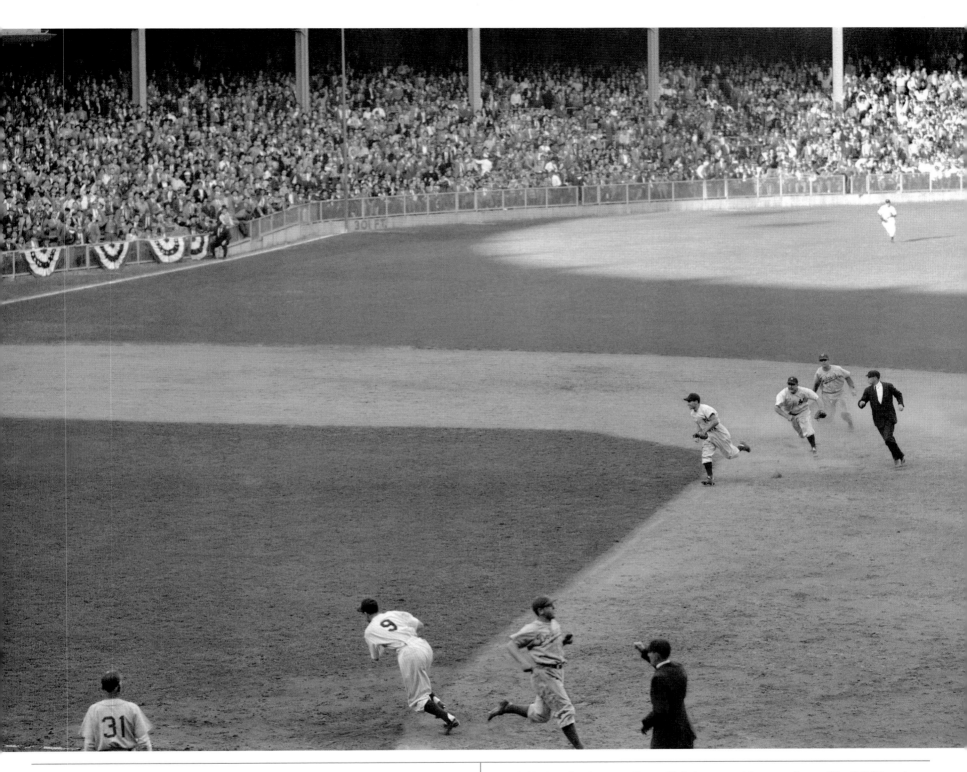

October 6, 1947
TWO-ACT FINALE

Another World Series becomes history as the victorious Yanks rush from the field after McQuinn took Stirnweiss' relay of Rizzuto's throw to double Edwards who had forced Miksis at second. Right after, Larry MacPhail announced his retirement as Yankees president. The Series was the 11th won by the Yankees.

Charles Hoff

That's Yankees first baseman George McQuinn, second baseman George "Snuffy" Stirnweiss, and shortstop Phil Rizzuto combining for the double play against Dodgers Bruce Edwards and Eddie Miksis, ending Game 7 with a 5–2 win for the Yankees. It was the Yankees' first championship in four years. MacPhail, the temperamental Yankees co-owner since 1945, stole some of the headlines with his surprise announcement in the locker room.

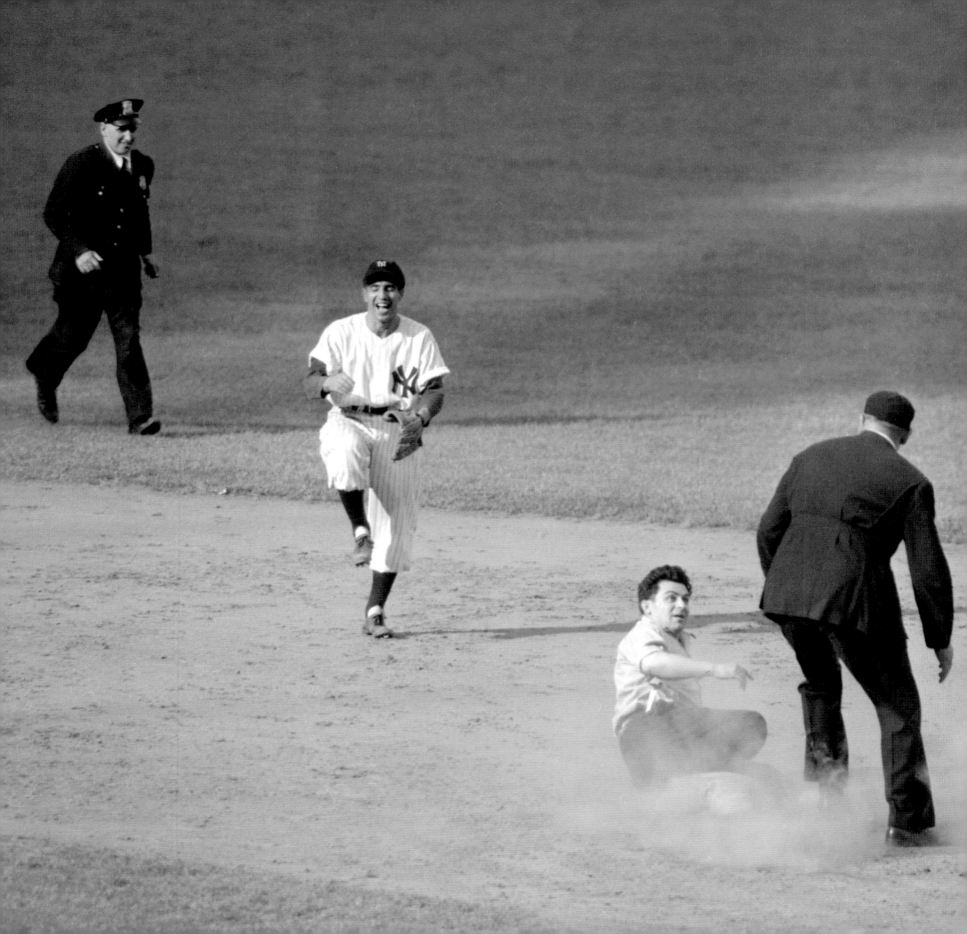

Nothing went right. The World Series was decided in cities north and west of New York, the only time in eleven years the city didn't have a team to root for in October. On June 13, the fifty-three-year-old Babe Ruth had his No. 3 retired in a Yankee Stadium ceremony, and he died on August 16. The Dodgers, with their talented line-up, couldn't mount a serious threat and finished in third place. The Giants were much further away, in fifth place. Only the Yankees kept it interesting, awfully interesting. With the schedule running out in seven days, the Yankees, Boston, and Cleveland were tied for first place. In the unlikely event they stayed that way, a coin toss was held in the league president's office, and it was determined that Cleveland would play in Boston, with the winner staying home to play the Yankees. If that seemed to favor the New York team, they gave up their advantage almost immediately. They lost the next day, and Cleveland began inching ahead. With two games remaining in the season, the Indians were a game in front; the Yankees and Boston were playing their last two at Fenway Park. And it stopped being interesting for the Yankees in the first inning, when Ted Williams connected for a two-run homer. The Yankees lost, 5–1, and were eliminated—and where is Bucky Dent when you really need him? So the three New York teams were all forced to wait until next year, and the expectations were made even greater because of a game of musical dugouts. The Giants, tired of finishing too far back, asked the Dodgers in mid-season if Burt Shotton was available to become their manager. The predictable answer was no, but that didn't end the conversation. The Dodgers offered Leo Durocher, and the Giants accepted. The Yankees fired their manager, Bucky Harris, and announced his unexpected successor a day after the World Series ended. His name was Casey Stengel.

This fan apparently tried to show some photographs to Joe DiMaggio in center field, then ran to the infield, where Hubbard grabbed him. (The *Daily News* reported that the man—a Brooklyn resident—was sent to Bellevue Hospital for observation.) The day proved to be something of a bad joke—the Indians won both games of the doubleheader—and so did the season, although the Yanks fell short of the Indians and Boston Red Sox only at the very end. The next day was much more somber: a final honor at Yankee Stadium for the terminally ill Babe Ruth.

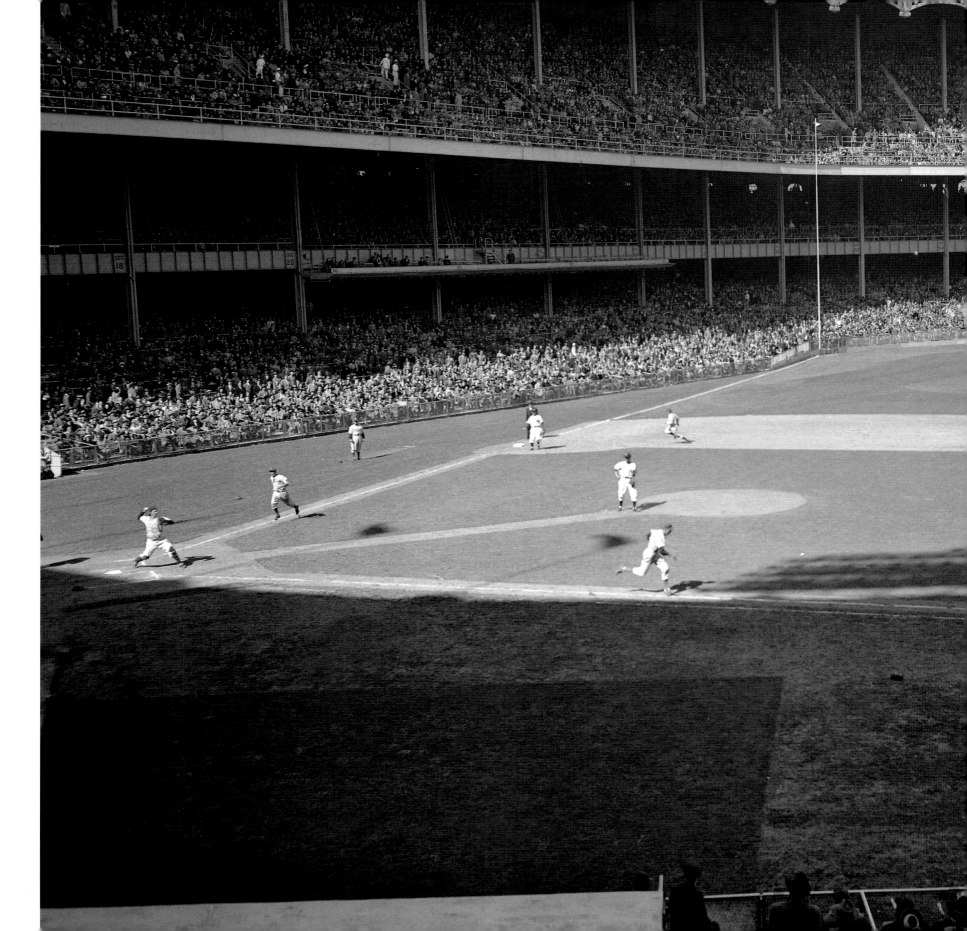

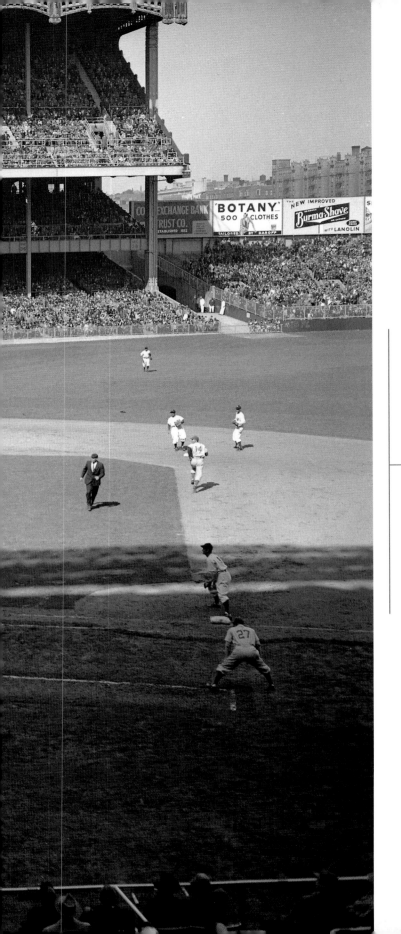

April 18, 1948
SNUFFED
Potential big second inning for Dodgers dies as Jack Banta hits into double play. Play was Embree to Lollar to McQuinn. Dodgers again beat Yanks. Score: 5-3, at the Stadium.
Bill Quinn

Before Opening Day, on April 19, there were preseason exhibition games between the Yankees and the Dodgers. This one set an exhibition-game attendance record, with 62,369 fans showing up in the Bronx. George McQuinn was in his second and final year at first base; pitcher Red Embree and catcher Sherm Lollar played lesser roles on the team.

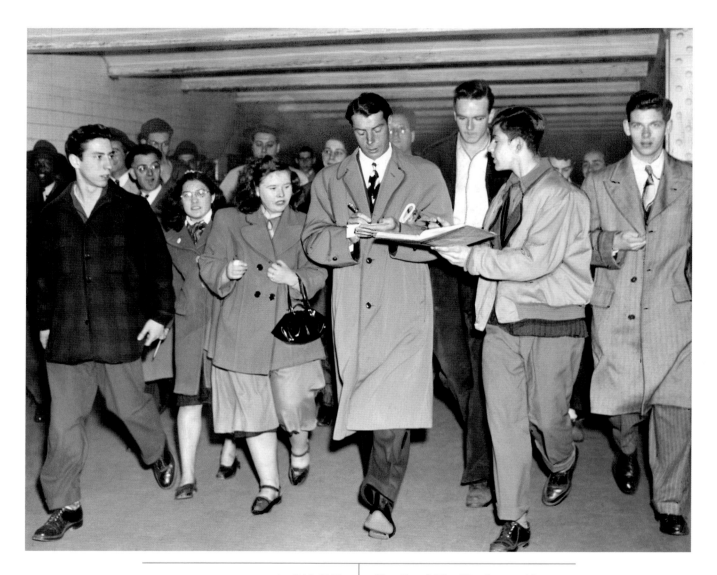

April 15, 1948
THE YANKS ARE IN (TOWN)
Joe DiMaggio signs autographs for fans who met him at Pennsylvania Station yesterday when he arrived back in town with the World Champions.
Nick Petersen

More than 2.37 million fans went to Yankee Stadium in 1948 to see the champs, setting a record for Yankees home attendance that held until 1979. DiMaggio, of course, was the team's biggest draw, and in 1948 the Yankee Clipper led the American League in home runs (thirty-nine) and runs batted in (155) while hitting .320.

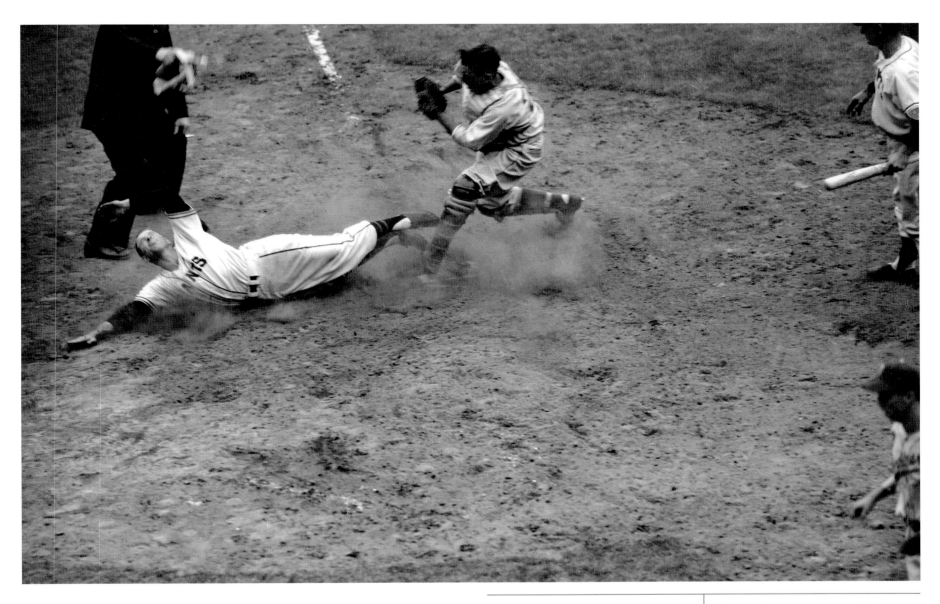

April 21, 1948
RHAWN-DOWN
Trying to score from third after Bragan's
pickoff peg went awry in 8th inning.
Rhawn of the Giants is cut down at the
plate on Reese's retrieve of bad throw and
return to Bragan. Giants won, 9-5.
Walter Kelleher

During this ugly second game of the season,
Dodgers manager Leo Durocher—back from
his one-year suspension, and feuding
all spring with an overweight Jackie
Robinson—used a record twenty-four players;
the five pitchers gave up eleven hits and
thirteen walks. Bobby Bragan and Bobby
Rhawn were utility players.

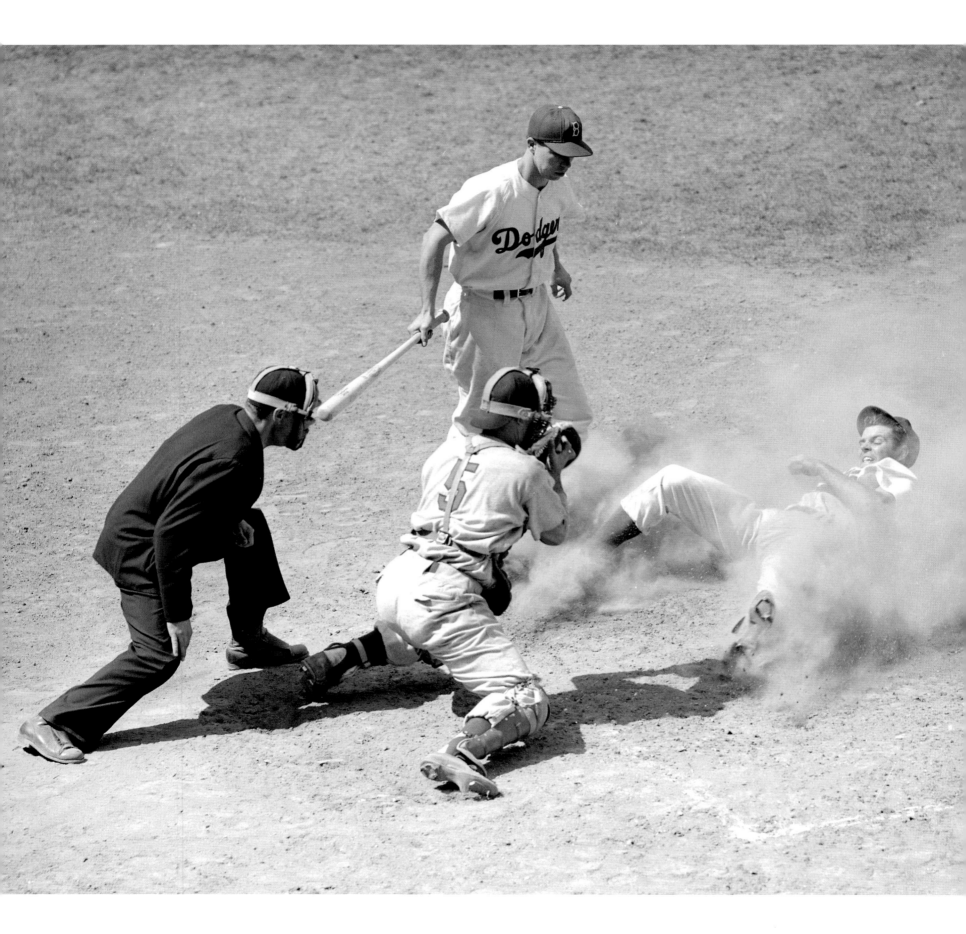

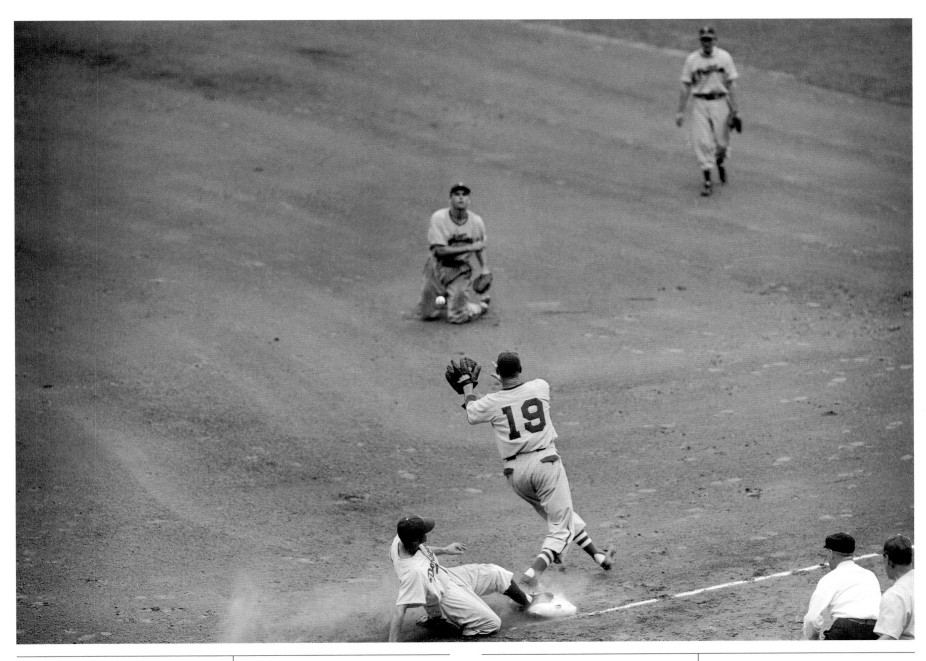

May 24, 1948
A CLOSE SWIPE

Miksis of Dodgers, who sewed up the ball game with his bag-cleaning double in 4th, rubs a little more salt into Reds' wounds by stealing home. Six runs this frame boosted Flock to a 9-4 win.

Hank Olen

Eddie Miksis was a utility player. After thirty games, the Dodgers were in sixth place, eight games out of first.

July 1, 1948
LOW PEG

Dick Sisler is on his knees, tossing to pitcher Schoolboy Rowe at first, but the Flock's Marv Rackley is safe in the 1st frame. Sisler tumbled while fielding the grounder.

Charles Hoff

Rackley played left field. Rowe, a former Tigers ace, was nearing the end of his career; Sisler, playing first base in 1948, was two years away from pennant-clinching fame. The Phillies beat the Dodgers, 4–2, sweeping their series at Ebbets Field. The Dodgers were still in sixth place, nine back. Two weeks later, Dodgers president Branch Rickey brought back Burt Shotton and shipped the turbulent Durocher to the Giants, who wanted to ease out their beloved manager and former star, Mel Ott.

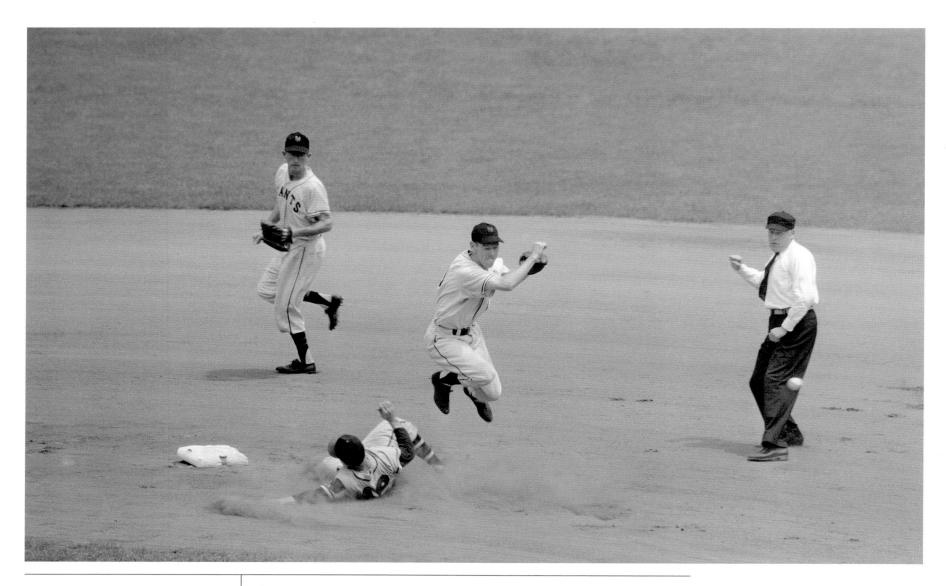

July 5, 1948

TOUGH SLEDDING FOR EDDIE

The Giants' Buddy Kerr leaps high to peg to first to double Boston's Tommy Holmes as Eddie Stanky slides vainly at second in 1st frame. Clint Hartung fielded the ball. Giants edged out the Braves, 6-5, in 13 innings.

Hank Olen

The Braves went on to win the pennant, however, led by Holmes's bat and pitching aces Johnny Sain and Warren Spahn, while the Giants finished in fifth place, thirteen and a half games out. The aggressive Stanky, a Dodger in 1947 (and a Giant in 1950–51), had been traded to make room at second base for Jackie Robinson. Four days after this game, the most famous Negro Leaguer of them all, Satchel Paige, debuted in the majors at last, pitching two shutout innings in relief for Cleveland. Already about forty-two and well past his Hall of Fame prime, he went 6-1 for the season and continued to pitch for a few more years—then returned for three final shutout innings, for the Kansas City Athletics, in 1965.

September 21, 1948
THE HARD WAY
Roy Campanella, Dodger catcher, watches
as Pirate Vic Lombardi drops after being
hit by a wild pitch in the 2d inning. The
Bucs beat the Brooks, 6-3, after taking the
playoff, 12-11. The prelim finished the dis-
puted tussle of Aug. 25.
John Tresilian

Campy was a newcomer; Lombardi had been a Dodgers pitcher the year before. The end of that
August game had to be replayed because the Pirates successfully protested that the Dodgers'
reliever hadn't pitched one complete at bat before being yanked, as required. A month later,
with two on and two out in the ninth again and Brooklyn up 11–9, the batter walked (instead
of hitting into a game-ending force-out as happened in August), and a hit then delivered three
runs and the upset win for the Pirates. Over all, the Dodgers played better under Shotton than
under Durocher but ended up seven and a half games behind the Braves (who then lost to the
Indians in six games).

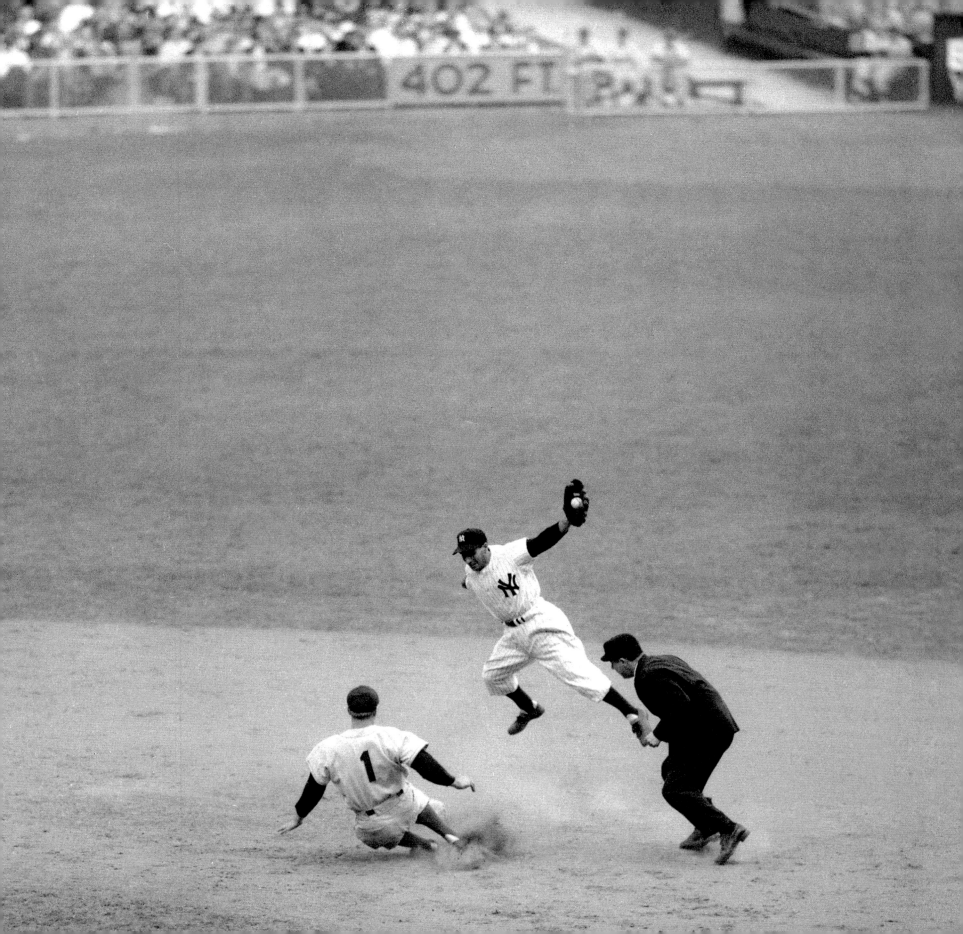

Uh-oh, this looked like the wrong year to be taking in games in the Bronx. The Yankees, who had specialized in winning narrow pennant races, had failed a year earlier, and now their best people were blowing out too many birthday candles. Who's on first? Good question. The Yankees used seven players at that position this year. Worst of all, the great DiMaggio, who had signed baseball's first $100,000 contract, sat out the first half of the season with an aching heel. Not many thought the new manager, Casey Stengel, who had been nothing but a total failure in his previous managerial stints, a loser and a clown, could right this Yankee ship. The Dodgers, on the other hand, with no regular over the age of thirty, were displaying the form that would carry them to five World Series appearances in the next eight years. Not bad for a team whose first forty-six years in the league had produced only two October opportunities. The Giants, with Leo Durocher in his lab coat trying to find the right formula, finished twenty-four games away. They did get a near-MVP season from one young player. His name was Bobby Thomson, and he'd make much more of an impression a couple of years later. It was the fifty-nine-year-old Stengel who made an immediate difference. He had the Yankees in contention from the start, and they were five games ahead of the Red Sox when they began a late June series in Fenway Park. DiMaggio, at last, was ready to begin earning the first few dollars of that $100,000. The Yankees won all three in Boston, and DiMaggio, surprising himself, accounted for four homers and nine runs batted in. He was approaching the plate, after one of those homers, when Stengel bolted out of the dugout and began salaaming his superstar. But baseball doesn't follow a script, and so the last weekend of the season, when the schedule put the Yankees and Red Sox on the same field for the last two games, the Bronx team was a game behind the Red Sox. The Yankees had to win both or they'd win nothing. The first game was tied in the eighth inning, and Stengel used two left-handed pinch hitters against Boston right-hander Joe Dobson. They failed. The next batter, Johnny Lindell, was another righty, and Casey had one more lefty swinger available, Charlie Keller. He decided to stay with Lindell—who rewarded him with the game-winning home run. The next day, the Yankees won it all. In the World Series, the first game was 0–0 until Tommy Henrich lived up to his nickname of Old Reliable with a ninth-inning home run. The second game, another 1–0 afternoon, belonged to the Dodgers. The third game produced more ninth-inning drama. The game was tied when Johnny Mize, sold by the Giants to the Yankees in late August for $40,000, delivered a two-run single. The Yankees won the Series, the first ever shown on national television, in five games. A lot more people than usual saw the Dodgers lose.

In Game 1 of the World Series (Yankees vs. Dodgers), a classic pitchers' duel watched by 66,224 at Yankee Stadium, rookie starter Don Newcombe (one of the first to benefit from the integration of baseball, and the National League's Rookie of the Year) struck out eleven and gave up only five hits—but the last was the one that counted: a solo game-winning home run by Tommy Henrich. Meanwhile, Yankees starter Allie Reynolds fanned nine and pitched a two-hit shutout.

May 24, 1949
PARDON MY GLOVE . . . !

Any ball a player can get his hands on is in play and Jack Phillips, Yankees
first sacker, is fully cognizant of this feature of the game as he makes a
backtwisting catch of foul pop in the 9th at the Stadium. Fans duck for cover.

Walter Kelleher

With a ten-run fifth inning, the Yankees won 13–3 against the St. Louis Browns, a mediocre
team that won one pennant in fifty-two years—and that was in 1944, during the talent
drought of World War II. After the 1953 season, the Browns moved to Baltimore and became
the third (but longest-lasting) team called the Orioles. Phillips, one of the backups for Tommy
Henrich (who played first and some outfield but had severe injuries, including broken verte-
brae), was in his final year with the Yankees.

May 30, 1949
FLASHY TIE

Tearing in from 2d on wild pitch by Rex Barney in 9th of Polo Grounds opener, Lockman hits the dirt and is safe. Miksis takes Campanella's recovery. Play sent game into extra innings. Dodgers finally won in 13th, 2-1. Giants won afterpiece, 7-4.

Walter Kelleher

The Dodgers pitcher, no longer a fifteen-game winner as in 1948, almost blew the opener of the doubleheader with two walks and then this throw, letting Giants left fielder Whitey Lockman come all the way home from second. But Jackie Robinson came through again, with an extra-inning home run. He was the National League's Most Valuable Player in 1949, and its leader in batting average (.342) and stolen bases (thirty-seven).

September 7, 1949
LADY'S AID

Twenty-year-old Rose Conway is an ardent Yankee rooter. She came down from Mount Vernon to Yankee Stadium last night to help her crippled boys win a big one from the Boston Red Sox. And these pictures prove Rose worked very hard for the thrilling 5-2 victory. The triumph, which increases the Yanks' lead over the pursuing Bosox to 2½ games, was witnessed by 66,874 fans—and Rose.

Bill Meurer

The sixth photo (taken by Walter Kelleher) in this *Daily News* centerfold sequence shows the great Joe DiMaggio striking out. Joltin' Joe missed seventy-eight games, and Yogi Berra was injured nine times, among a total of seventy-one injuries afflicting the "crippled boys" in 1949—good reason for Joe Trimble of the *Daily News* to call this game "the most magnificent victory of the season." But the best was yet to come.

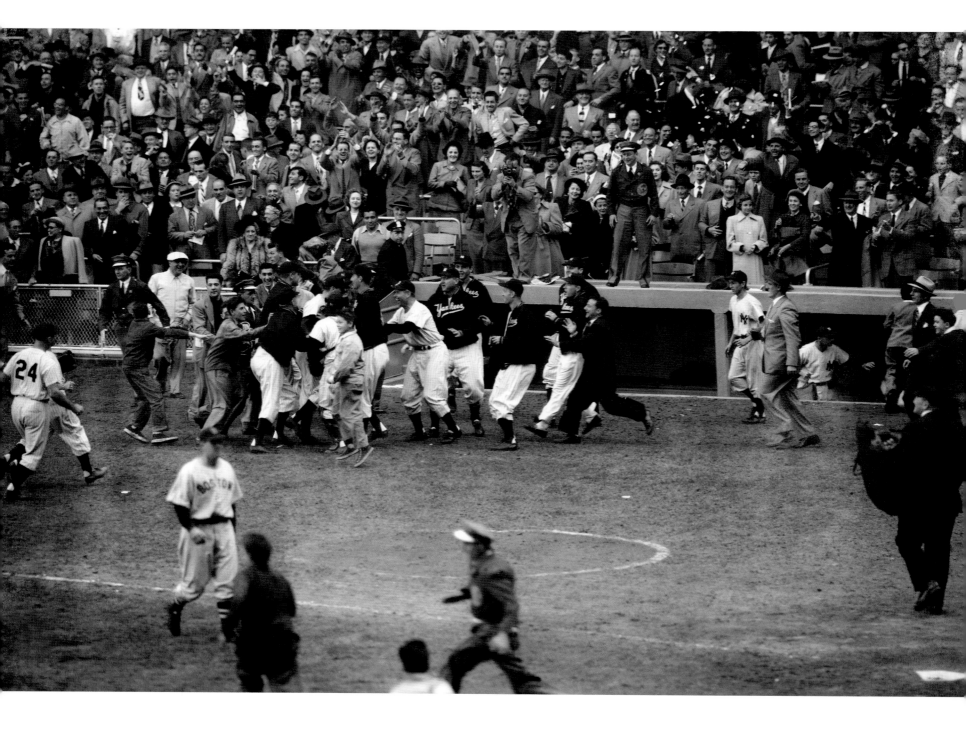

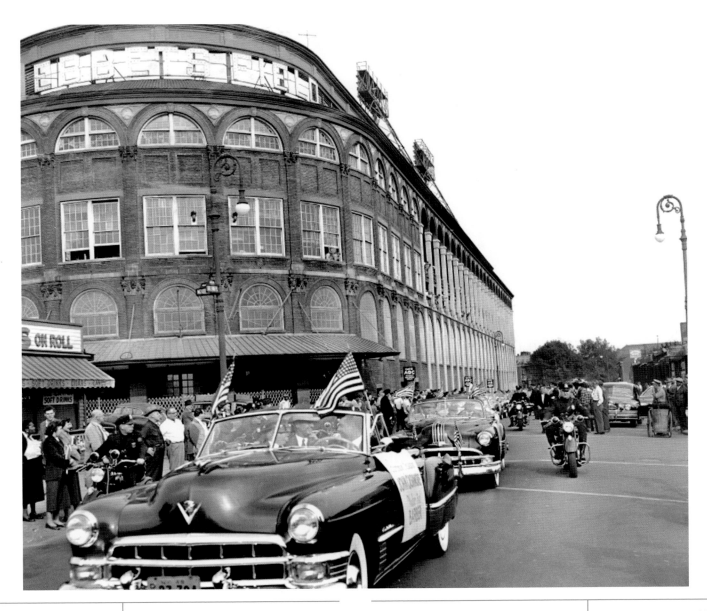

October 2, 1949

Vic Raschi, whose 21st victory of the season was the most important one he'd ever fashioned, is mobbed by teammates and fans overflowing from the jammed stands after the last out had been registered.

Tom Watson

The Red Sox—down twelve games in early July—battled back in the closing weeks, and the two teams went into the last day of the season tied for first. It took this final game, an exciting 5–3 win at home, for the Yankees to clinch the pennant, for the sixteenth time. Bosox star Ted Williams, who missed the Triple Crown about as narrowly as anyone can (forty-three home runs, 159 RBIs, and a .3427 average—.0002 behind the Tigers' George Kell), never again came this close to the ever-elusive World Series.

October 4, 1949

On the same day the Yankees won the pennant, the Dodgers took the National League flag with a 9–7 win at night over the third-place Phillies in what Dick Young called "10 agonizing innings." About 6,000 fans met the train bringing the players back to New York. Two days later, the Dodgers' motorcade left Ebbets Field for a two-mile, two-hour parade to Borough Hall, with an estimated 900,000 people lining the streets. The World Series began the next day, with a last-minute 1–0 Yankees victory.

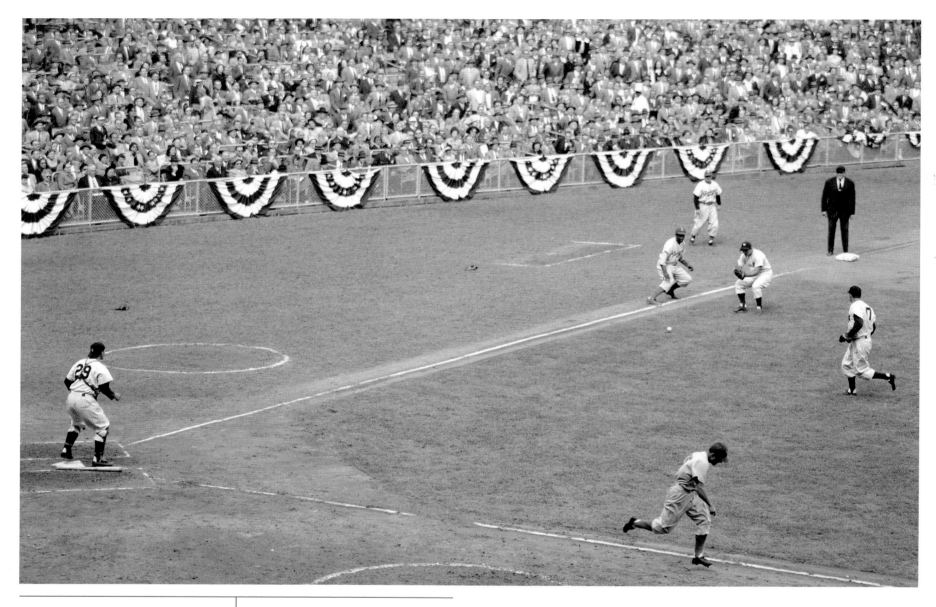

October 6, 1949

CHARTING THE COURSE OF SWIFT FAMILY ROBINSON

Odds dropped, blood pressure soared and gate receipts loomed bigger on the baseball horizon. All this was assured yesterday with one deft swoop of a piece of hickory. The meaningful mace was wielded by Gil Hodges and with it he delivered the clutch hit which scored Jackie Robinson from 3d with the only run of the game in the 2d inning at Yankee Stadium.

Ossie Leviness

After doubling into the left-field corner early in Game 2, Robinson had taken third when Jerry Coleman slipped as he caught Gene Hermanski's foul pop. Robinson was forced to hold when Marv Rackley—seen here (in one photo from a sequence) running futilely for first base—bounced to third. But Robby was able to stroll home when Johnny Lindell in left booted Hodges's ball. The *Daily News* headline for Game 2: "Bums Tie It!"

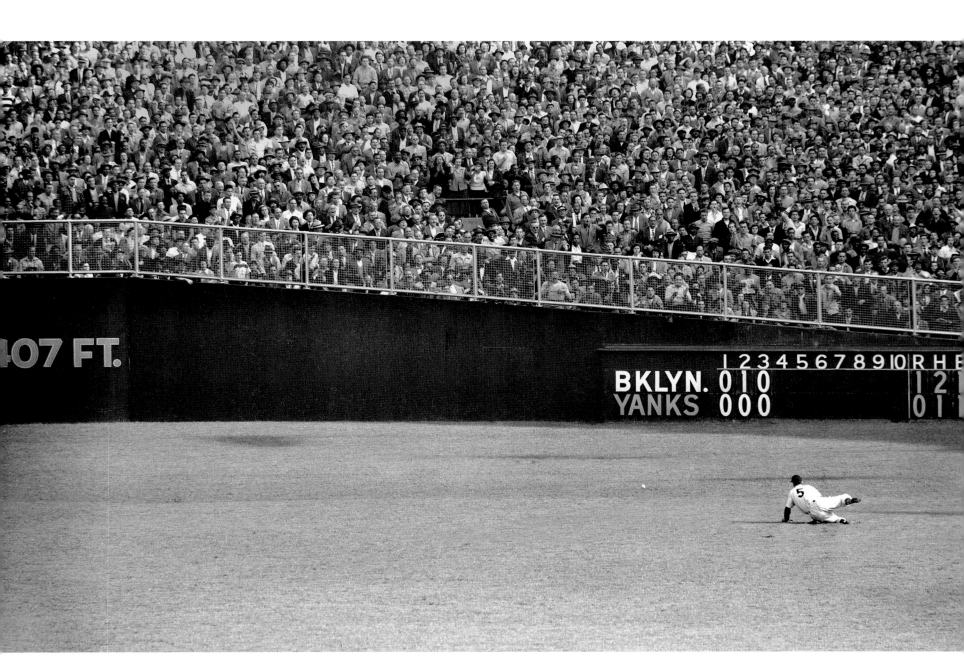

October 6, 1949

CRASH LANDING FOR YANKEE CLIPPER

Hermanski's hit to right center in Dodger fourth goes for a triple when DiMaggio trips in attempt to retrieve ball on one bounce in front of bleachers.

Tom Watson

The Dodgers left fielder was out at the plate when Marv Rackley hit a slow roller to Coleman at second. A Game 2 crowd of 70,053 saw DiMag, usually an outstanding and graceful center fielder, go down when the ball took a crazy hop as he tried to lunge for it.

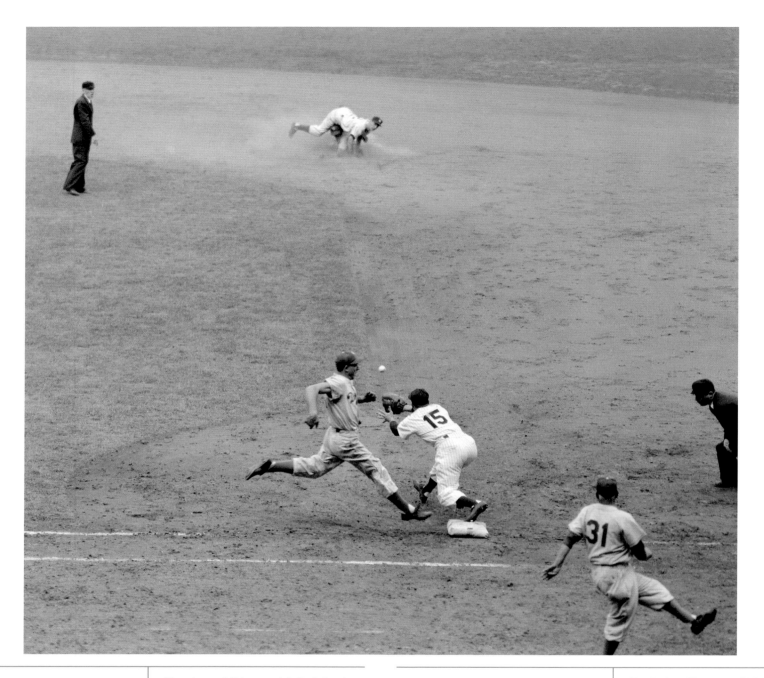

October 6, 1949
BENT, NOT BROKEN
Luis Olmo certainly bends Gerry Coleman in
half with this footballish block in seventh
inning forceout play, but Luis couldn't
break up double play as Gerry's relay beats
Gil Hodges to first by half a step.
Ossie Leviness

The winner of this second 1–0 pitchers'
duel in a row was Elwin "Preacher" Roe,
acquired at the end of 1947 in a trade
with the Pirates, and now pitching with a
sore hand that had been hit by Johnny
Lindell's line drive in the fourth. Yankees
ace Vic Raschi took the loss.

October 7, 1949
PROP-WASH FROM YANKEE CLIPPER
DiMaggio, a bit of a washout so far, is
caught by special long-focal-length lens in
bleachers as he strikes out in first inning.
Branca's pitch is nesting safely in
Campanella's mitt.
Fred Morgan

The Yankee Clipper hit .346 in 1949 but
was still weak after being hospitalized with
viral pneumonia in mid-September, and he
got only two hits in eighteen at bats in the
Series. In Game 3, played at Ebbets Field
before 32,788 fans, DiMaggio struck out
twice and popped out twice. In fact, starter
Ralph Branca gave up only two hits and
one run—until the climactic ninth inning.

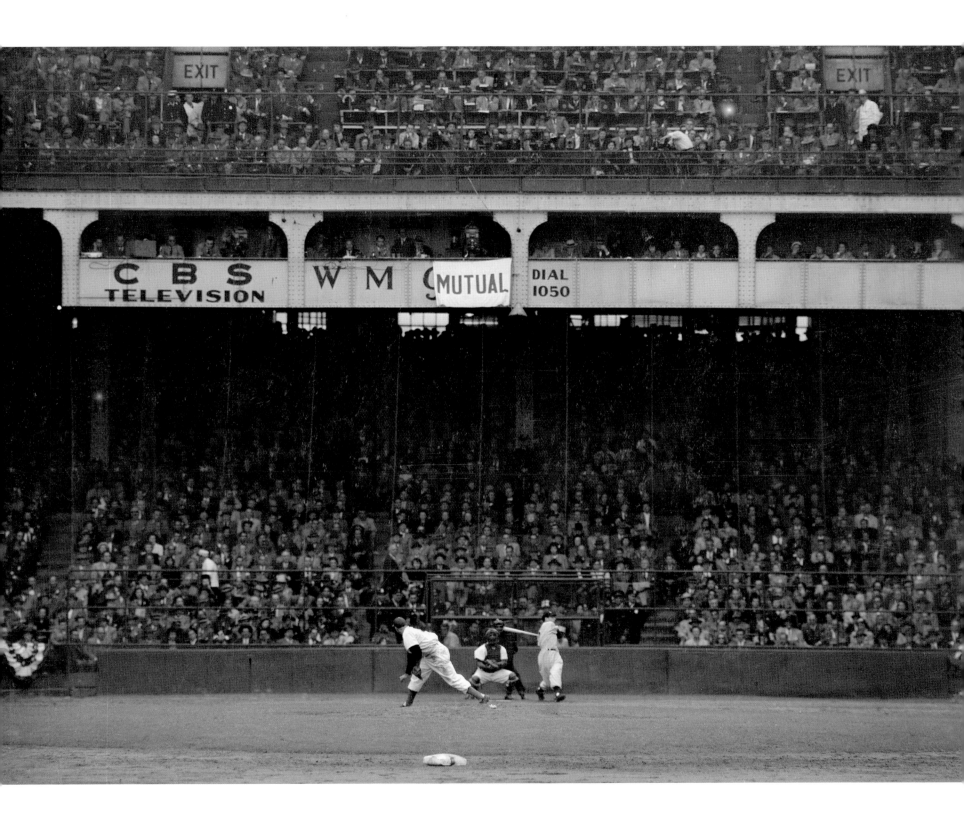

October 7, 1949
OF MIZE AND AMEN!

They call him The Big Cat and last night, over glasses of bitter-tasting brew, the good burghers of Brooklyn were still talking of his sharp claws. They were speaking of Large Jawn Mize, the ex-National Leaguer, who returned to familiar precincts yesterday to shove defeat down the throats of the Brooklyn Dodgers when he singled with the bases loaded in the 9th. It took a subsequent single by Yanks' Coleman to drive in what proved to be the winning marker in the contest, but Big John's poke was the one that shattered a pitching duel and drove Ralph Branca from mound. Mize's single was the biggest blow, despite three Brook homers.

Ray Waters

As a Giant, until the Yankees picked him up on August 22, Mize had led the National League with 138 RBIs in 1947 and tied with Ralph Kiner for the home-run title in 1947 (fifty-one) and 1948 (forty). The Hall of Fame slugger, now thirty-six and injured late in the season, was pinch-hitting for part-time outfielder Cliff Mapes—a last-second substitution by the manager whom Red Smith called "Field Marshal Casey von Stengel"—when he whacked Branca's fastball on a 2–1 count to break open Game 3. Coleman's insurance run, which proved vital, came off reliever Jack Banta.

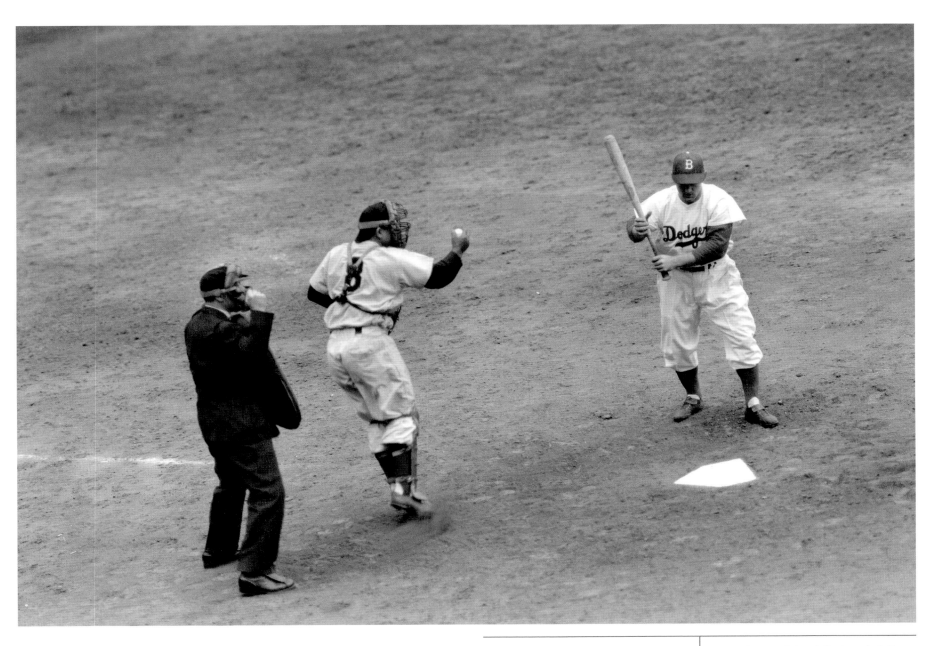

October 7, 1949
The end of an imperfect day for
the Dodgers. Yank catcher Berra
triumphantly holds aloft a called
third strike that put Edwards
out and ended the third game of
the series. Umpire is Passarella.
Charles Hoff

In the bottom of the ninth, down 4–1, the
Dodgers fought back with solo home runs by
Luis Olmo and Roy Campanella off short re-
liever Joe Page, who'd pitched the ninth in-
ning of Game 2 but was brought in as early
as the fourth inning of Game 3 after starter
Tommy Byrne loaded the bases. Page
pitched a one-hitter until the ninth, and
after the two homers he managed to get
pinch hitter Bruce Edwards—and the win.
Calling that final strike is Art Passarella.

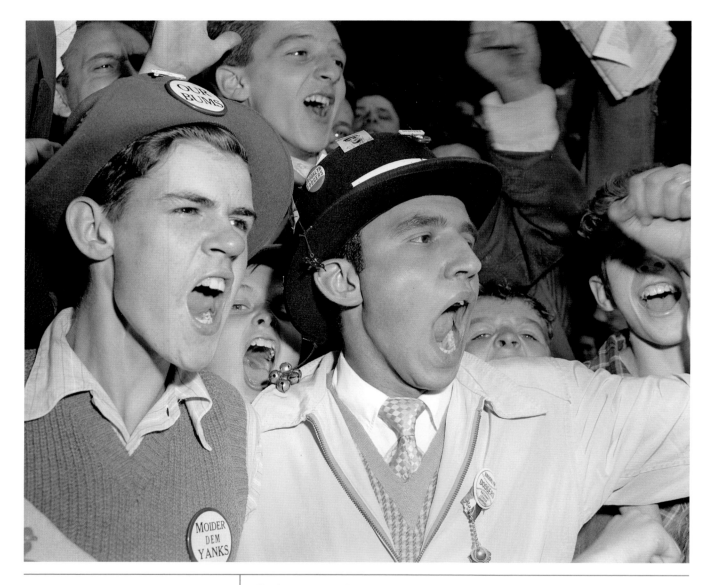

October 8, 1949
Bud Keehon (left) and Phil Sileo were
enthusiastic fans but their team—you
know who—lost.
Ed Clarity

The buttons read "Our Bums" and, in glorious Brooklynese, "Moider Dem Yanks." But it was not to be. With 33,934 fans mostly cheering on their beloved Dodgers at home, the Yankees took Game 4 on a 6–4 score. In fact, they were leading 6–0, having knocked out Don Newcombe in the fourth inning, until Yankees starter Ed Lopat—usually "Steady Eddie"—gave up seven singles and four runs in the sixth. Allie Reynolds came in and took out the last ten Dodgers, five on strikeouts.

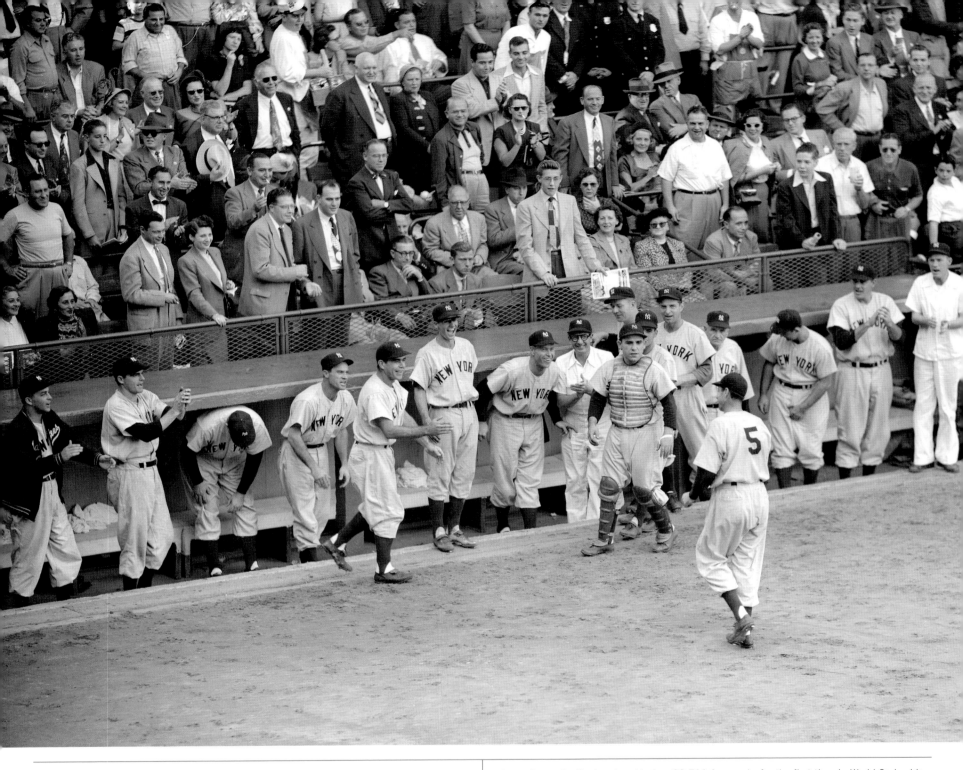

October 9, 1949
ELECTRIFIED BY JOE'S CIRCUIT
Every member of the Yankee team comes out of the dugout to greet Joe DiMaggio after he clouted a homer in the 4th inning at Ebbets Field yesterday. Dodger fans, who are obvious in their dejection, exhibit less appreciation.

Hank Olen

Game 5 was the finale, played before 33,711 fans and—for the first time in World Series history—with the ballpark lights turned on, by order of Commissioner Albert "Happy" Chandler, before the ninth inning began at about 4:50 P.M. With Preacher Roe's hand still injured, the Dodgers had to start Rex Barney, who gave up five runs by the third inning. After six innings the Yankees had a 10–2 lead. The Dodgers rallied for four runs in the seventh, but Joe Page relieved starter Vic Raschi and ended the game, with two on in the ninth, by striking out Duke Snider, Jackie Robinson, and Gil Hodges. Winning the Series mainly by shuffling Raschi, Reynolds, and Page, Stengel won most of the baseball writers' votes for Manager of the Year.

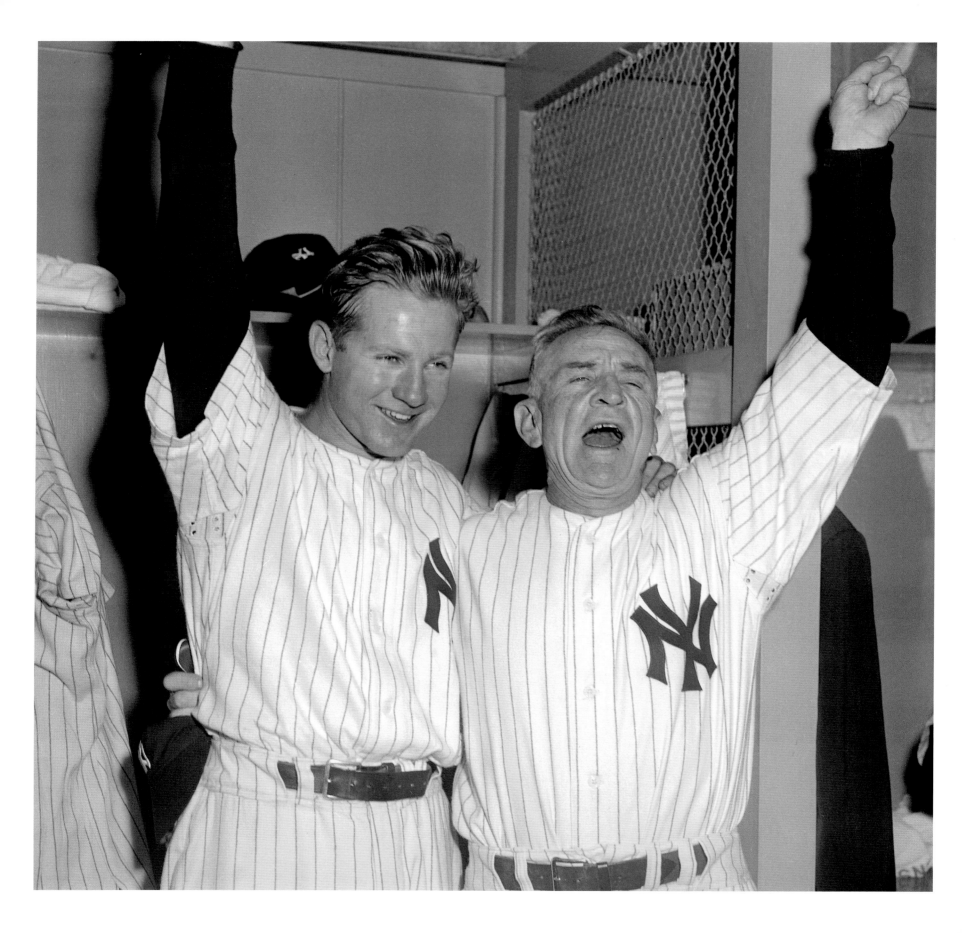

Cal Abrams was running toward home plate, the last inning of the last game of the season. He would score the winning run, and a day later the Dodgers and Phillies would begin a playoff that the "Phading Phils" had no hope of taking. Hold that thought. Four teams in the American League won more than ninety games this season, but the Yankees won more than the others to earn the second of five straight trips to the World Series. Joe DiMaggio had his last great year (thirty-two home runs, 122 RBIs, .301), and Yogi Berra continued to send out Hall of Fame signals (twenty-eight, 124, .322). But the league's MVP was the smallest Yankee, the Scooter, Phil Rizzuto. The sparkplug of their over-thirty pitching staff was a twenty-one-year-old left-hander who was born a few miles from Yankee Stadium, a Yankee fan who saw his first game at nine. Whitey Ford joined the team in June, and he won 9 of his 10 decisions. Before he was done, in 1967, he added 227 more victories. The other New York team, the Giants, were finally stirring. Over the winter, they traded old sluggers Willard Marshall and Sid Gordon for Alvin Dark and Eddie Stanky, the hustling kind of players Leo Durocher wanted. They ended up in third place, their best finish in a decade. And now let's get back to the Dodgers, who closed the season with a flurry, winning thirteen of their last sixteen. They began the last day of the season against the league-leading Phillies, whose lead was only one game. A Dodgers win would force a playoff. They seemed to have what they needed, in the ninth inning of a tie game, when Abrams led off with a walk, and Pee Wee Reese followed with a single. Abrams was on second when Duke Snider, swinging on the first pitch, hit a low liner to center, another single. The Phils' center fielder, Richie Ashburn, was playing unusually shallow for the power-hitting Snider. He thought the Duke of Flatbush might be bunting on the first pitch to advance the runners. So when Abrams was waved home by third-base coach Milt Stock, the accurate peg from Ashburn, whose arm was nothing to throw home about, nailed Abrams by about fifteen feet. The Dodgers weren't out of chances. Reese reached third on the play, Snider second, and Jackie Robinson was intentionally walked to load the bases. But the next two Dodgers couldn't bring them in. Dick Sisler's three-run homer in the tenth inning ended the Dodgers' season. The Yankees took over from there, putting away the Phillies in four games. Casey Stengel's team was making it look easy.

October 7, 1950
TO ERR IS HUMAN . . . TO FORGIVE IS EASY
Eddie Ford, the 21-year-old rookie who hurled the Yanks to their 4th straight victory over the Phils in this year's World Series, is subjected to the contagious spirit of jubilation as he stands next to manager Casey Stengel following yesterday's finale at Yankee Stadium.
Charles Payne

The other front-page shot in some editions of the *Daily News* was of the usually reliable Gene Woodling blowing Ford's shutout by failing to spot Andy Seminick's two-out fly ball in the ninth, allowing two runs to score. In came Allie Reynolds, out went pinch hitter Stan Lopata on three fastballs, and Ford (not yet "Whitey") at least had the 5–2 victory—and became the youngest pitcher to win a World Series game. That made it easy for him to overlook Woodling's failure. As for Stengel, it was the supposedly washed-up old clown's second straight championship.

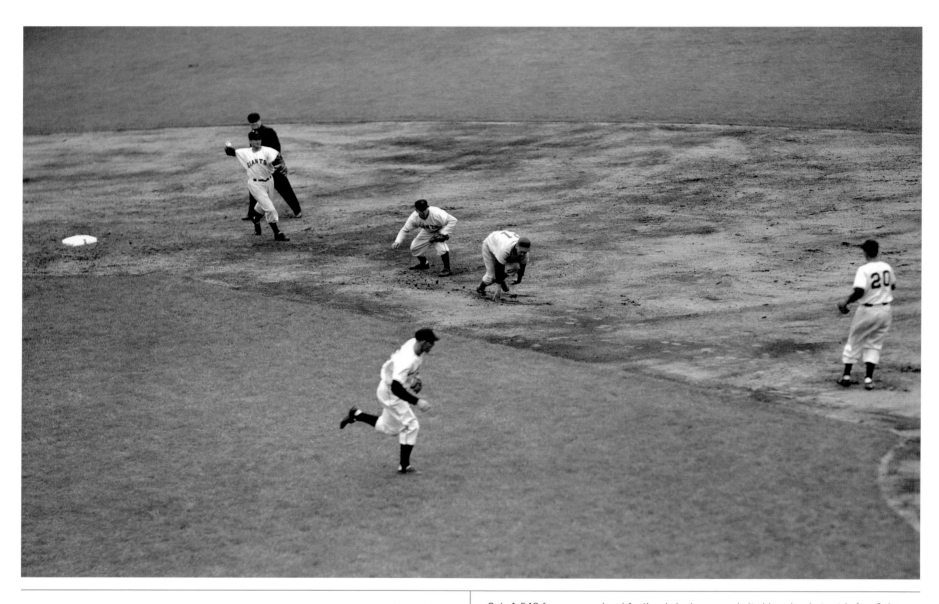

May 18, 1950

LITTLE BEAR IN BIG TRAP

Terwilliger of the Chicago Cubs is hung up between second and first after being picked off by Hartung of the Giants in first inning at Polo Grounds. Dark cocks to throw as Terwilliger bends for first. Hartung (foreground) leaves mound to assist in play. He finally made putout. Giants won, 10-4.

Nick Petersen

Only 1,542 fans were on hand for the six-inning game, halted by rain—but not before Cubs manager Frankie Frisch (the Hall of Fame second baseman for the old Giants and Cardinals) had been ejected and the Cubs' Rube Walker and then the Dodgers' Monte Irvin (a former Negro League star who was finally getting real playing time in his second year with the Giants, at age thirty-one) had each hit a grand slam. Shortstop Alvin Dark (the 1948 Rookie of the Year) and Eddie Stanky came from the Braves at the end of 1949, for Jewish slugger Sid Gordon. Wayne Terwilliger went to the Dodgers in June 1951. Clint Hartung sometimes pitched and sometimes played outfield.

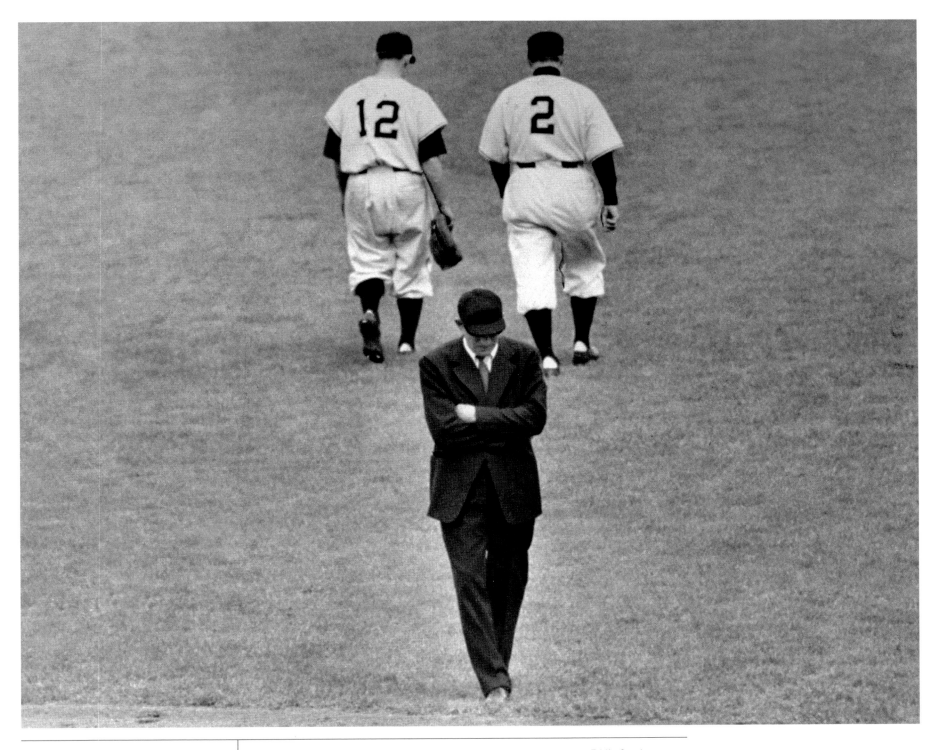

May 25, 1950
FAREWELL ADDRESS
—Muggsy and Lippy go by-by.
Tom Watson

Part of a series of back-page photos, with this longer explanation: "When Eddie Stanky was thrown out of game by Ump Lou Jorda in fifth inning for protesting a call too strenuously, it was like old times again as manager Leo (Lippy) Durocher of the Giants bounced out to take up the cudgel in defense of his fiery second sacker. When it was all over, Leo needed a defense. For third time this year, he was tossed out of game." Durocher is wearing no. 2; "Muggsy," of course, is Stanky, who flung down his bat after being called out on strikes at the Polo Grounds. By the way, the Cardinals won the game, 7–5, in the thirteenth inning.

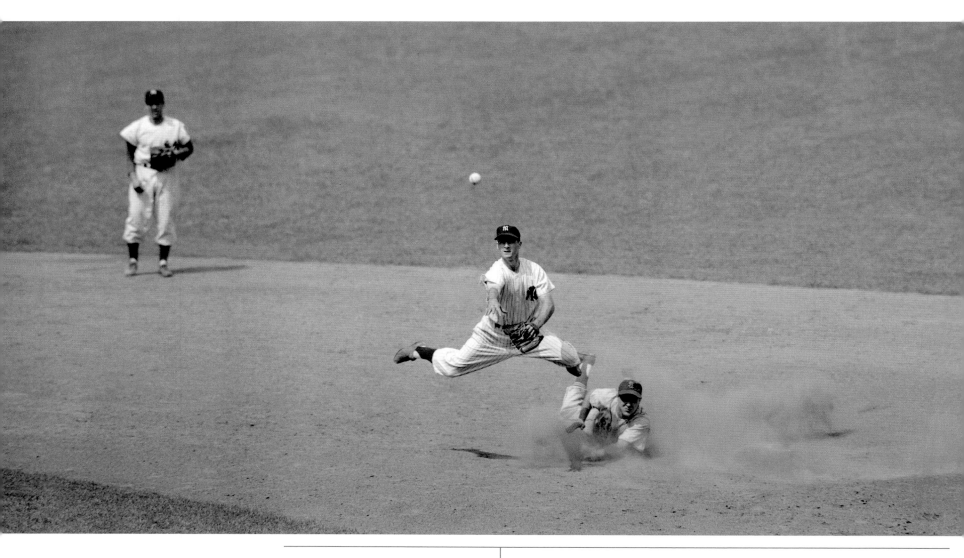

June 11, 1950

WHADDYA TRYIN' TO DO, KOKOS, CROAK US?

Dick Kokos, hard-sliding slugger of Browns, did his best to dish out basepath mayhem at Stadium yesterday. He makes Jerry Coleman do spread-eagle at second base, so that relay to first was too late to double Sherm Lollar in sixth of opener.

Hank Olen

Kokos, an outfielder, had tried the same thing in the fourth inning, but that time Lollar, a former Yankees catcher, was out too. The Yankees won, 1–0, on a three-hitter by Vic Raschi, then took the tail end of the doubleheader, 4–2. St. Louis finished this season forty games out (but six ahead of the Philadelphia A's—whose part-owner and manager, Connie Mack, retired at age eighty-seven, after *fifty* years at their helm, with a matchless career record of 3,731–3,948). Coleman, the Yankees' regular second baseman in 1949–51 and a World Series hero in 1949, set a team record in 1950 by turning 137 double plays.

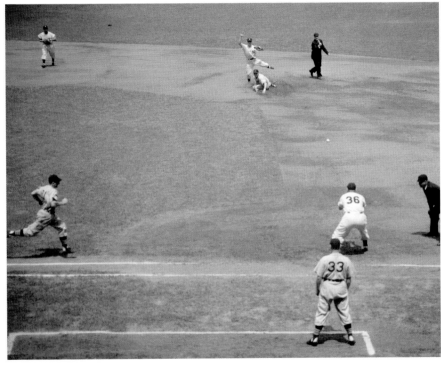

July 23, 1950
SCENES FROM A TWO-ACT PLAY
Grabbing Kell's first inning grounder,
Rizzuto of the Yanks fires to second where
Gerry Coleman covers for the force on
Lipon, coming down from first.
Meanwhile, Mize makes sure he get his
foot on the first base bag, to take throw for
the double play on Kell. Yanks lost, 6–5.
Seymour Wally

Hall of Fame third baseman George Kell hit .340 in 1950. Johnny Lipon was Detroit's shortstop. DiMaggio and Berra each hit a home run at Yankee Stadium, but Tigers pitcher Saul Rogovin beat them with a grand slam.

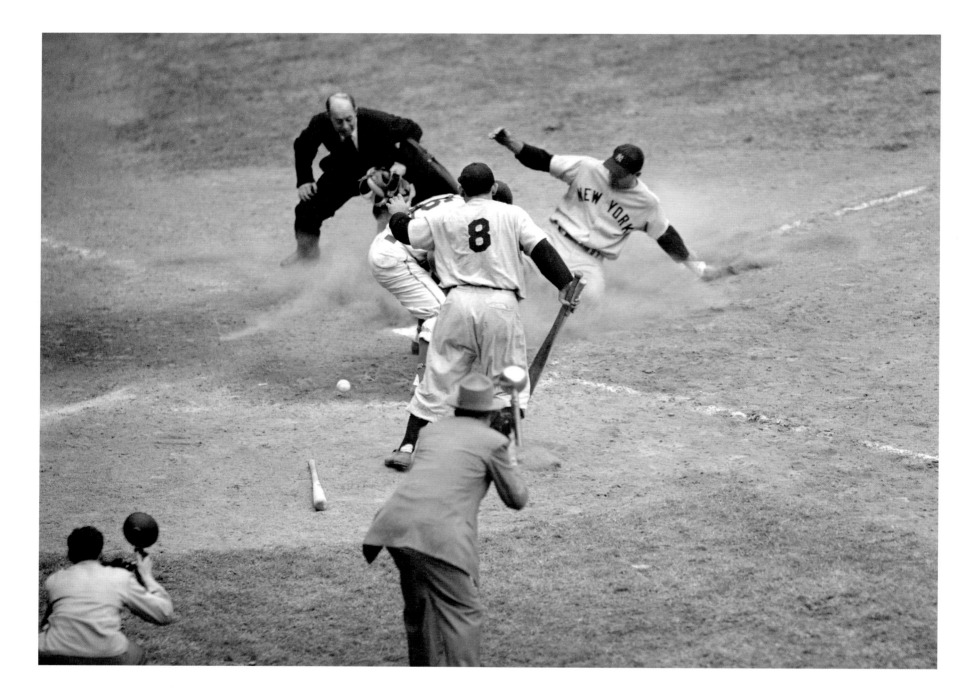

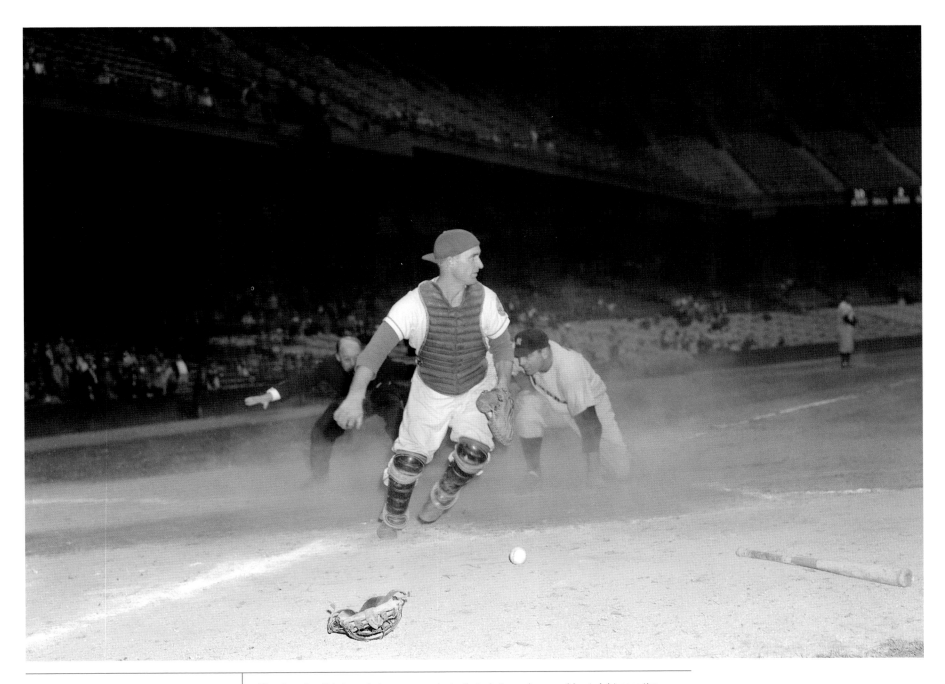

September 28, 1950
DOUBLE AND REDOUBLE

Cliff Mapes of the Yankees slides safely home in 10th inning as ball eludes A's catcher Joe Tipton. As Cliff straightens up, Joe is still chasing ball. Cliff slashed double past third with one out in 10th and scored on Phil Rizzuto's single. Phil also scored. Yanks won, 8–6. Tigers won, 4–3, assuring Yanks of at least a tie in AL race.
Walter Kelleher

The day after this two-photo sequence (note that photographers could get right near the action), the Yankees clinched the pennant again, by resting while the Indians beat the Tigers. Detroit had been in first place for 119 days and kept battling for it right up to the end, but the Tigers wound up in second, three games back. Rizzuto not only bunted and scooted around the bases brilliantly, but he also batted .324, got two hundred hits, went a record fifty-eight straight games without an error, and was named the league's Most Valuable Player.

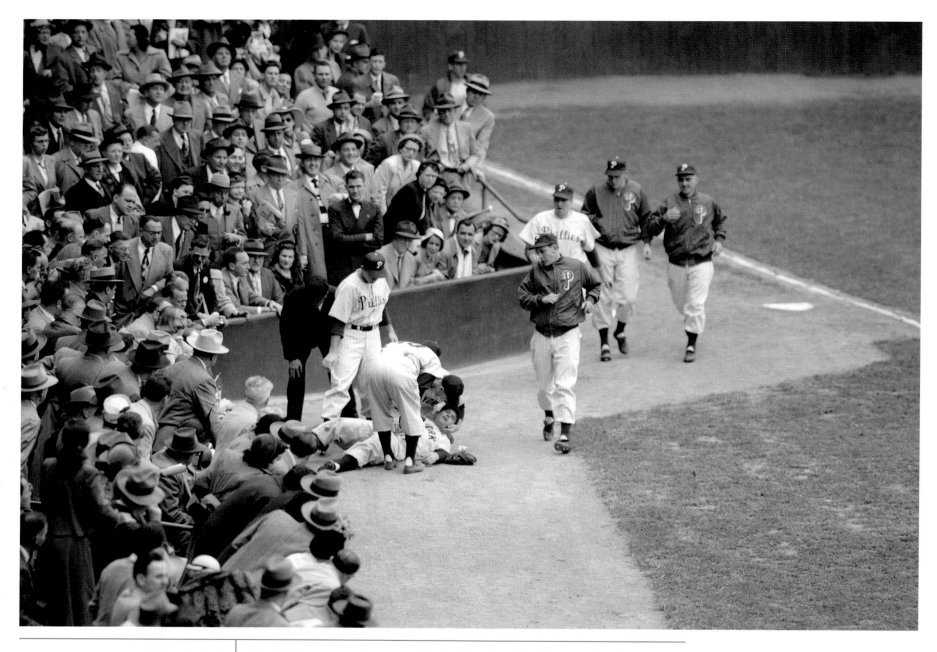

October 4, 1950
DEALT FOUL BLOW

In the spirit of sportsmanship, Phillies rush out to see how Gene Woodling is faring as the Yankee outfielder lies on ground after running into field box. Gene was chasing Waitkus' foul fly in 1st. He had wind knocked out of him. Yanks won Series opener at Philly, 1-0, as Raschi hurled two-hitter.

Hank Olen

The Phillies were pennant winners for the first time since 1915. (They wouldn't win another until 1976.) But they were worn out from holding on to first place since mid-July against the Dodger onslaught, right up to the end of the last game. Three days later, they were facing two-time (and by 1951, three-time) twenty-one-game winner Vic Raschi. Woodling held left field for the Yankees for most of 1949–54. At thirty-one, Eddie Waitkus was an elder statesman of the Whiz Kids; the World War II veteran was back at first base for Philadelphia after recovering from being shot—by a crazed woman in her hotel room on June 14, 1948.

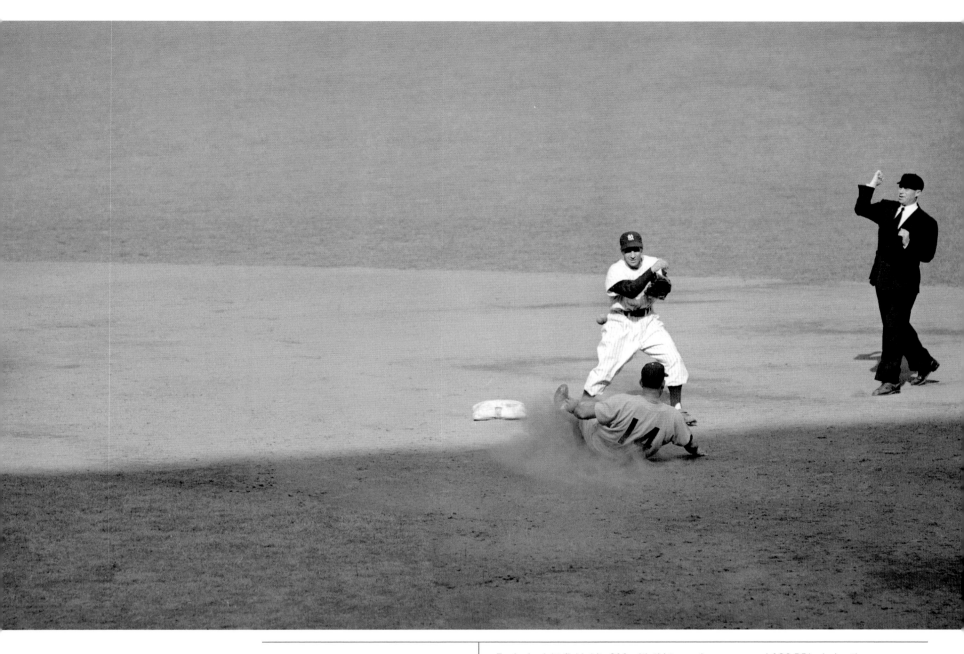

October 7, 1950
PHIL VS. PHILLIES
Phil Rizzuto, Yank shortstop who played
errorless ball in Series, is undaunted by
Del Ennis' slashing slide into midway in
sixth inning of finale. Phil relays Gerry
Coleman's toss to first to double another
futile Philly, Dick Sisler.
Bill Meurer

Ennis, in right field, hit .311 with thirty-one home runs and 126 RBIs during the season;
Sisler, back in left after Waitkus returned to first, had thirteen homers and a .296 average.
Joined by center fielder Richie Ashburn, catcher Andy Seminick, and pitchers Robin Roberts
and Curt Simmons, the Phillies kept it close in the first three games of the World Series,
losing the second 2–1 (on a tenth-inning homer by DiMaggio), and the third 3–2 (blowing
a lead in the ninth). But young Eddie Ford, who went 9–1 in his first season, with a 2.81
earned run average, shut down the Whiz Kids for eight innings in Game 4.

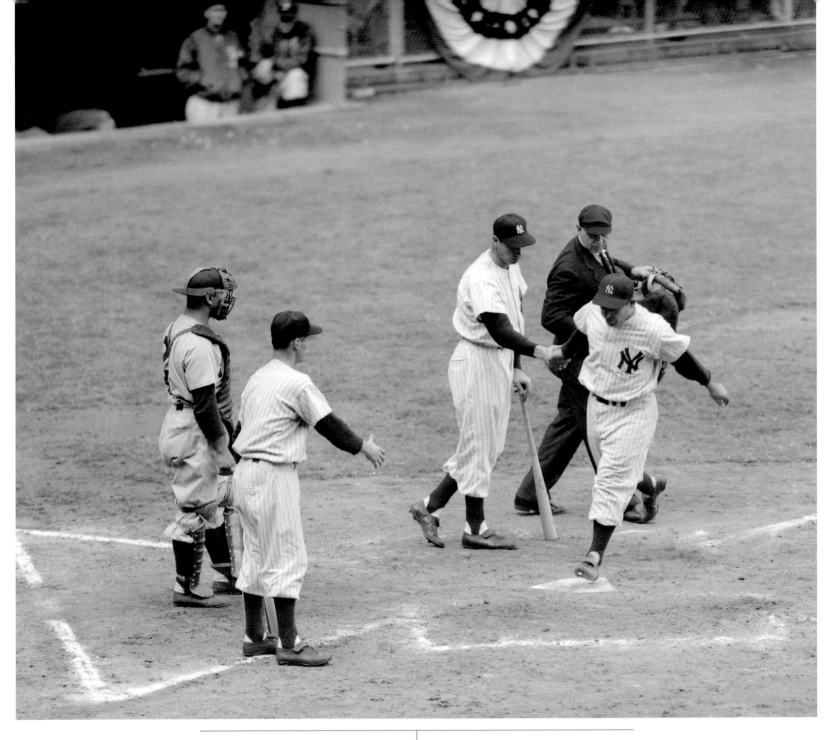

October 7, 1950
WELCOME HOMER
Joe DiMaggio greets Yogi Berra as squat
howitzer scores on sixth-inning homer,
which proved to be winning run.
Bill Meurer

Berra's home run in the second of two
games at Yankee Stadium started a three-
run rally in the the bottom of the sixth
inning, on top of two runs in the first; hit
by a pitch, DiMaggio soon followed Berra
home, on a triple by Bobby Brown (who
then scored on a hit by Hank Bauer).

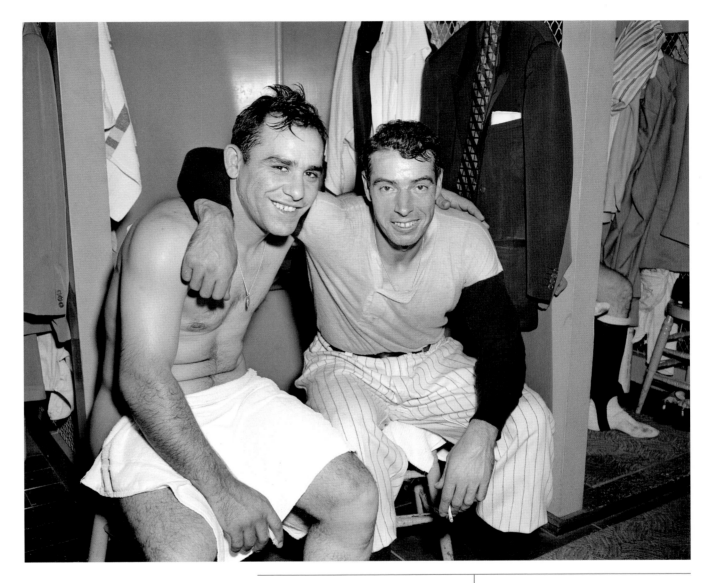

October 7, 1950
Yogi Berra and Joe DiMaggio cool off
before showering. The Phils, of course,
had long since been cooled off.
Charles Payne

The home-run heroes of Games 2 and 4:
Berra was still near the beginning of his
Hall of Fame career; DiMaggio was at the
end of his next-to-last season.

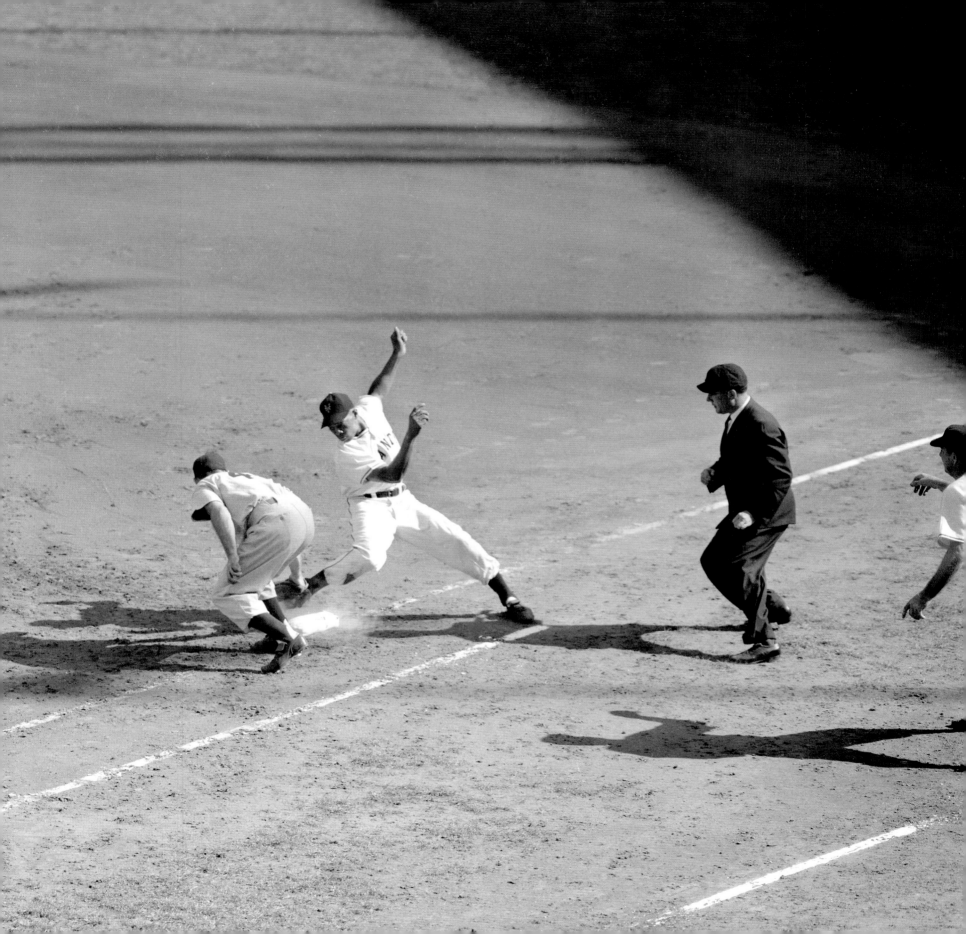

The October 3 game between the Giants and Dodgers—you know, the one that ended with Mr. Thomson's home run—continues to be replayed. Is there anything we haven't been told about that afternoon, or the night before? We know where Brooklyn manager Charlie Dressen ate dinner (at Rocco's) and what he ate (clams, mussels, spaghetti), and that Bobby Thomson drove a blue Mercury to the Polo Grounds, Ralph Branca an Oldsmobile. Outfielder Andy Pafko rode the subway from Brooklyn. Pitcher Larry Jansen wouldn't let the maids at the Henry Hudson Hotel change his bedspread, even though it was ink-stained. His Giants were winning; you don't mess with success. What we may never know, because it hardly matters, is what the Yankees were up to. They moved into first place with two weeks left in the season and just kept winning. Allie Reynolds threw a pair of no-hitters that season, Yogi Berra was the Most Valuable Player, Mickey Mantle split his rookie season between Yankee Stadium—the outfield and the bench—and the minor-league team in Kansas City. Joe DiMaggio finished the worst season of his baseball life. The Yankees were rooting for the Giants to win the playoff series for purely financial reasons: the Polo Grounds had twenty thousand more seats than Ebbets Field, and the players' share of the Series loot came out of the gate receipts. It was a piece of arithmetic nobody expected to be doing. On August 11, the Dodgers were in first place, thirteen and a half games ahead of the Giants. The teams had to keep playing; there was a schedule, after all. But, really, what was the point? Three weeks later, after winning twenty of twenty-three, the Giants closed the gap to six games. That Grand Canyon of a lead was disappearing. Part of the Giants' success story, it turns out, was an elaborate sign-stealing scheme. One of the players was stationed in their center-field clubhouse, manning a telescope, picking up the signals being used by the opposing catcher. A buzzer system was hooked up from the clubhouse to the Giants' dugout and bullpen: one buzz for a fastball, two for a curve. Did it make a difference? Dodgers fans will say yes until their last breath. When the lead was down to four games, an enterprising sportswriter sought out Albert Einstein and asked him to do the math, to make a prediction. Einstein picked the Dodgers. The Giants weren't impressed. They kept winning, and the Dodgers weren't able to win quite enough games. The last day of the season, with both teams tied for first place, the Giants won 3–2 in Boston, and the Dodgers needed fourteen innings to outlast the Phillies, 9–8. The first playoff game at Ebbets Field was decided—this is almost impossible to believe—by a two-run home run by Thomson against Branca. The Dodgers won the next one, 10–0, behind Clem Labine. Why does it seem as if Game 3 began in the ninth inning? The Dodgers were ahead 4–1, when Alvin Dark led off that last inning with a single. Don Mueller followed with his single. Monte Irvin popped out. Whitey Lockman poked an opposite-field double to left, and Dark scored. And Dressen brought in Branca to replace his ace, Don Newcombe. Branca's first pitch to Thomson was a fastball, a strike, across the middle of the plate. The next pitch was another fastball, not nearly as attractive, high and inside. Thomson swung and made history. If you say the World Series mattered, fine, have it your way. But not many talk about the Series, which the Yankees won in six games. On December 11, the Yankee Clipper, the great DiMaggio, retired. New York was still talking about the National League playoffs.

October 6, 1951
FIRST THINGS FIRST
Mays scampers back to 1st ahead of
Raschi's pickoff peg being applied by
Collins in the 2d.
Fred Morgan

The fancy footwork by Giants rookie Willie Mays came during Game 3 of the World Series against the Yankees, three days after Bobby Thomson's "Miracle at Coogan's Bluff." Mays batted only .274 for the season, with twenty home runs and sixty-eight RBIs—but it was enough to get the twenty-year-old named Rookie of the Year. Much better years lay ahead. Incidentally, it was a fly ball by Mays to right-center field in the fifth inning of Game 2 that both Joe DiMaggio—in his last year—and rookie Mickey Mantle were pursuing when DiMag made a late call for it and Mantle stopped short, caught his cleats on a drain cover, and tore up his knee. The injury afflicted him throughout his career.

June 26, 1951
Lippy gives lip to Donatelli in 2d because
Augie cautioned Maglie.
Walter Kelleher

As Dana Mozley of the *Daily News* noted, Sal "the Barber" Maglie liked "to shave them thin," and previous meetings between the first-place Dodgers and second-place Giants had involved a lot of "bean balls and rough stuff." The Giants ace (who went 23–6 in 1951—and was 59–18 in 1950–52) became the major league's first twelve-game winner in 1951 with this three-hit, 4–0 shutout—but not before getting three warnings from umpire Augie Donatelli about his pitches inside. That brought out manager Leo Durocher. The umpires also warned Dodgers ace Preacher Roe (22–3 in 1951, and 52–16 in 1950–52), who took a loss for the first time in eleven games.

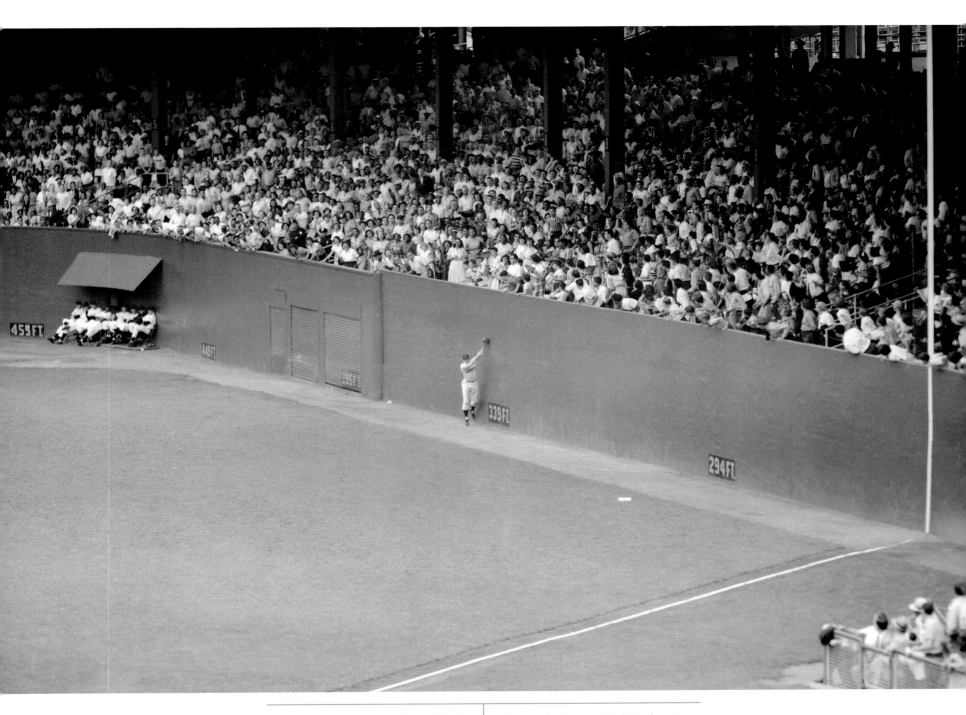

June 28, 1951
UP AND OUT

Giants' Don Mueller leaps high and spears Furillo's liner off Polo Gounds' right field
wall above the 339-foot mark in the 6th inning. Hodges, who was on 1st, was able to
make 2d after catch, which uncorked this free-for-all rhubarb.

Charles Hoff

A second back-page shot shows the ensu-
ing argument—but the umpire ruled that
Gil Hodges, the Dodgers' slugging first
baseman, had tagged up properly. The
Dodgers ended up with three runs in the
inning, for a 4–2 lead over the Giants. But
that wasn't the end of the game. . . .

June 28, 1951
PARTING GESTURE
Plate umpire Barlick signals 3d called
strike on Dodgers' slugger Hodges and
turns to go—thus ending the ball game,
with the Giants winning, 5-4.
Charles Hoff

Two innings after the Dodgers scored three times, Monte Irvin's second homer off Ralph
Branca, a three-run blast in the eighth, gave the Giants the lead again. (Irvin, whose first
home run had broken a 1–1 tie in the fourth, led the league with 121 RBIs in 1951, along
with twenty-four homers.) In the ninth, with the tying run on third, Hodges never took the bat
off his shoulders as reliever Sheldon Jones fanned him. After Al Barlick's call, as Jim
McCulley of the *Daily News* put it, "Hodges stood at the plate dumbfounded for a full minute
while a full case of remorse set in." At this point, the Giants were only four and a half games
behind the Dodgers.

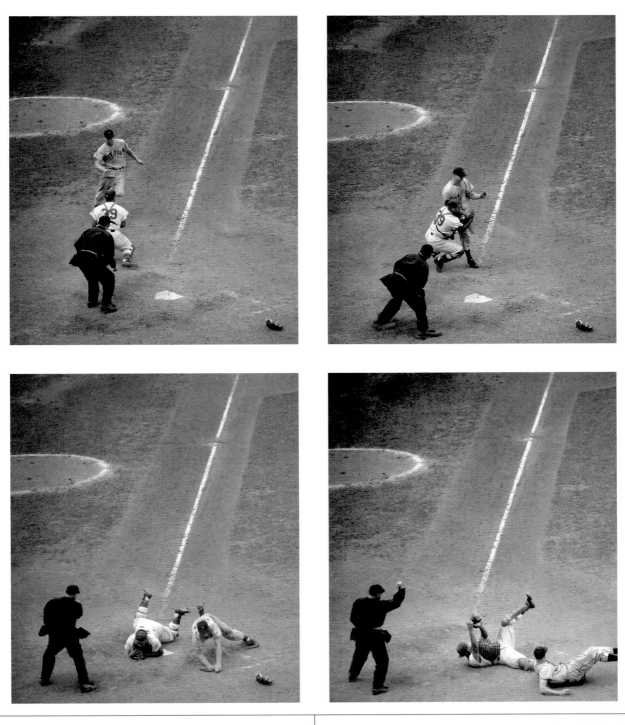

August 9, 1951
A PLAY THAT UNBUTTONED THE LIP

With the Dodgers ahead 6–5 and none out in the ninth yesterday at Ebbets Field, Giants' Manager Durocher waved Whitey Lockman all the way from first base on Willie Mays' double. Sequence fotos show how the desperate effort to knot the count failed. The Lip complained in vain that Campanella juggled ball. Then walk and DP followed to give Brooks victory.

Walter Kelleher

Campanella hit two home runs, the second breaking a tie. But this collision—after he held on to Jackie Robinson's relay of Carl Furillo's throw from right—took him out for four days, and he suffered from bone chips for the rest of the season. Nevertheless, Campy was the National League's Most Valuable Player in 1951 (.325, thirty-three homers, 108 RBIs). After this game (which also saw a league-record twenty-four walks), several Dodgers loudly taunted the Giants, who by then had fallen to twelve and a half games behind.

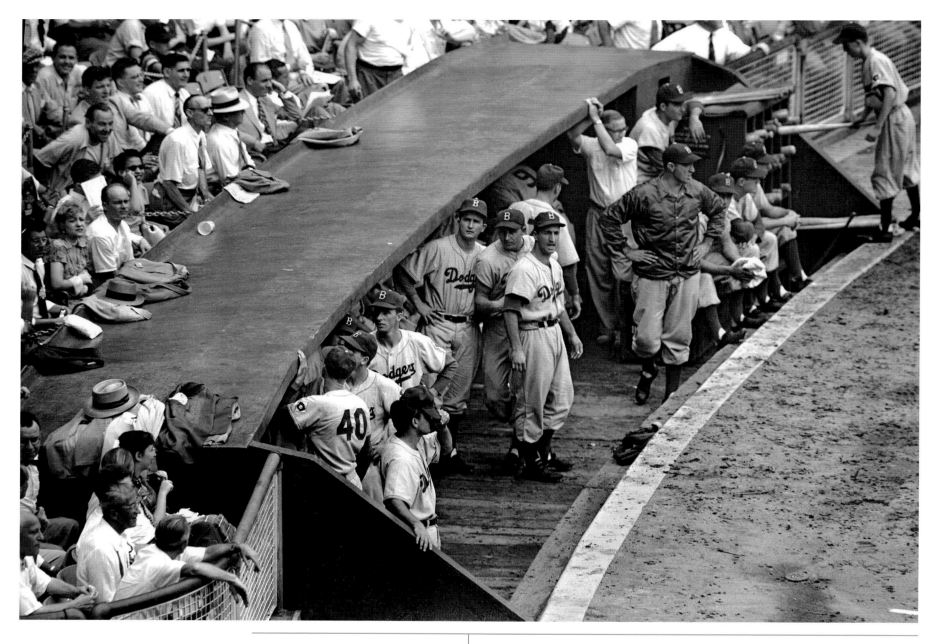

August 16, 1951

CHALLENGE TO GENTLEMAN JIM

Not in accord with official scorer's ruling
on Reese's grounder in 8th, several Brooks
vent their wrath at him from safety of
dugout. The "him" upstairs in press box
was Jim McCulley of THE NEWS, who
ruled "error for Thomson" instead of "hit
for Reese." With that decision, Reese's hit-
ting steak ended after 22 games.

Charles Hoff

The Giants, seething over the Dodgers' taunts on August 9, went on a sixteen-
game winning streak, the longest in the National League in as many years. This 2–1 win
at home was their sixth straight; Sal Maglie got his seventeenth win in the pitchers' duel with
Don Newcombe. McCulley, writing about his own official scoring, said of the disputed play,
"It was a hard grounder but otherwise routine. . . . Bobby booted it and that was that."
But it was OK—Thomson had scored in the seventh on a wild pitch, and that proved to be
the game winner. By August 27, the Giants were back to five games behind the Dodgers. On
September 28, with two games left to play, a Dodgers loss in Philadelphia moved the Giants
into a tie for first.

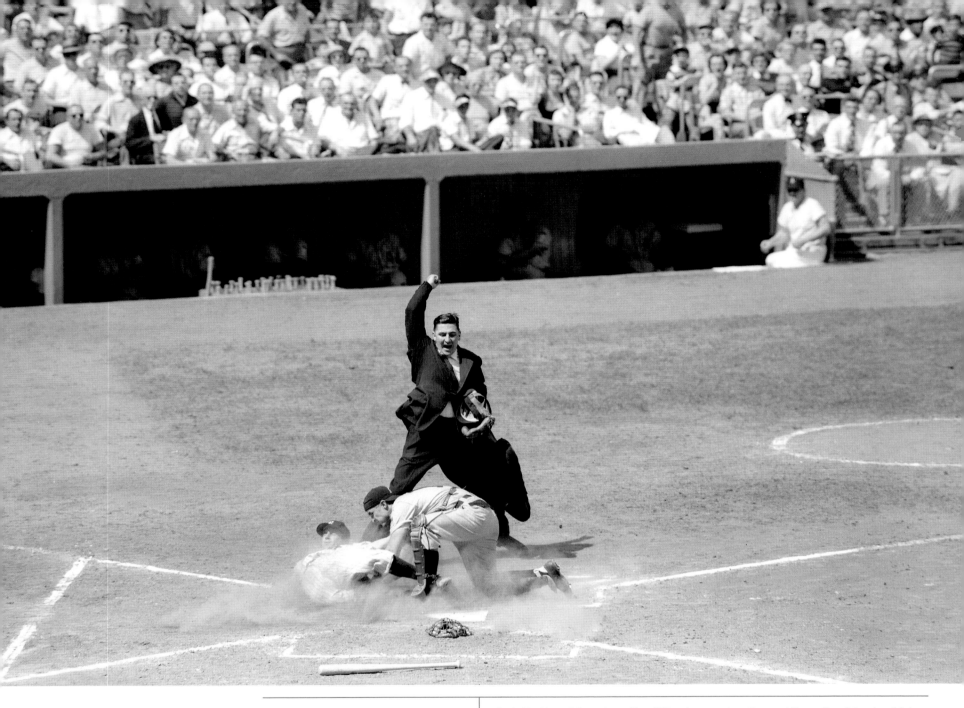

August 18, 1951
COLEMAN'S OUT, SO'S TIPTON

Gerry Coleman is erased by Athletics' backstop Tipton as Yanks' acting short-stop tries to score from third on McDougald's grounder to Majeski in third inning yesterday at Stadium. Tipton suffered a severe sprain of left ankle on play and was taken to Lenox Hill Hospital. He's expected to be out several days. Yanks won 5-1.

Charles Hoff

Both Mantle and the aging, ailing DiMaggio were struggling, and it was the platooning third baseman Gil McDougald, not Mantle, who hit .306 and became the Yankees' first Rookie of the Year. This game gave Vic Raschi, one of the team's three aces, his seventeenth win. (Allie Reynolds ended up with that, while Raschi and Ed Lopat went on to win twenty-one each. As for 1950 Series hero Whitey Ford, he was in the military for the next two seasons.) The A's, including Hank Majeski and Joe Tipton, ended up in sixth place, twenty-eight games out. The day after this game, the last-place St. Louis Browns' new owner, Bill Veeck, pulled his most famous stunt in a lifetime of them: he sent to the plate a first-inning pinch hitter named Eddie Gaedel, who was 3-foot-7. With a minuscule strike zone, Gaedel walked on four pitches, and a day later midgets were banned from baseball.

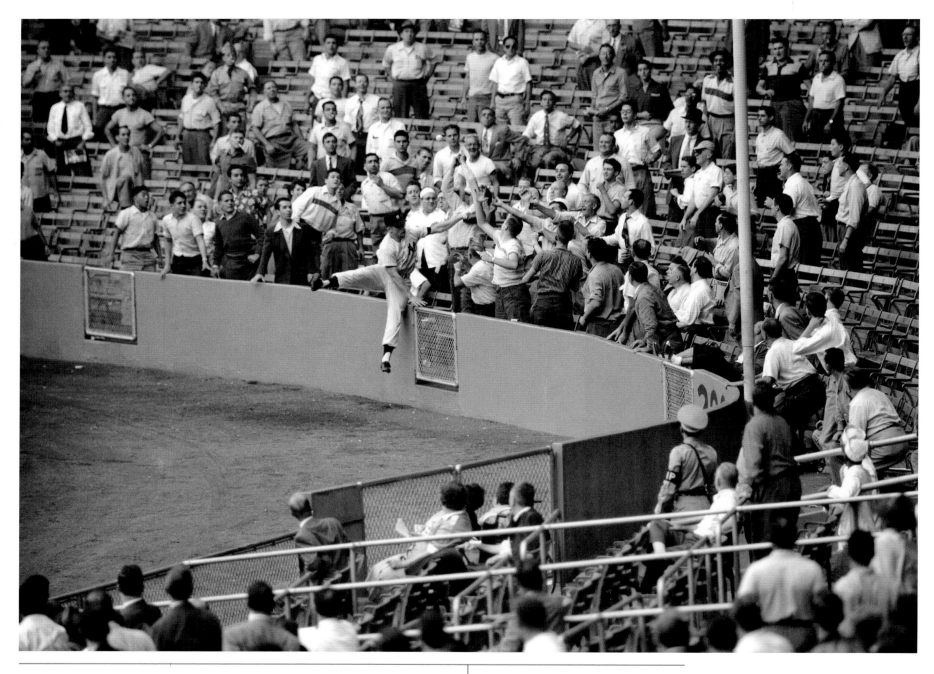

September 20, 1951
MICKEY MISSES

Yankees' Mickey Mantle kicks and leaps high but Eddie Robinson's 7th inning solo drive eludes him and drops among clutching fans in right field seats. Drive put the White Sox ahead, 4-2, but the Yankees subsequently scored 3 runs in the 8th, on Joe Collins' homer with two aboard, to pull out the game, 5-4.

Leroy Jakob

Mantle, overwhelmed at age nineteen, had been sent back to the minors for a month and a half but was up again by the end of August. Robinson's twenty-nine homers in 1951 helped the Chicago White Sox make an early run for the pennant, which had eluded them ever since the notorious "Black Sox" scandal of 1919—but they collapsed and wound up seventeen back.

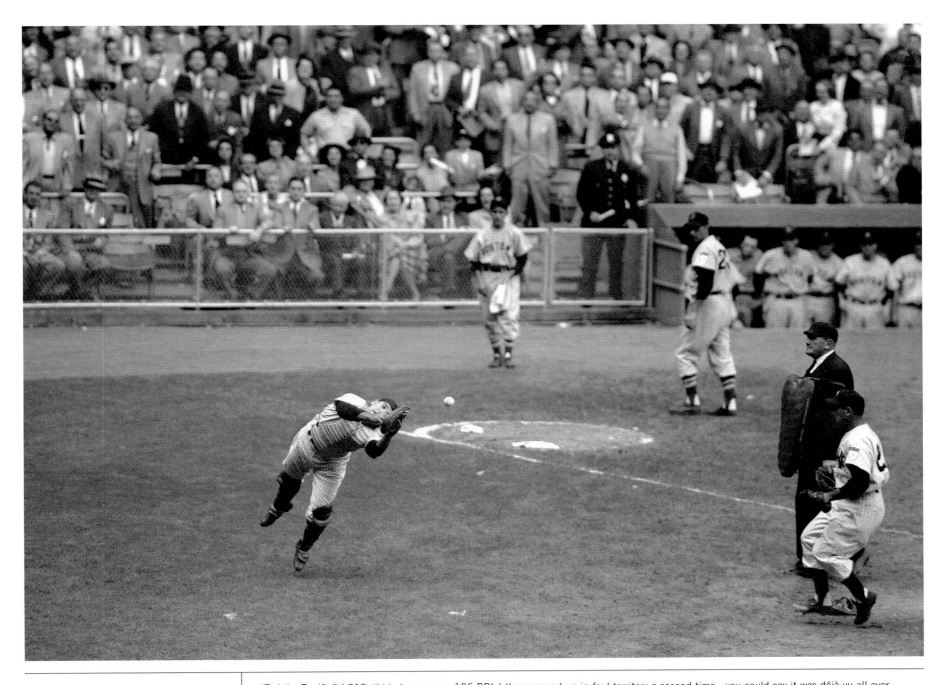

September 28, 1951
HIS SLIP'S SHOWING
Yogi Berra drops Williams' 9th inning
pop up with two out.
Hank Olen

"Ted the Terrific" (.318, thirty home runs, 126 RBIs) then popped up in foul territory a second time—you could say it was déjà vu all over again—and this time Yogi caught it. The Yankees' 8–0 win over the Boston Red Sox was Allie Reynolds's second no-hitter of the season (his first was on July 12, a 1–0 pitchers' duel against the Indians' Bob Feller). The Red Sox had climbed to three games behind the Yankees, then lost all eight they had left and wound up in third. Their 11–3 loss to complete this doubleheader clinched the third straight pennant for Casey Stengel's Yankees (over the Indians). Only two other managers had ever done that in their first three seasons: the Cubs' Frank Chance (of Tinkers-to-Evers-to-Chance double-play fame) in 1906–8 and the Tigers' Hugh Jennings in 1907–9. As for Berra (.294, twenty-seven homers, 88 RBIs), he was the American League's MVP.

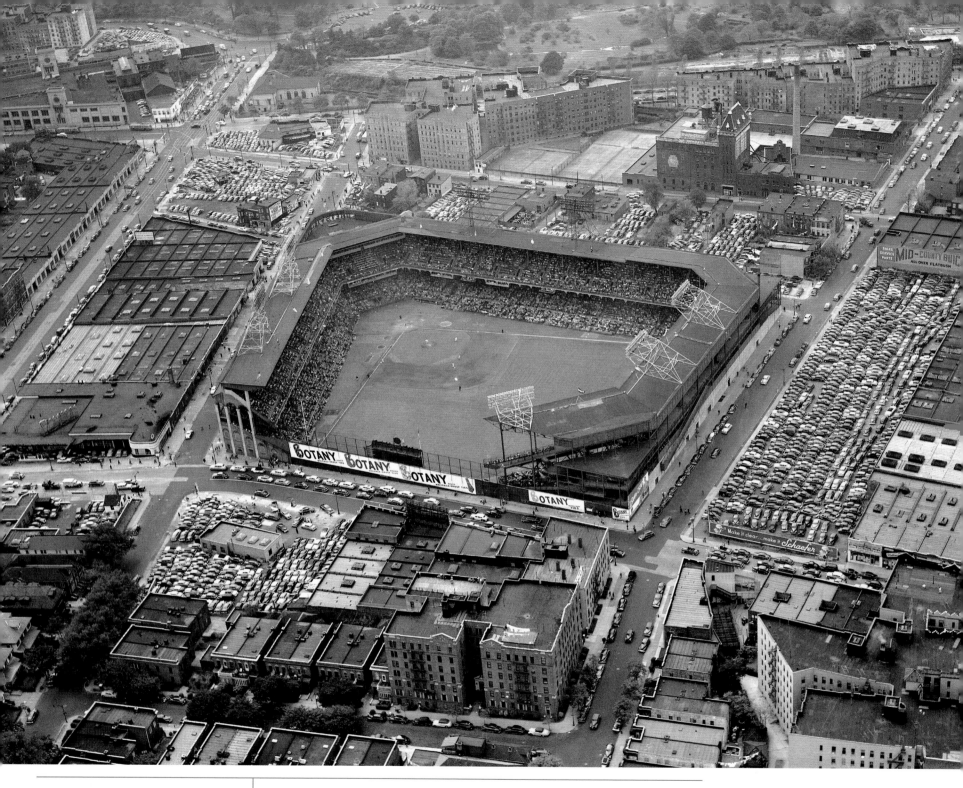

October 1, 1951
Ebbets Field—yesterday's focal point
for baseball fans. When camera clicked
Giants were at bat in first inning.
Charles Payne

The pilot of the *Daily News* plane was Al DeBello. Jackie Robinson's extra-inning homer
against Philadelphia the day before had kept the Dodgers in a first-place tie with the Giants,
forcing this three-game playoff series. The Dodgers had lost the only previous one in baseball,
five years earlier against the Cardinals. (The Indians and Red Sox had engaged in a one-game
playoff in 1948, which put Cleveland in the World Series.)

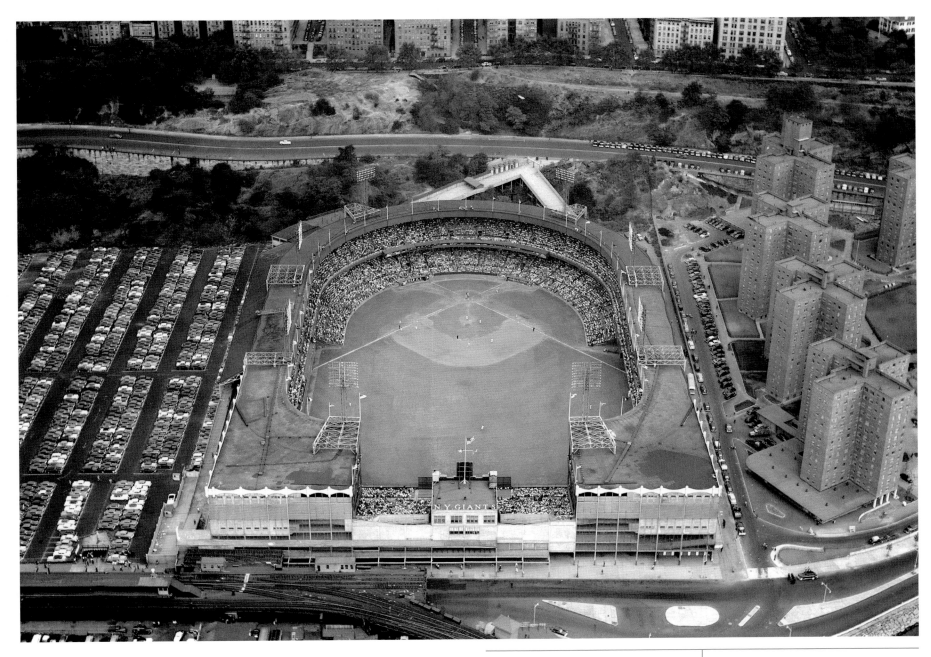

October 2, 1951
Gordon Rynders

Pilot Al DeBello flew over the Polo Grounds the next day for this *Daily News* "airview," taken during the second playoff game.

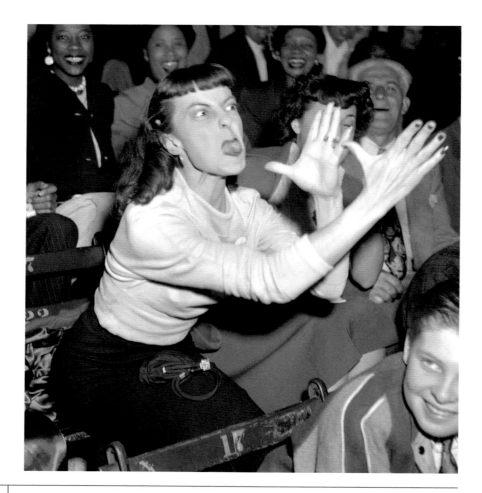

October 1, 1951
Obviously a Dodger fan.
Ed Clarity

As the headline for the article accompanying this photo and caption succinctly put it, "Giants Win First Game, 3 to 1." Jim Hearn's five-hitter, and home runs by Bobby Thomson and Monte Irvin, beat the Dodgers' Ralph Branca. The next day it was the Giants fans' turn to be angry, as Clem Labine and the Dodgers blew away the Giants at the Polo Grounds, 10–0; Jackie Robinson, Gil Hodges, Andy Pafko, and Rube Walker all homered. The Giants had a chance in the third inning when, down just 2–0, they loaded the bases with two outs. But on a 3–2 count, a Giant named Bobby Thomson struck out, missing a curve that was way outside.

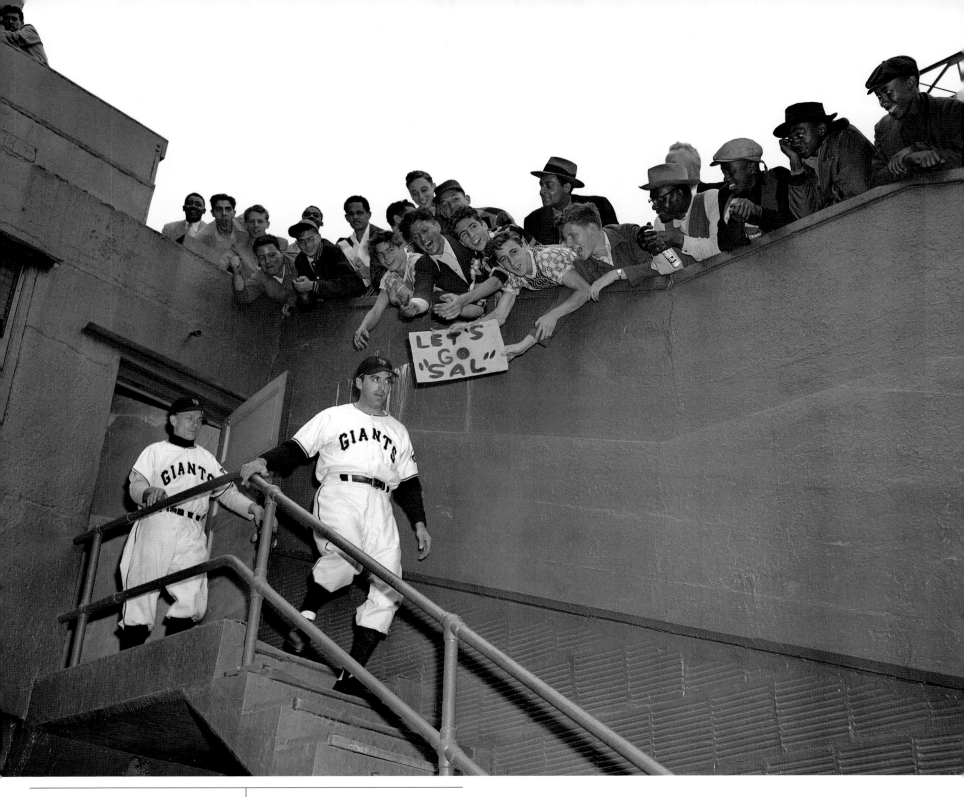

October 3, 1951
Giants starting pitcher Sal Maglie
heads down clubhouse stairs to begin
warming up for big assignment.
Fans give Sal a rousing sendoff.
Charles Payne

For their biggest game, the Giants went
with their best pitcher. Against him, the
Dodgers put up twenty-game winner Don
Newcombe. (They were saving their own
best pitcher, Preacher Roe, to open the
World Series.)

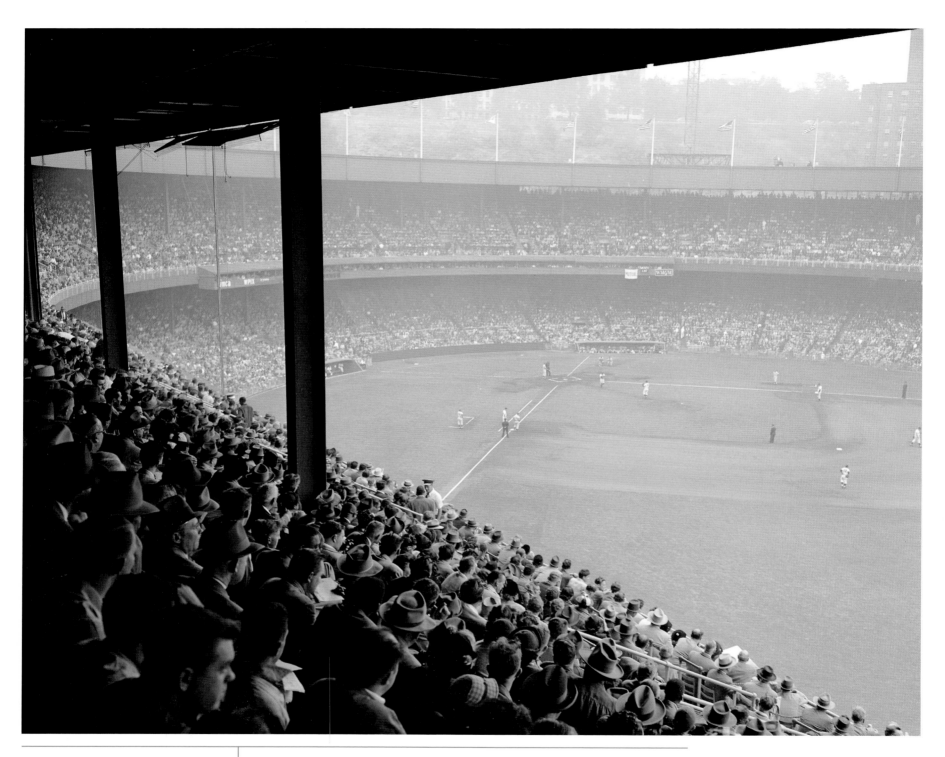

October 3, 1951

The Polo Grounds were packed again for the final game of the playoffs. It was a pitchers' duel—one Dodgers run in the first inning (Jackie Robinson singled home Pee Wee Reese), one Giants run in the seventh (Monte Irvin tagged up and scored from third on a sacrifice fly to center by Bobby Thomson, who'd blown a second-inning rally by getting caught in a rundown)—until the eighth, when the Dodgers scored three runs on two pairs of singles, with a wild pitch and walk in between. Although Newcombe struck out the side in the eighth, he had complained for two innings that he was worn out. Yet manager Charlie Dressen (Burt Shotton's successor in 1951) left him in for the ninth inning—until he gave up three hits.

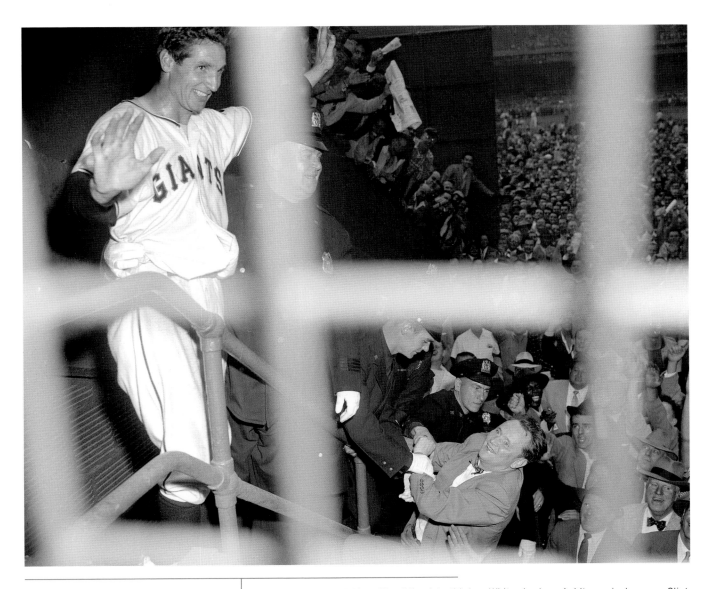

October 3, 1951

THE SHOT HEARD 'ROUND THE WORLD

The man of the hour, Bobby Thomson, protected by police, waves to cheering fans from clubhouse steps after his 3-run homer put Giants in World Series.

Seymour Wally

Don Mueller injured his ankle sliding into third on Whitey Lockman's hit, so pinch runner Clint Hartung was on third and Lockman on second when Newcombe finally came out and—on the recommendation of Dodgers bullpen coach Clyde Sukeforth (soon to be fired)—in came Ralph Branca (13–12, 3.26 ERA), with one out in the ninth and the Dodgers still up 4–2. Carl Erskine (16–12, 4.46 ERA) was also warming up, but Branca (who'd given up three home runs to Thomson in 1951) had been getting loose since the fifth inning. The game, the playoffs, and the Dodgers' hopes all ended two fastballs later, at 3:58 P.M.

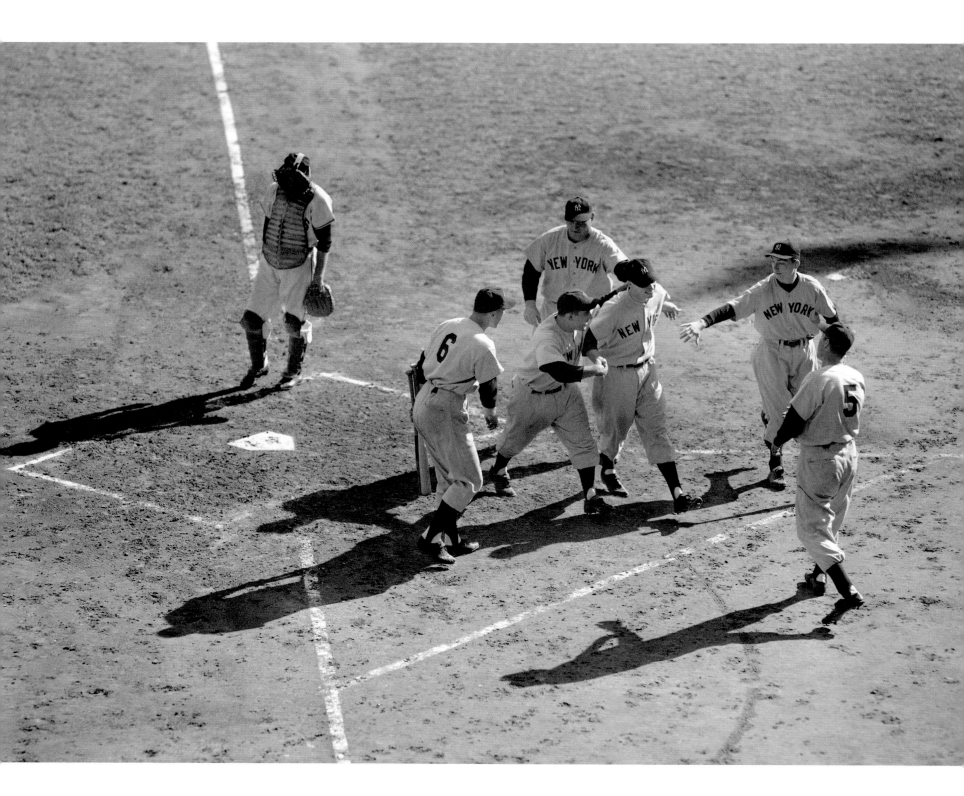

October 9, 1951
MAC'S GOING GREAT SHAKES
Yankee rookie Gil McDougald, who has just scored after blasting a grand-slam home run in the third inning at the Polo Grounds, is greeted by next batter, Brown (6), DiMaggio (5), Berra (shaking his hand), Mize (behind Mac)—the three who rode in—and batboy. Forlorn figure is Giants' catcher Westrum. It was third grand-slam in Series history, the first by a rookie.
George Torrie

The Giants and Yankees alternated World Series wins: Giants, 5–1; Yankees, 3–1; Giants, 6–2 (on a fifth-inning rally literally kicked off by the hard-playing Eddie Stanky, who kicked the ball out of Phil Rizzuto's glove and into the outfield); Yankees, 6–2 (including Joe DiMaggio's eighth and last career Series home run). Then, in Game 5 at the Polo Grounds, the versatile infielder McDougald knocked in Berra, DiMaggio, and Mize on his homer, as Wes Westrum looked on.

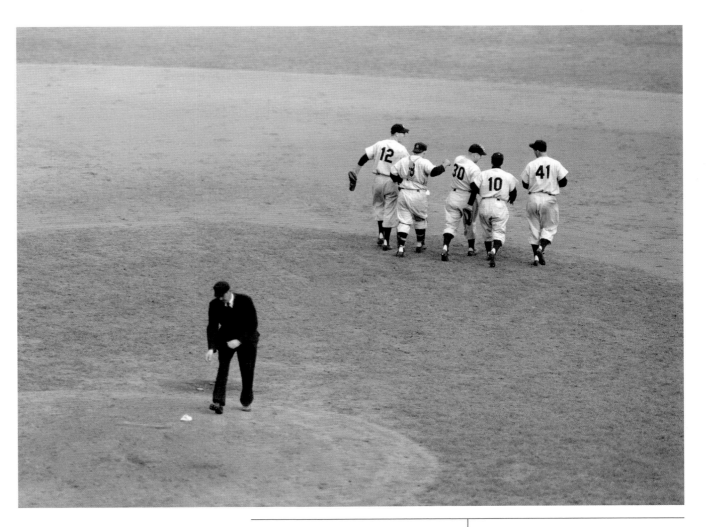

October 9, 1951
A JAUNTY CREW
of Yankees leaves Polo Gounds diamond after whaling the Giants in yesterday's Series game. L. to r.: Gil McDougald, Yogi Berra, Ed Lopat, Phil Rizzuto and Joe Collins.
Fred Morgan

Steady Eddie Lopat, the Game 2 winner, pitched the Yankees to a 13–1 walloping of the Giants (and Game 2 loser Larry Jansen) in Game 5. McDougald was clearly the hero of the game, but Rizzuto added a two-run blast of his own—just some of the icing on the cake.

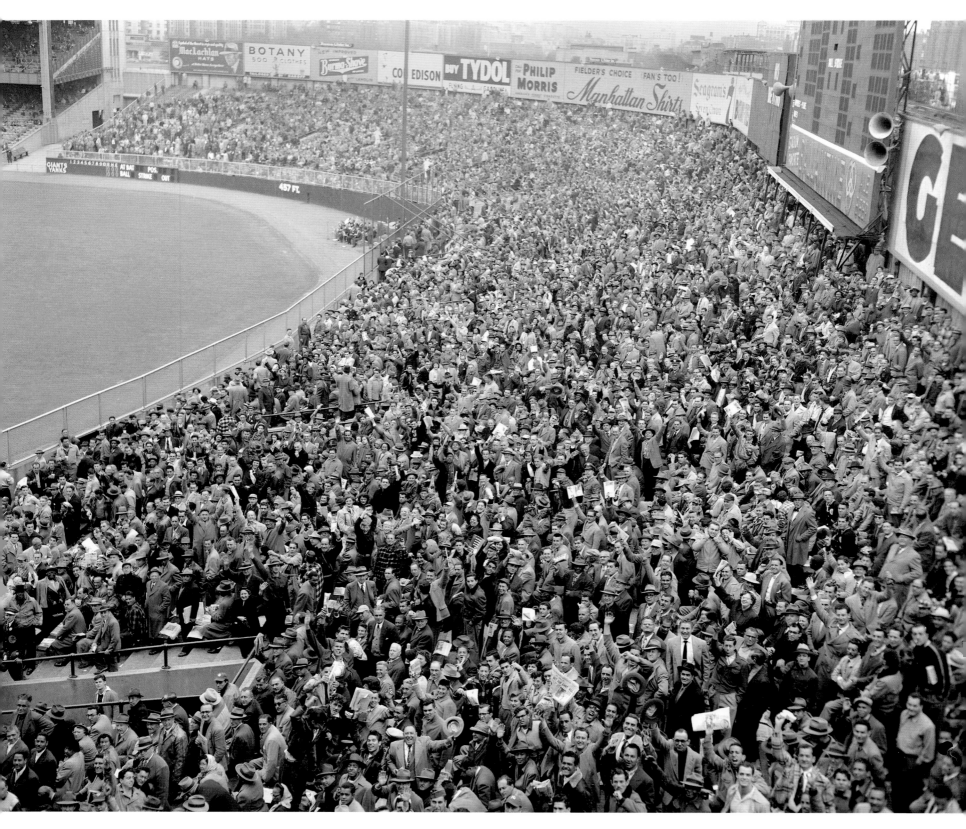

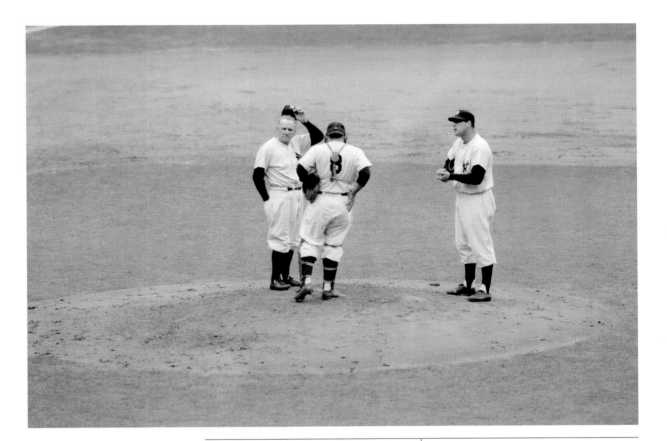

October 10, 1951

There were 61,711 fans on hand at Yankee Stadium for Game 6. Game 3 loser Vic Raschi was up against Game 1 winner Dave Koslo. Here the bleacher crowd is paying attention to the camera—but soon all eyes would be glued to the field.

October 10, 1951
A worried Casey Stengel, faced with a change of pitchers in the 7th, stands on the hill scratching his head. With him are pitcher Raschi, about to be derricked, and catcher Berra.
Fred Morgan

Reliever Johnny Sain—the former Boston Braves ace starter, picked up in August in a trade for Lew Burdette—had to rescue Raschi when he got into trouble, but the Yankees were up 4–1 at this point, thanks to a bases-loaded triple by the always hustling Hank Bauer in the sixth, and Sain got out of that jam and another one like it in the eighth. (Also in the eighth, Joe DiMaggio doubled to right, then was thrown out when Gil McDougald tried to bunt him over. It was the last hit in the Yankee Clipper's career, and he walked off the field to a standing ovation.)

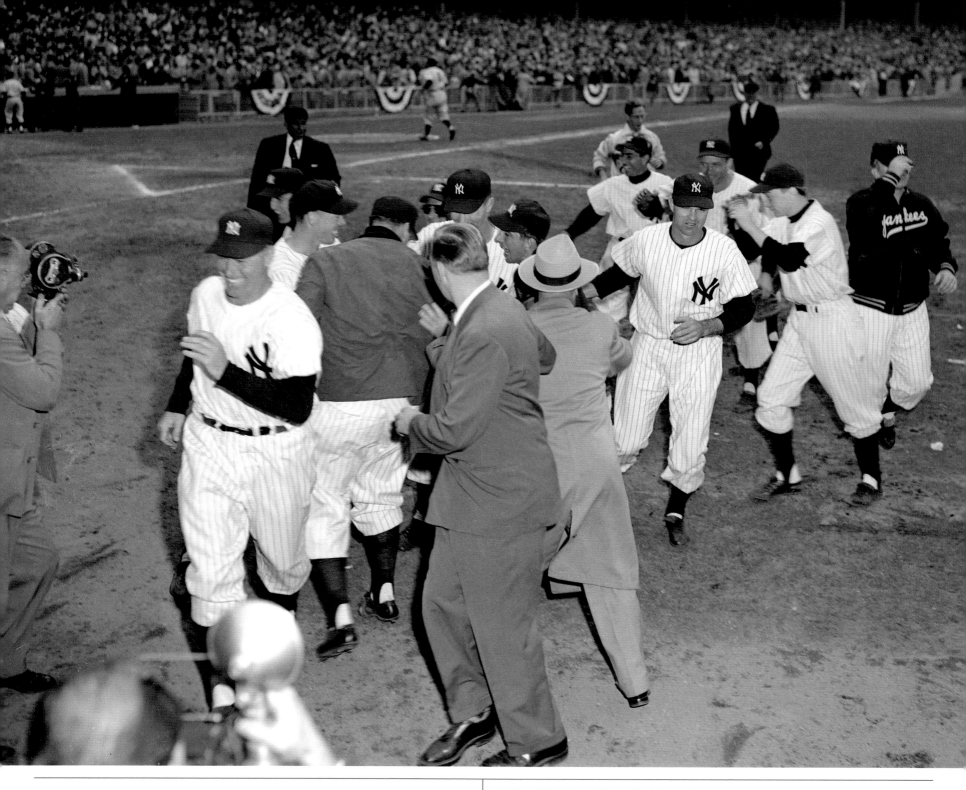

October 10, 1951
YANKS WINNERS—STILL CHAMPIONS

Seconds after the Yankees won yesterday's game and the Series they rush jubilantly off Stadium diamond, led by coach Jim Turner (left). Among others are starting pitcher Raschi (in jacket) and McDougald (over Raschi's shoulder) congratulating pitcher Kuzava, who finished game, and pitcher Sain (hand at waist) who relieved Raschi.

Ed Clarity

In the ninth inning of Game 6, with the Giants down 4–1, they singled to load the bases with no outs. In came reliever Bob Kuzava, acquired in June from the Washington Senators, to face Monte Irvin, the hottest hitter in the Series (at .458). Irvin and Bobby Thomson flied out to left, but each time the runner on third tagged up and came home. With two outs and the score 4–3, pinch hitter Sal Yvars lined to right—but Hank Bauer came through again, with a diving catch that ended the game and the Series. Stengel had won three Series in a row, a feat the Yankees previously achieved only during the glory years of 1936–39.

December 11, 1951

IN HIS LAST TURN, JOE MAKES A HIT

The final score's in. Joe DiMaggio, for 13 seasons a star of the New York Yankees, ponders the future in the club's Fifth Avenue offices after announcing his retirement yesterday. Inroads on his health created by night games was the big factor in DiMag's decision. Like the champ that he was, Joe bowed out gracefully. George Torrie

Dick Young's article in the *Daily News* quoted the thirty-seven-year-old DiMaggio as saying, "I honestly believe night ball cut short my days by about two years. You don't get to bed until two in the morning, or so, and wake up at 10. I found that wasn't enough rest to get the aches and pains out of my system." The aches were mainly in his shoulders, when he swung the bat, and in his right knee. This complete player's thirteen-year Hall of Fame career (1936–51, with three years off for military service) needs no recap. Suffice it to say that there were never more than one or maybe two rivals for the claim, in his annual introduction on Old-Timers Day, that he was the "greatest living ballplayer."

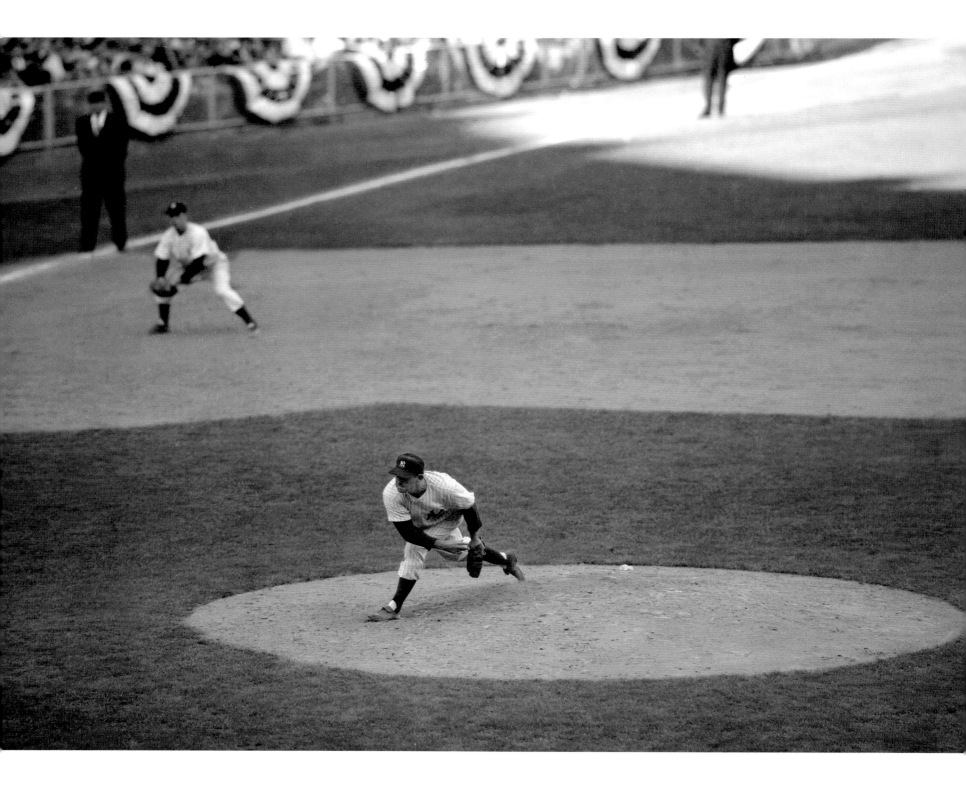

The Yankees needed players. Center field, his home for thirteen seasons, was now DiMaggio-less. Phil Rizzuto was anchoring an infield that had lost Bobby Brown, the third baseman, and Jerry Coleman, at second, to military service. Johnny Mize, thirty-nine, was too old to spend all those innings at first base. Steady Eddie Lopat, who had won twenty-one games a year earlier, was in dry dock for much of the season with a shoulder injury. So Casey Stengel, who once celebrated a World Series win by crowing, "I couldn't have done it without my players," was forced to look for a new set of players. And since the Yankees were usually a magnet for talent, he found them. Joe Collins became the full-time first baseman, and Gil McDougald took over at third. The new face at second, the manager's pet, was a brash twenty-four-year-old named Billy Martin. In 1948, Stengel's last year as a minor-league manager, at Oakland, he had won 114 games. He had a veteran club, with one noteworthy exception: this same Billy Martin. When Casey was hired by the Yankees, he let the front office know he wanted Martin in pinstripes. "Most of the other players never talked back to Casey," Rizzuto said. "Billy always did. In a loud voice too." As soon as Martin joined the Yankees, he had the temerity to introduce himself to DiMaggio, that most private of men. The rookie and the aging superstar became close friends. And Martin was the same kind of bobo to DiMag's successor, the shy Mickey Mantle. The new center fielder hit .311 in 1952, his first full year. In mid-September, the Yankees' lead over the Indians was a half game, and the teams met in Cleveland with first place at stake. Lopat, healthy again, out-pitched twenty-two-game winner Mike Garcia, and the Yankees won, 7–1. Then they won enough to take the pennant by two games. Brooklyn, meanwhile, was having an easier time of it. The Dodgers were under .500 against the first-division teams, but they pounded the bottom three clubs—the Reds, Braves, and Pirates—losing only eleven of sixty-five against them. The Giants, hoping to repeat, suffered a severe blow in spring training when Monte Irvin, their RBI leader a year earlier, broke his ankle. At the end of May, Willie Mays began his two years in the army. Charlie Dressen took his best relief pitcher, Joe Black, out of the bullpen a few weeks before the season ended, and he made Black the Dodgers' Game 1 Series starter against the Yankees. Black responded with a complete-game six-hitter. He gave up only one run in his seven innings in Game 4, but the Dodgers didn't score at all. He was back on the mound for Game 7 in Ebbets Field, and pitched heroically, until a long homer by Mantle in the sixth gave the Yanks a 3–2 lead. Mantle added an RBI single in the seventh. The Dodgers had one last chance, in the same inning, when they loaded the bases with one out. The second out was Duke Snider's pop foul, and when Jackie Robinson hit another pop-up, between the mound and first, the Dodgers seemed done. But the Yankees' infielders were slow to react, and with three Dodgers racing for the plate, it was the second baseman, running at full speed, who was able to grab the ball a few inches from his shoe tops. The grateful Yankees surrounded him in the dugout and pummeled him. "Can you believe this? They pat you on the back for catching a pop," said Billy Martin.

October 4, 1952
STAR BILLING
Allie Reynolds flashes form which limited
Dodgers to four hits as he whiffed 10 in his
2-0 whitewash job. All Allie needed was
homer belted by Johnny Mize in 4th inning.
Charles Hoff

The "Superchief" (he was part Creek)—seen here pitching his 1952 World Series masterpiece against the Dodgers, Game 4—had his best season as a Yankee: 20–8, with a league-leading ERA of just 2.06. The thirty-seven-year-old capped off 1952 with two wins in the Series. (In his final two seasons, he did more pitching in relief, before a back injury forced him to retire after eight years with the team.) The other Yankees ace was still Vic Raschi (16–6), as he had been from 1948 on; however, Ed Lopat won just ten games, and Johnny Sain eleven.

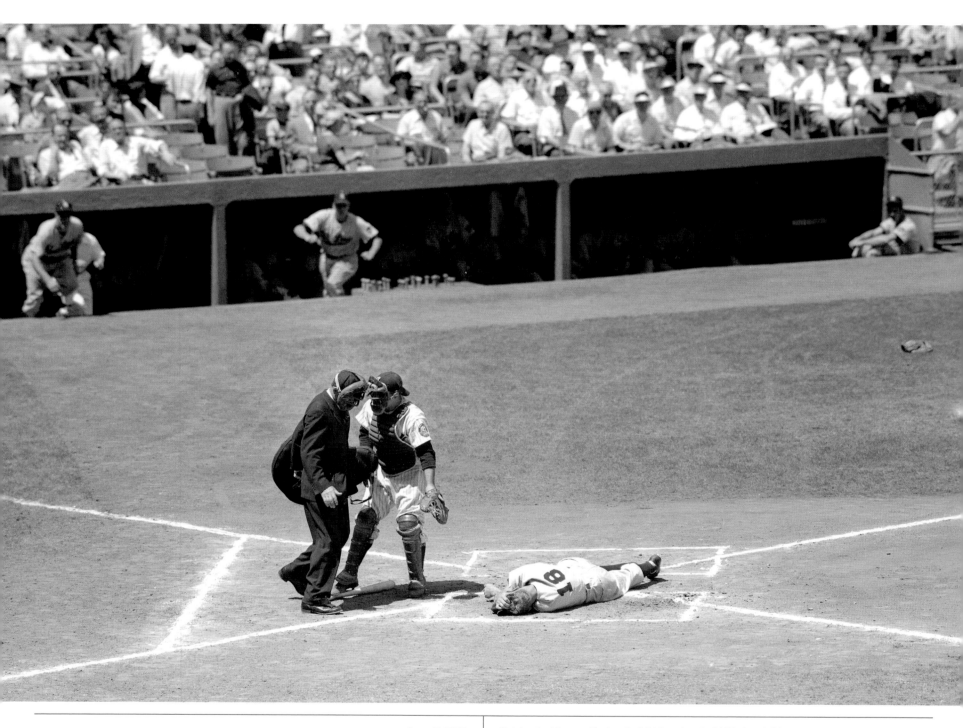

June 7, 1952
FELLED BY PITCH
Jim Delsing, St. Louis Browns' outfielder, holds top of head after being struck by pitch delivered by the Yanks' Allie Reynolds in first inning at the Stadium yesterday. Berra wheels to Ump Paparella for advice. Although he was carried from the field on a stretcher, Delsing's injury was called not serious.
Charles Hoff

Delsing had been a Yankee in 1949 and early 1950. In addition to this KO, Reynolds racked up nine Ks in the Yankees' 2–1 win. He finished the season with 160 strikeouts. The Browns ended their next-to-last season in St. Louis thirty-one games out of first—but fourteen ahead of the Detroit Tigers. The Yankees had gotten off to a slow start but were moving up; three days later they had gone from third place to first, where they stayed for most of the rest of the season (though the Indians got dangerously close in mid-September). Berra led the team with thirty home runs, setting a league record for catchers.

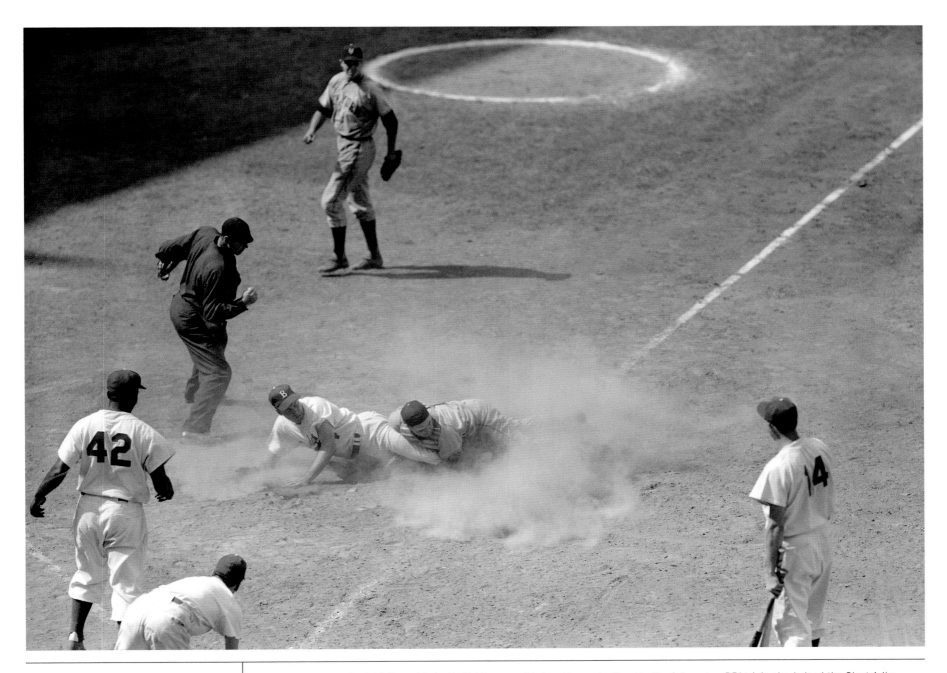

July 3, 1952

THE TIE WAS NEVER KNOTTED

Trying to tally run that would have tied the score, Snider is cut down, Mueller to Yvars, in 8th at Ebbets Field. He was on second when Shuba singled. Ump Secory calls play. Giants won, 4–3.

Tom Watson

George Shuba was pinch-hitting, with Jackie Robinson on third and two outs. Don Mueller (whose two-RBI triple also helped the Giants' Jim Hearn get his ninth win) nailed Snider with this throw from right field to backup catcher Sal Yvars. In the *Daily News,* Dick Young wrote, "Duke, who is a poor base-runner for a man of his superior speed, took the scenic route home. . . . [Snider,] by turning third in a wide circle that almost doubled his required running distance, made it no-contest. He was out by some 20 feet." With their sixth straight win against the first-place Dodgers, the Giants were now only two games behind their cross-town rivals—but that was as close as they came. It didn't help that their 1951 Rookie of the Year, Willie Mays, had to enter the army on May 29; he didn't return until 1954.

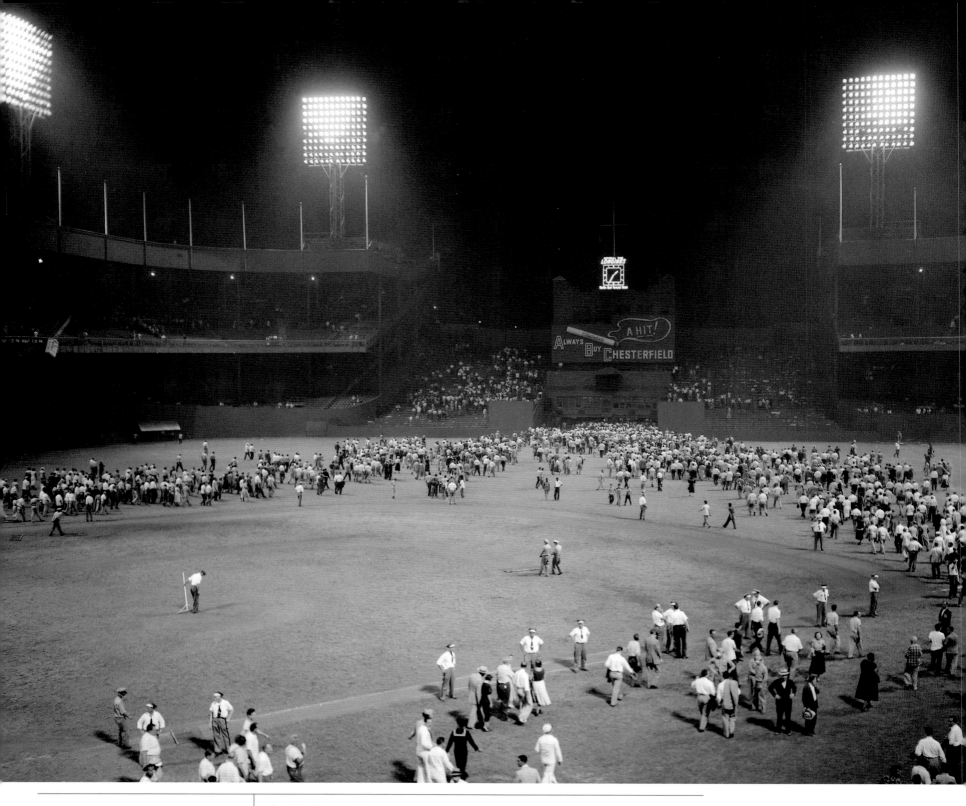

August 5–6, 1952
The clock says 1:35 A.M. and weary but happy (Giant) and not-so-happy (Dodger) fans head home after Giants won marathon thriller.
Walter Kelleher

Don Mueller got a hit that scored Jim "Dusty" Rhodes from second in the fifteenth inning to give the Giants a 7–6 win at the Polo Grounds. The game lasted one minute short of five hours. Despite the win, the Giants had slipped to five and a half games back by now. Ironically (and mercifully), the next day's game was called by rain after one inning.

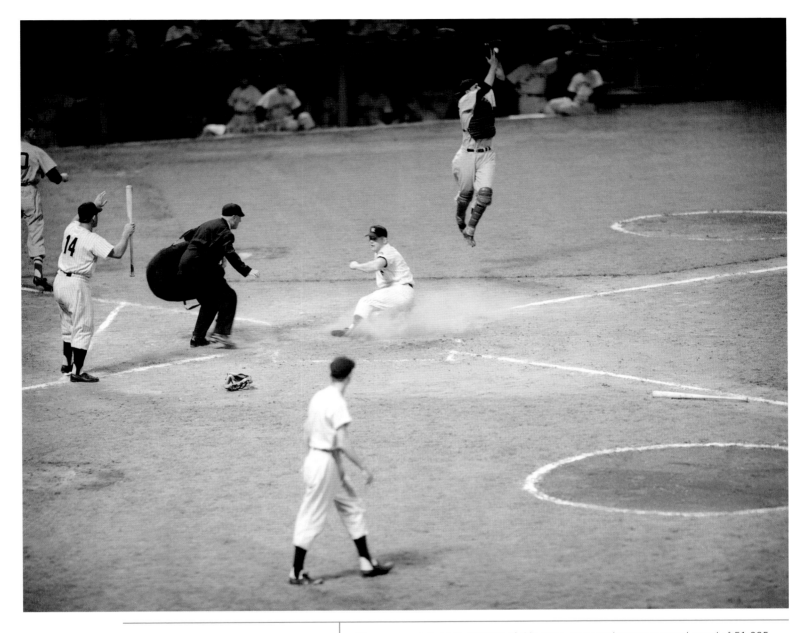

August 11, 1952

HOME IS WHERE THE HEART LEAPS

In this unusual night action foto, Bosox catcher Sammy White goes up for Dom DiMaggio's high-bouncing throw home of Berra's hit to center. Mantle scores easily from second on 4th-inning play. Grieve calls play. Behind Reynolds' two-hit hurling, Yanks shelled the Sox, 7-0, at the Stadium.

Walter Kelleher

There was no television coverage of this game, so a regular-season-record crowd of 51,005 showed up to watch the blossoming Mickey Mantle, now in Joe DiMaggio's old home in center field, also hit two home runs in one game for the first time. Without Ted Williams, who was a pilot in the Korean War during most of 1952–53 (after missing all of 1943–45 by serving in World War II), the Red Sox wound up in sixth place. Dom DiMaggio, in his next-to-last season, was always overshadowed by his elder brother Joe (and both overshadowed the eldest brother, Vince, over in the National League through 1946), but he was a superb center fielder and fine hitter. White was the superior defensive catcher for the Red Sox in 1952–59.

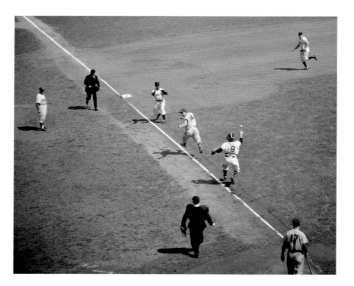

September 6, 1952
RUNDOWN CONDITION
Trapped off third as Erskine misses
squeeze bunt in 2d inning of opener
at Polo Grounds yesterday, Hodges turns
to retreat toward third. Westrum's throw
to Thomson nailed him, though. Double
play ensued when Pafko tried to move
from second to third.
Bill Meurer

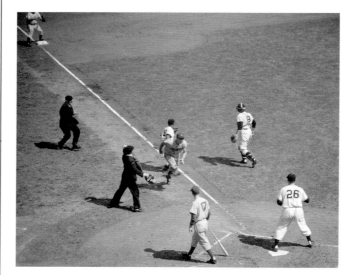

Gil Hodges, trapped between Giants Wes
Westrum and Bobby Thomson in the first
photo, trots off the field in the second shot
as the action shifts to third base, and the
third photo, for the double play on Andy
Pafko. All four were sluggers, though only
Pafko hit over .270 for the year. Dragging,
then tossing, his bat is pitcher Carl Erskine.
He went 14–6 on the season and threw a
no-hitter against the Cubs on June 19. The
Giants won this game, 6–4, then beat the
Dodgers again, 7–3, in the second game of
the doubleheader at home.

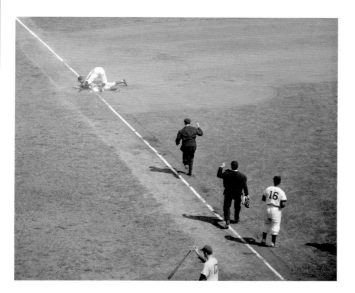

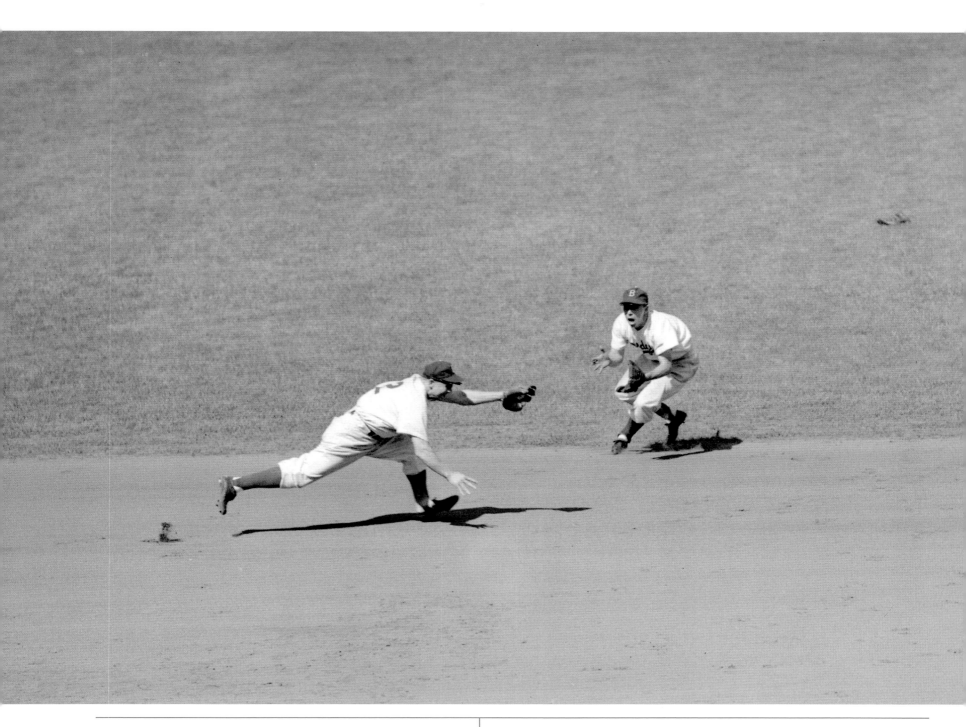

GREAT EXPECTATIONS

Pee Wee Reese, mouth open, feet set, hands poised, is all set to gobble up Ralph Kiner's 4th inning bouncer. But along came Bobby Morgan to snatch ball with a great stop and throw the Pirate slugger out. Dodgers succumbed to Pirates, 4-1, at Ebbets Field and had lead reduced to three games by Giants.

Charles Hoff

The Giants moved up by beating the Cubs, 2–0. Pirates first baseman George "Catfish" Metkovich had only seven home runs all season (while teammate Kiner had thirty-seven), but he hit two of them in this game. With this win, the last-place Pirates also moved up on the Dodgers—who were *52* games ahead! Pittsburgh ended up 54 ½ back, with a 42–112 record (including 3–19 against the Dodgers), and didn't improve until the late 1950s, before roaring back with the famous World Series upset win against the Yankees in 1960. Reese was still one of the Dodgers' mainstays, and in 1952 he led the league with thirty stolen bases. Morgan was filling in for Billy Cox at third base.

October 1, 1952
SOUVENIR
Home run ball hit by Gil McDougald nestles
in solar plexus of fan as Pafko leaps in left
field. Blow in third inning of Series opener
at Ebbets Field evened count after
Robinson's homer in previous inning.
Fred Morgan

The ball is just above the "FR" in the sign.
The Dodgers finished four and a half games
ahead of the Giants and returned to the
World Series for the first time in three
years—and their fourth attempt to best the
Yankees. As in 1947, the hard-fought con-
test went to seven games. In Game 1, to
counter Allie Reynolds, Dodgers manager
Charlie Dressen gave the ball to the National
League Rookie of the Year, Joe Black, whose
fifteen wins had all been in relief. Jackie
Robinson led the team regulars with a .308
batting average in 1952, and he hit nine-
teen home runs before the one in Game 1.

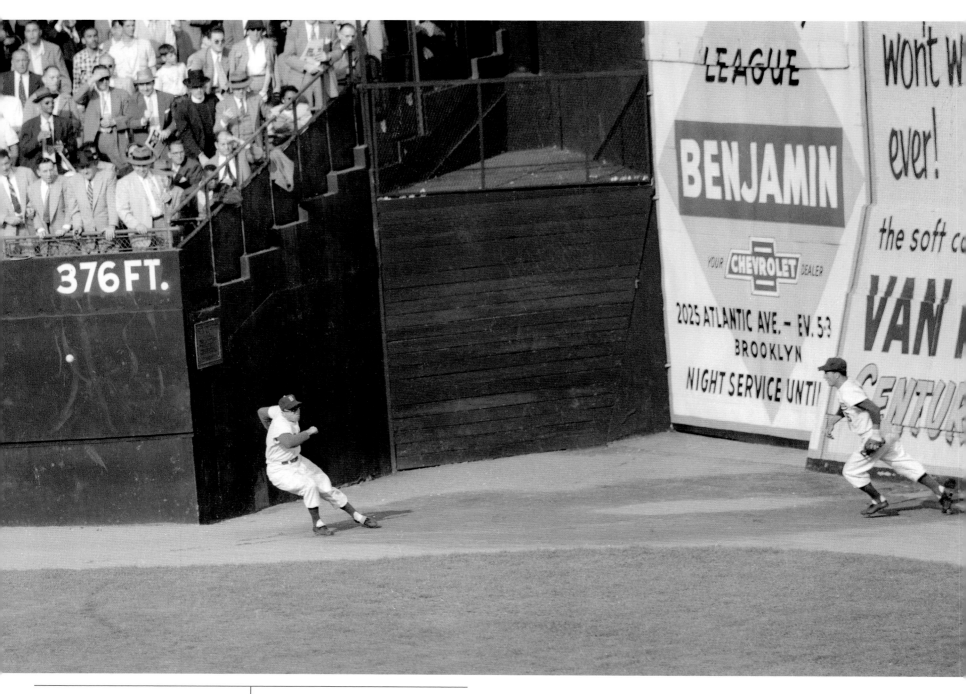

October 1, 1952
HOPPED UP BALL

Snider appears to be in a dither as he reverses his field in chasing Woodling's pinch-hit triple in eighth. It was the longest hit ball of the game, hitting the screen in deep center and then taking a crazy hop off the concrete that has the Duke running in circles.

Fred Morgan

The 1–1 tie lasted until the sixth inning of Game 1, when Duke Snider homered with Pee Wee Reese on base. Two innings later, Gene Woodling came to bat. He scored after this triple, making it 3–2—but Reese countered with a solo home run in the bottom of the inning. Black kept the Yankees at bay in the ninth and became the first black pitcher to win a World Series game. (Don Newcombe had lost two in 1949.)

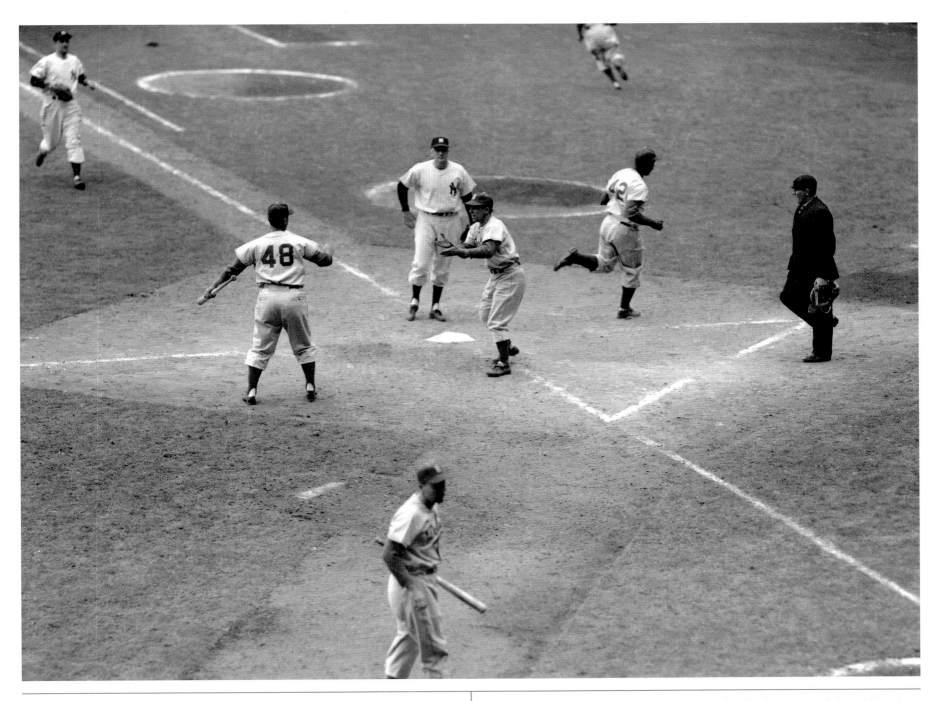

October 3, 1952

STANDING OVATION

Reese of Dodgers claps hands as Robinson follow him across plate on passed ball by Berra in 9th inning at Stadium. Pafko, who was the batter when Gorman's pitch eluded Yogi, stands at left. Gorman looks on disconsolately. These two runs were margin of Dodgers' win in 3d game of World Series. They now lead, two games to one.

Walter Kelleher

The Yankees came back with a 7–1 Game 2 win, as Vic Raschi gave up only three hits and Billy Martin (a utility infielder for two years but now the regular second baseman, while Jerry Coleman served in the military) highlighted a five-run sixth with his three-run home run. But this play made the difference in Game 3, played at Yankee Stadium—although Andy Pafko's single afterward probably would have scored them anyway. A 3–2 game (in which Berra had homered earlier) was now a 5–2 game, and Johnny Mize's pinch-hit home run in the Yankees' half of the ninth wasn't enough. Tom Gorman was the reliever, but starter Eddie Lopat got the loss; Preacher Roe took the win.

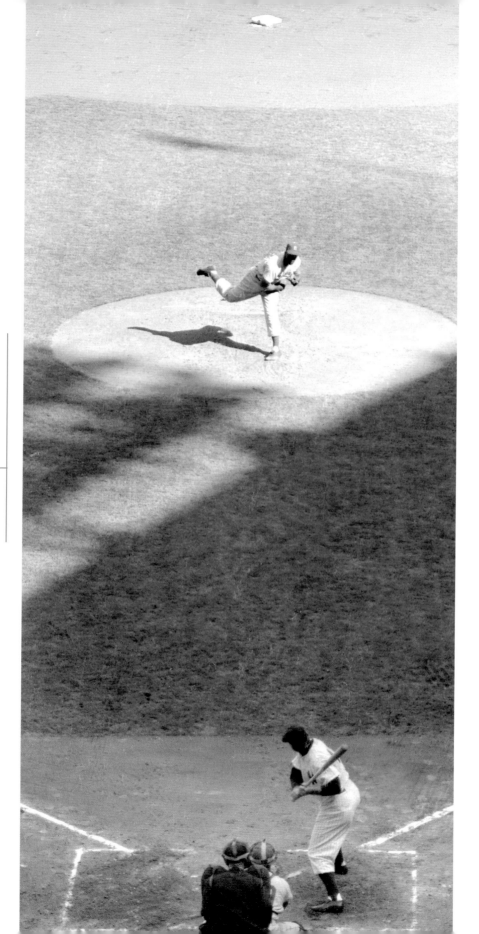

October 4, 1952
Big John Mize, 40-year-old baseball
veteran, cocks his war club as Joe Black
fires one at him in the fourth inning
at Stadium. The next second, the
ball was sent rocketing into rightfield
seats for game-winning homer.
Hank Olen

In Game 4, Allie Reynolds faced
Joe Black again. Like Reynolds, the
Game 1 winner gave up only four hits.
This is the one that counted.

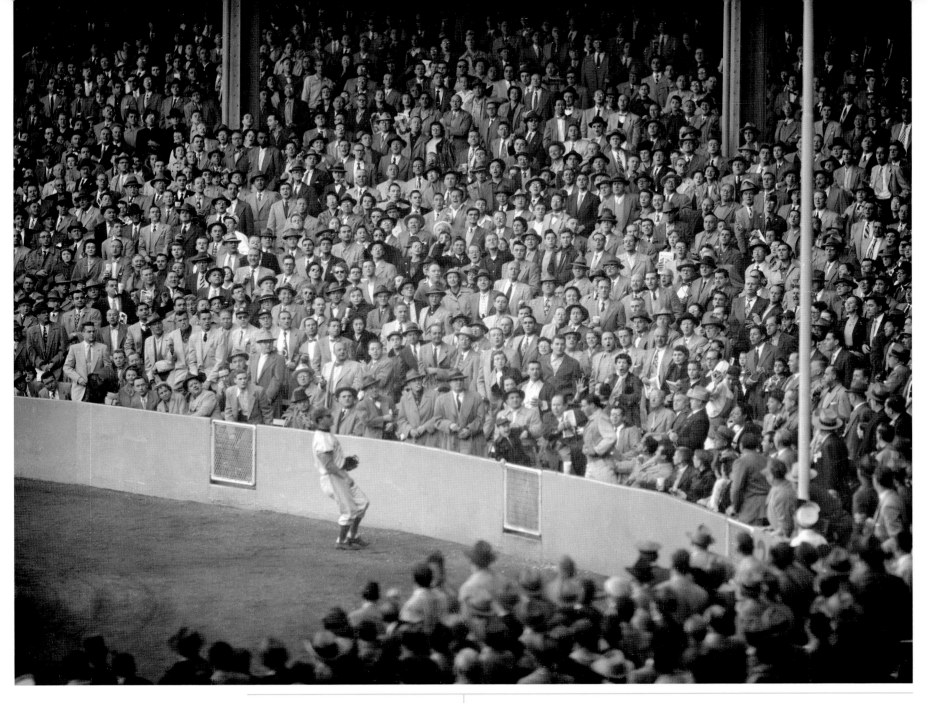

October 4, 1952
AIRMAIL, SPECIAL
Dodger right fielder Furillo waits
wistfully at gate as Johnny Mize's homer
soars rows back in fourth inning.
George Torrie

This was Mize's second of three home runs in the World Series; he batted .400, knocked in six runs, and was named Series MVP. Not bad for someone who was almost (though not quite) forty, and in the next-to-last season of his Hall of Fame career. Four innings later, Mantle tripled, scoring on Reese's throw into the stands—but that was just a bonus. The Series was all tied up, and it stayed that way after the next two games. Game 5, Yankee Stadium: Duke Snider's four RBIs, including a game-winning double in the eleventh inning, beat Mize's three-run homer (with Andy Pafko and Carl Furillo leaping to snare other home-run balls). Carl Erskine gave up five runs in the fifth, then set down the last nineteen Yankees to beat Johnny Sain (relieving Ewell Blackwell), 6–5. Game 6, Ebbets Field: Snider's two home runs, in the sixth and eighth, were matched by Berra's in the seventh and Mantle's in the eighth; the difference was Yankees starter Vic Raschi's seventh-inning grounder off the knee of Dodgers starter Billy Loes, scoring Gene Woodling from second.

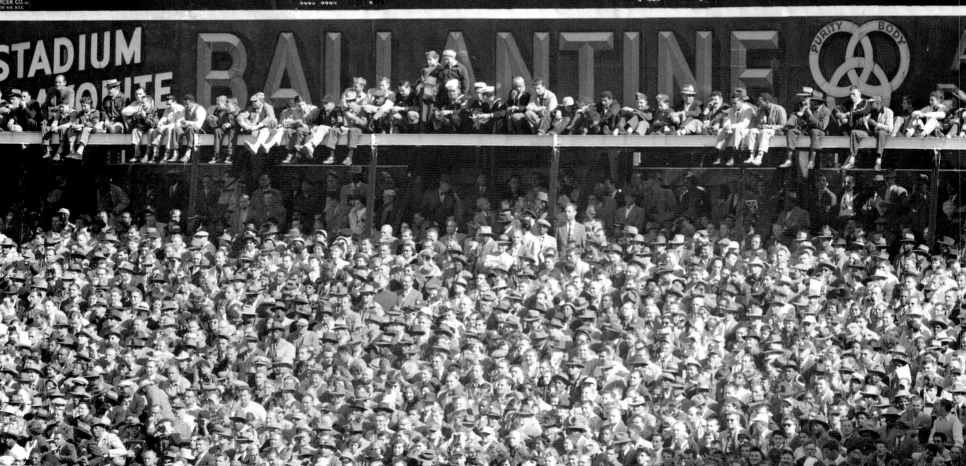

October 4, 1952
Part of the overflow crowd of 71,787 perches on rim of scoreboard at Yankee Stadium as World Series enters its fourth—and most exciting—game.
Charles Hoff

It was the best postseason attendance at Yankee Stadium since Game 6 in 1947. Reynolds, the Game 1 loser, came back on two days' rest to pitch his four-hit gem. Reynolds's ten strikeouts included three against Jackie Robinson.

October 7, 1952
This scene, in bar on Dean St. and 6th Ave., Brooklyn, was repeated throughout Dodgertown yesterday. Hopes for their first World Series triumph shattered by Yankees after a bitter seven-game struggle. Dodger fans seek solace in their beer.
George Mattson

The grand finale was at Ebbets Field: Stengel used Lopat and Reynolds for three innings each, then Raschi briefly, while Dressen countered with Black, Roe, and Erskine. In the Dodgers' seventh, with the bases loaded, one out, and the Yanks up 4–2, Stengel called on Bob Kuzava (the last pitcher in the 1951 Series), who got Snider to pop out to second. Casey left in the southpaw to face Robinson, who popped up into the wind between the pitcher's mound and first. Kuzava waited for Joe Collins to get the ball, but the first baseman couldn't find it. At the last moment, second baseman Billy Martin made a shoestring catch, saving the game and the Series. Two innings later, Stengel became only the second manager, after Joe McCarthy of the 1936–39 Yankees, to win four years in a row—and once again the Dodgers fans had to "wait till next year."

Yogi Berra always believed that Mickey Mantle was more of a home-run threat when he batted right-handed. He may have convinced himself on April 17, 1953, when the Yankees were playing in Washington's Griffith Stadium, where any home run hit to left field had to cover at least 407 feet. That night, the fifth inning, Mantle swung at a pitch from Chuck Stobbs and sent the ball over the left-center-field wall, over the stands, and clear out of the ballpark, landing in the backyard of a house across the street from the stadium. Red Patterson, the club's public-relations director, left the press box, determined to measure how far the ball had traveled. He returned a half hour later and announced that the distance to that backyard—he even supplied the address—was an astounding 565 feet. Well, maybe it was, and maybe it was even longer. The truth is, Patterson never left the grounds. He told Mantle later that he stopped at a concession stand and had a few beers. All he measured was the time it would take to make the trip back to the press box. Mantle kept his secret until he collaborated on a book forty years later. The Yankees began the season trying to become the first team in history to win five consecutive pennants. The suspense, what little there was, ended in May when the Yankees won eighteen in a row. Nothing left for them to do but wonder who they'd oppose in the World Series. Again, the suspense was short-lived. The Dodgers, in first place by a commanding eleven games the first week of September, were playing their last game against the Giants that season and trying to beat their rivals for the tenth straight time. The Giants, slipping backward, would finish a sad fifth, thirty-five games behind Brooklyn. In the second inning, after being hit by a pitch that he was certain Leo Durocher had ordered, Carl Furillo left first base and charged into the Giants' dugout. He grabbed Durocher in a headlock and held on until the Giants pulled them apart. Somebody stepped on his hand, and broke a few bones. That was the major excitement until the fifth game of the post-season. The Series was tied and so was the game, until Mantle stepped up with the bases loaded and sent a pitch deep into the upper deck in left-center field. For that one, Yogi must have noticed, Mantle was batting left-handed. A day later, the Yankees won their fifth consecutive championship

Here are the four Yankees home-run hitters of Game 5 of the World Series against the Dodgers, gathered around the starting and winning pitcher.

January 30, 1953
Most Valuable Players for three years get
together at American Shops in Newark,
New Jersey. Larry Berra, with measuring
tape, MVP 1951. Phil Rizzuto, taking order
for suit, MVP 1950. Bobby Shantz, being
fitted for suit, MVP 1952.
John Duprey

Rizzuto, Yogi Berra, and other players were paid—sometimes with new suits—to make regular promotional appearances at the clothing store. Shantz was the ace of the 1952 Philadelphia Athletics, going 24–7 for a team that made it to fourth place for only the second time since 1933. After four injury-plagued years (he was 5–9 in 1953), Shantz made a comeback pitching for the Yankees in 1957–60—by which time Berra had won his second (1954) and third (1955) MVP awards, and Rizzuto had been moved to the broadcast booth.

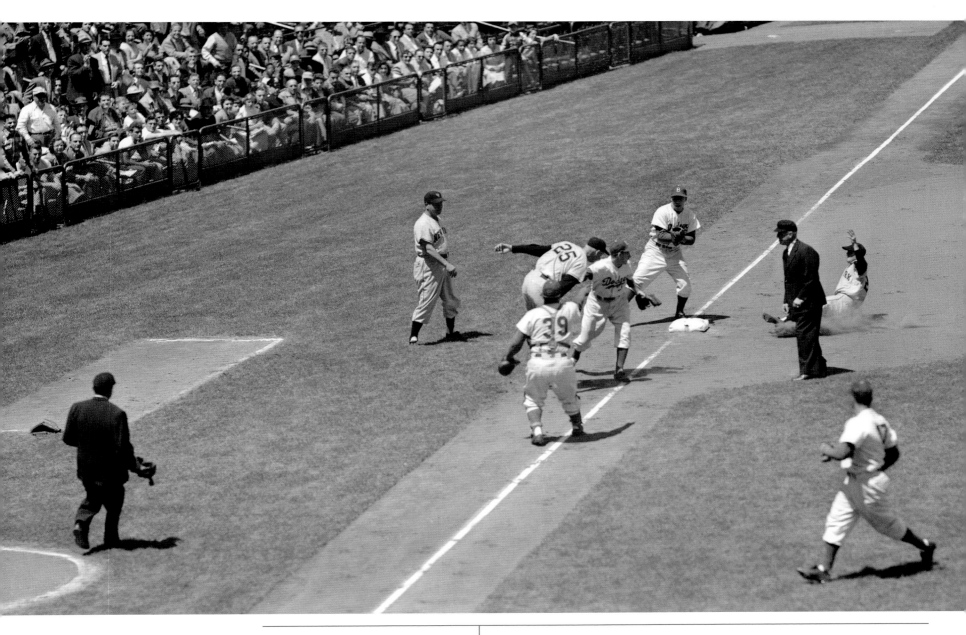

May 28, 1953
FEELING RUNDOWN AND PUTOUT
Cox makes tag on Lockman and turns to
see Mueller, who was on first, sliding into
third as Reese covers and Campy points.
Walter Kelleher

Hank Thompson's bouncer to the Dodgers' Billy Cox at third base, in the second inning,
caught the Giants' Whitey Lockman off third base. But by the time Cox tagged Lockman—
with Roy Campanella right behind the runner—Don Mueller had made it all the way into third
behind them. All of these players were good in 1953, but Campy was outstanding, hitting
.312, with forty-one home runs and a league-leading 142 RBIs. In fact, he was the National
League's MVP, for the second time in three years.

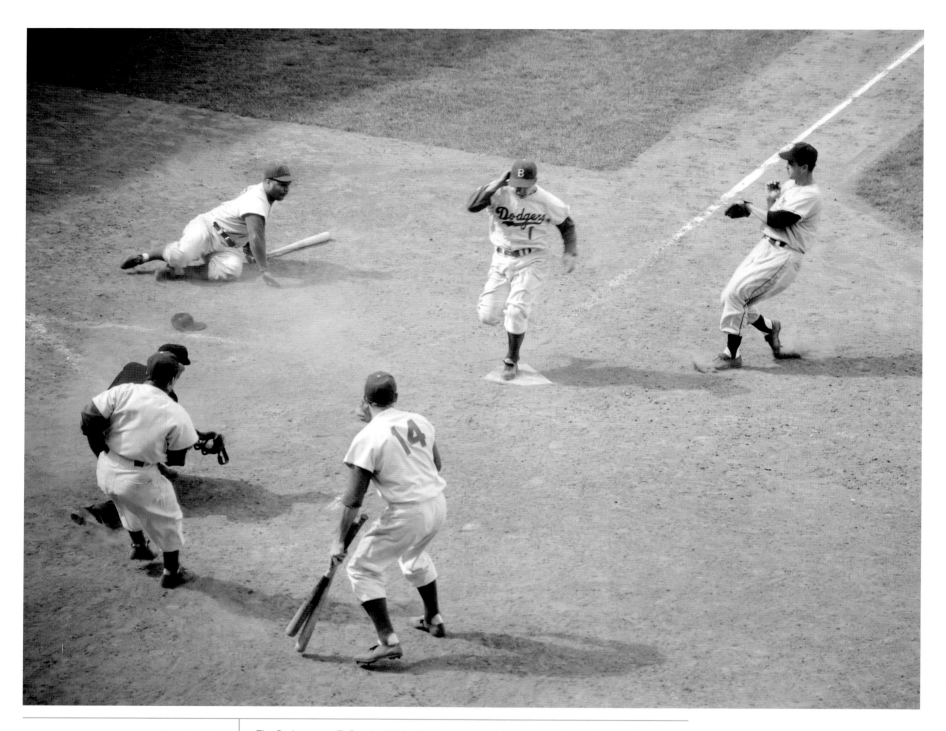

May 28, 1953
HOME FREE

Dodgers' Pee Wee Reese scores winning
run in 10th inning at Ebbets Field yester-
day without drawing a throw. Hodges (14),
Campy (on ground), Ump Ballanfant
and batboy watch Reese tally from
third as Wilhelm's knuckler got
away from catcher Noble.
Walter Kelleher

The Dodgers won 7–6 and, still in third place, moved to a game and a half out of first
during a tight, seesaw race among several teams. (The Giants were in fifth place but only
five back.) Gil Hodges had thirty-one home runs and 122 RBIs, though for the first time
Duke Snider and Campanella surpassed him in both categories. Ray Noble backed up Giants
catcher Wes Westrum. Hoyt Wilhelm, in his second season, appeared in sixty-eight games in
relief and pitched well, though his rookie year was when he'd led the league in winning
percentage (going 15–3) and in ERA (2.43). The durable knuckleballer went on to pitch a
record 1,070 games (for nine teams over twenty-one seasons) and was the first reliever
voted into the Hall of Fame.

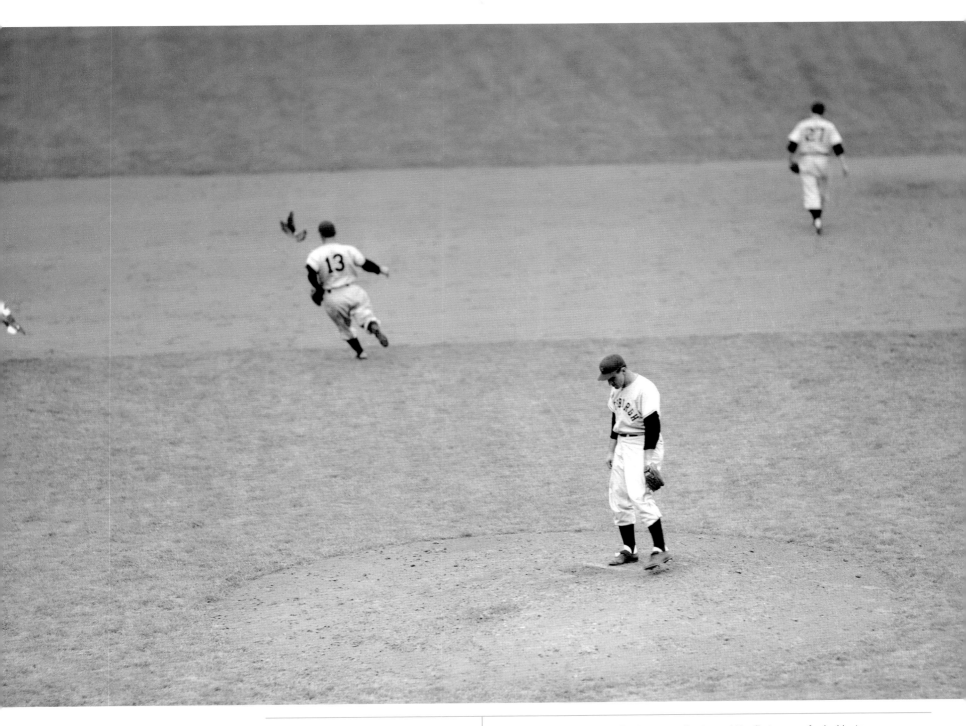

May 31, 1953
FLIGHT OF FLOCK
Neither Pirates nor pigeons could halt
Dodgers' 10-game winning streak
yesterday at Ebbets Field.
Walter Kelleher

The birds perching on the field temporarily stopped the first game of a lackluster doubleheader. Dick Young wrote, "The umpires and players had been spending more energy throwing pebbles at them, it seemed, than on the game." The second game was halted in the seventh inning because of darkness. The Dodgers won both, 4–3 and 4–1, completing a three-day, five-game sweep of the last-place Pirates (who finished *fifty-five* games out of first) and briefly moving back into first place. On June 27, Brooklyn took the lead for good.

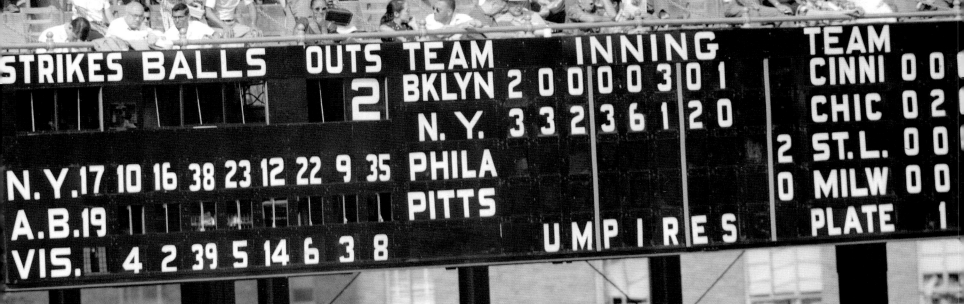

STRIKES BALLS OUTS TEAM INNING TEAM
2 BKLYN 2 0 0 0 0 3 0 1 CINNI 0 0
N. Y. 3 3 2 3 6 1 2 0 CHIC 0 2
N.Y. 17 10 16 38 23 12 22 9 35 PHILA 2 ST. L. 0 0
A.B. 19 PITTS 0 MILW 0 0
VIS. 4 2 39 5 14 6 3 8 UMPIRES PLATE 1

July 5, 1953
Overloaded Polo Grounds scoreboard
tells sad plight of Dodgers at hands of
Giants yesterday. Eighth-inning score
of 20-6 was the final tally. It was
Flocks' worst beating since 1944.
Charles Hoff

The Dodgers had a magnificent season—
but nobody's perfect. Fourteen of the
Giants' runs (off four Dodgers pitchers)
came on five home runs, including
Hank Thompson's grand slam in the fifth
(to go with his earlier two-run blast)
against one-inning reliever Ralph Branca.
Teammate Bobby Thomson added a
two-run inside-the-park homer—but that
wasn't against Branca, who won their
first face-off at the Polo Grounds since
that playoff game in 1951. Still, Branca
came in with the Giants already up
11–2, and by the time he got his first
out another six runners had come home.

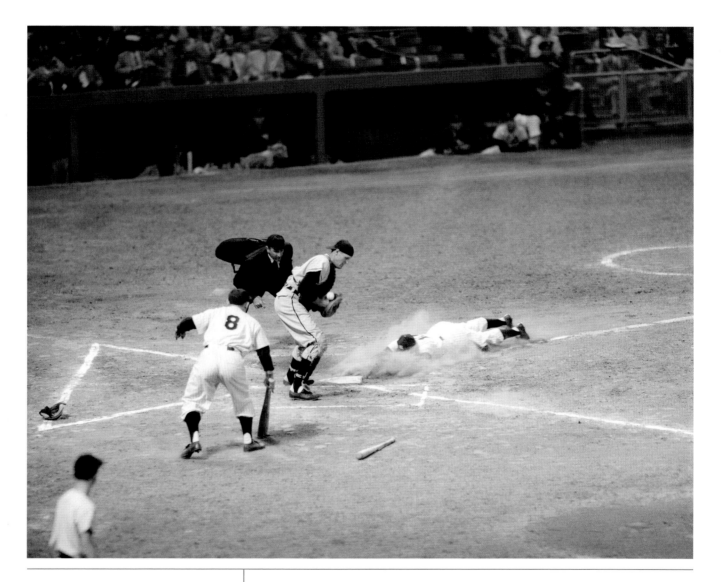

August 21, 1953
FLEA BITES DUST
Rizzuto, known familiarly as Scooter,
gets a snootful of dust as he slides into the
plate safely in the 1st. A's Murray takes
late throw. Yanks won, 5-4, in 11 innings.
Charles Hoff

Thanks to Hank Bauer's single after Rizzuto's bloop double, this was the first run of a
surprisingly seesaw game. The close score may be misleading: in their next-to-last year in
Philadelphia, the A's finished seventh, forty-one and a half games away from the Yankees.
Despite his career .273 average, Rizzuto continually made things happen for the Yankees,
both in the field and on the base paths (though he had only four stolen bases in 1953, down
from seventeen the year before and four straight years in double digits). Ray Murray was a
backup catcher.

August 30, 1953
OUT ON A LIMB
Card manager Ed Stanky sits in dugout with a towel wrapped around his knee and mimics Dodgers' Jackie Robinson after Robby struck out rather than put weight on his tricky knee in seventh at Ebbets Field. Brooks then exploded with 12 runs.
Fred Morgan

A bad knee had kept Robinson out of the two previous games, and he was being careful with it—so he nearly fell while avoiding a tight pitch. In response to Stanky's mockery, Robby waved a piece of cardboard at him on which he'd written, "How to make out a lineup.—By Ed Stanky"—a gibe at the ex-Giant for mistakes during his second season as player-manager that had twice led to Cardinals players being called out for batting out of turn. Fans joined in, booing Stanky and waving handkerchiefs. And all of a sudden the Dodgers had sent up fifteen batters in a row, scoring all seven who got hits and all five who walked. What had been a 6–3 game ended up a 20–4 whipping of the Cards (who finished the season in a tie with the Phillies for third place, twenty-two games back).

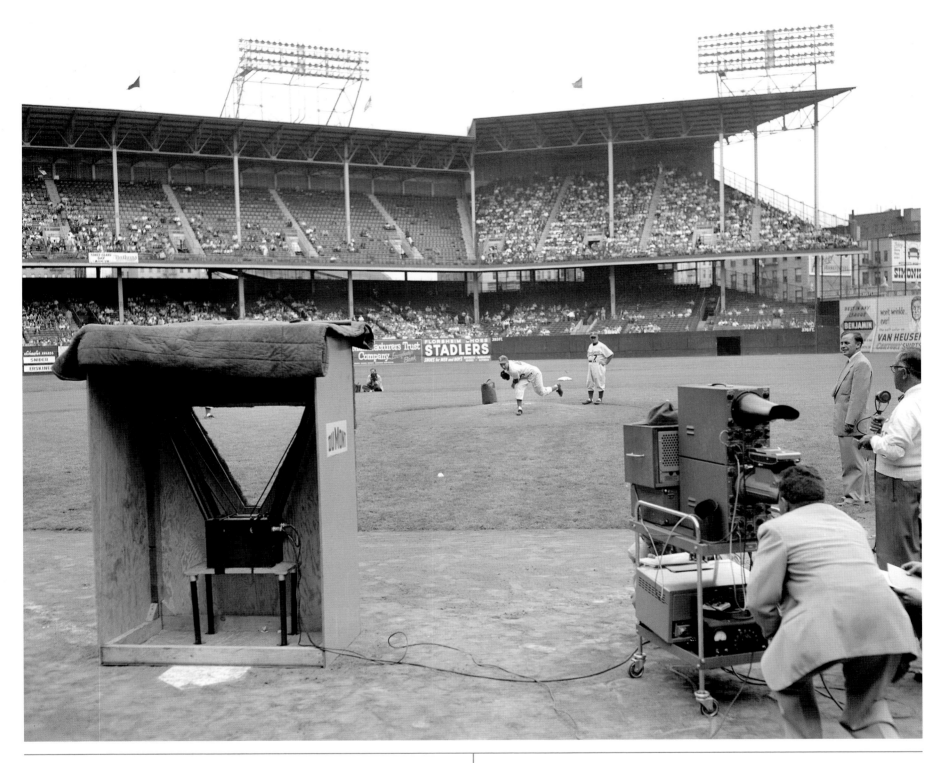

September 20, 1953

SPEED SPECIALISTS

Johnny Podres fires his fastball at a cathode-ray oscillograph to determine the speed at which the ball is traveling when it crosses the plate. Johnny's went 88.5 m.p.h., while Joe Black's registered 93.2. Bob Milliken's was caught at 83.5—but you couldn't prove it by the way the Phils caught up with it.

Charles Hoff.

The Dodgers won the game that Milliken started this day, 5–4, though they lost the second game of the doubleheader at Ebbets Field. Milliken usually pitched in relief, as did Black, who was having a sophomore slump with an earned run average of 5.33. Podres went 9–4 in a starting rotation led by Carl Erskine, whose 20–6 record also led the league with the best winning percentage. But Erskine's 3.54 ERA was the only starter's below 4, and the team's ERA was almost a full run higher than the Yankees'.

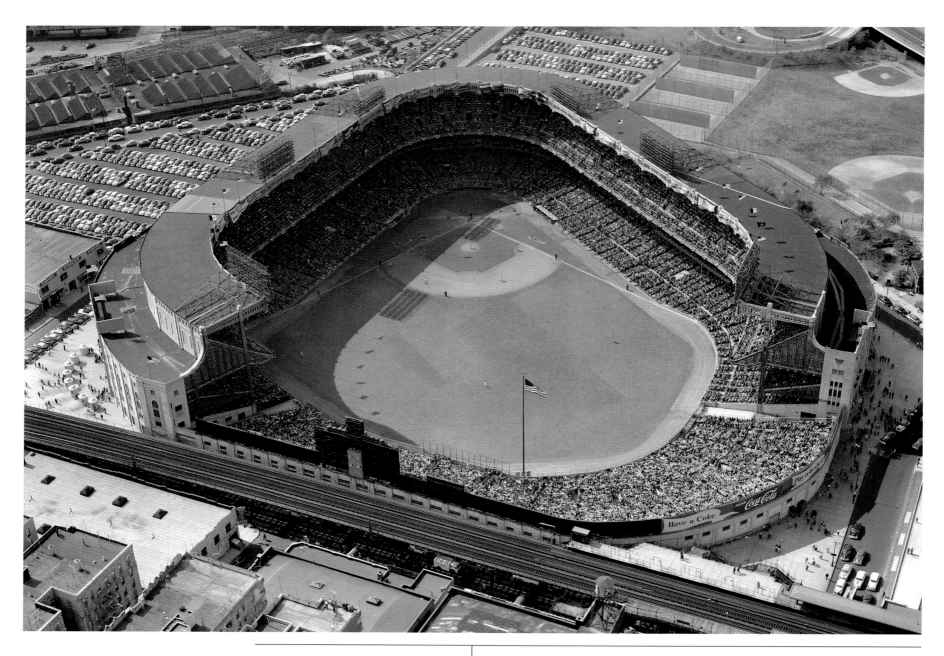

September 30, 1953

An aerial view of Yankee Stadium, packed with 69,374 fans for Game 1 of the fiftieth-anniversary World Series. (At eighty-six, Cy Young threw out the first ball.) The Yankees finished eight and a half games ahead of the Cleveland Indians to take an unprecedented fifth straight pennant. They had 99 wins, their most since 1942. Led by Berra and Mantle, they were first in the American League in batting, slugging, and other offensive categories. The Yanks were also superb on the mound, with a rotation anchored by Whitey Ford (18–6) and league ERA leader Ed Lopat (16–4), and in the field. Facing them again in the postseason, the Dodgers led the majors in batting (.285) and home runs (208), were tops in their league defensively, and had a pitching staff that was almost as good as the Yankees'. The Dodgers finished their regular season with 105 wins—their best record in all of their sixty-five years in Brooklyn. In Game 1, the Dodgers fell into a four-run hole in the first inning but tied the score by the seventh. Joe Collins's homer promptly untied it, and the Yankees added three more to win 9–5.

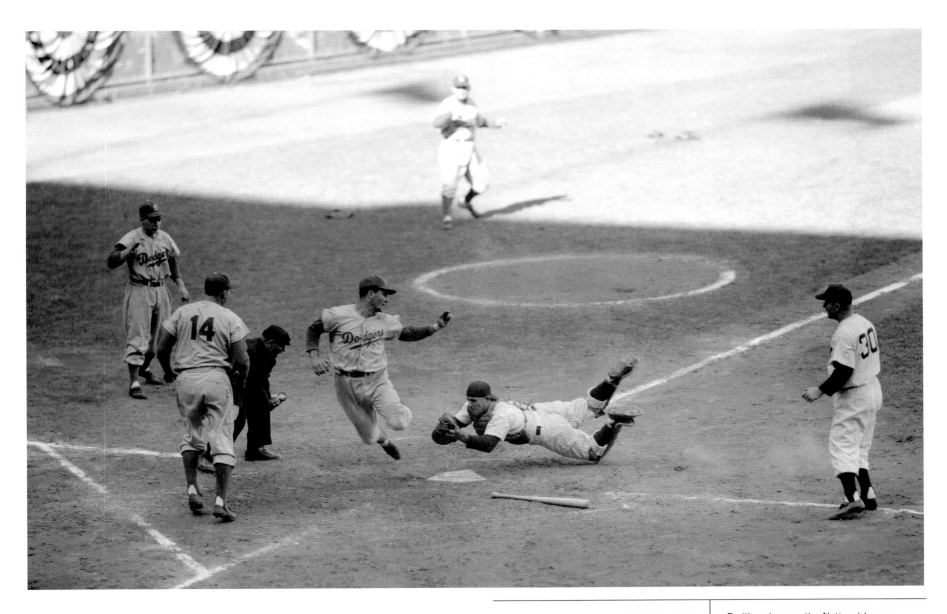

October 1, 1953

CARL'S PLAYING HARD TO GET

Dodgers' Carl Furillo exposes as little tagging area as possible as he wings home from first on Cox line drive double into the left field corner in fourth inning of second Series game at Stadium. Yanks' Yogi Berra dives headlong at Carl's flying feet but not in time. Ump Bill Stewart calls the play while Gil Hodges (14), who also scored on the hit, and the Brooklyn batboy look on. Yanks won, 4-2, for a 2-0 Series lead.

Leroy Jakob

Furillo, who won the National League batting title with a .344 average, was back after missing nearly a month with his hand injury. In Game 2, the Yankees took the lead in the first inning again, but this play put the Dodgers ahead 2–1 in a pitchers' duel between Ed Lopat and Preacher Roe. Then Billy Martin came through again, with a game-tying home run in the seventh, and Mantle's two-run homer in the eighth put the game away for good. The 4–2 win sent the Yankees off to Brooklyn with a two-game lead.

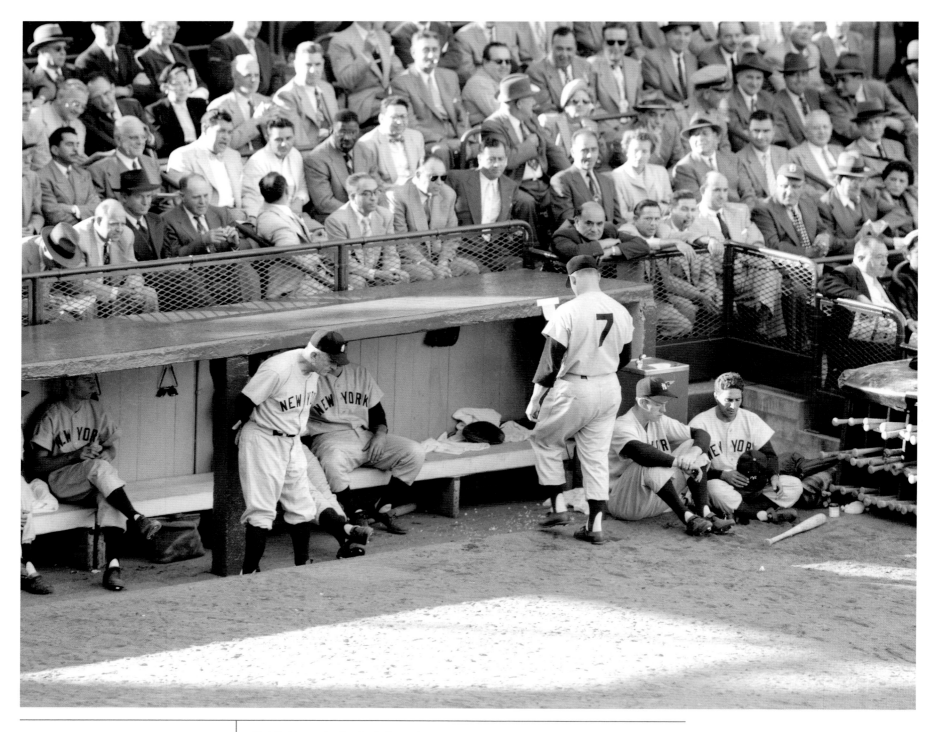

October 2, 1953
Mickey Mantle is the picture of dejection
after fanning for the fourth time. And
what can Casey Stengel say to the kid who,
only the day before, won the second game
with a homer?
Charles Hoff

Carl Erskine, so ineffective in Game 1, came back only two days later to blow away the
Yankees with a Series-record fourteen strikeouts on devastating curveballs—including four
against Joe Collins too. Playing with an injured hand, Roy Campanella provided the tie-breaking,
game-winning home run on Vic Raschi's first pitch in the eighth. The final score was 3–2.

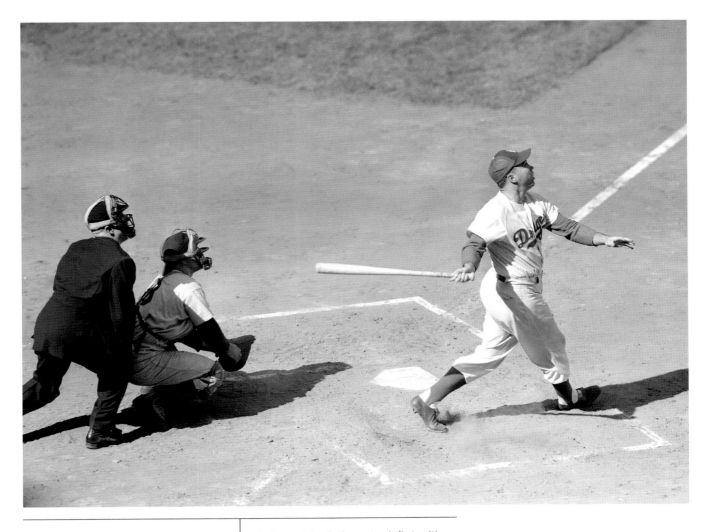

October 3, 1953

A HIT SHOW

Dodgers' Duke Snider follows through after crashing a long double off the right field wall in first inning of fourth Series game at Ebbets Field. Ump Gore and catcher Berra watch flight of the hit, which drove in two runs.

Charles Hoff

In Game 4 the Dodgers struck first, with three first-inning runs off Whitey Ford. Snider added another double and a home run during the game, and Junior Gilliam had three doubles. Although Gil McDougald homered for the Yankees, Billy Loes (14–8 during the season) pitched well, and the game went into the ninth inning with the Dodgers up 7–2.

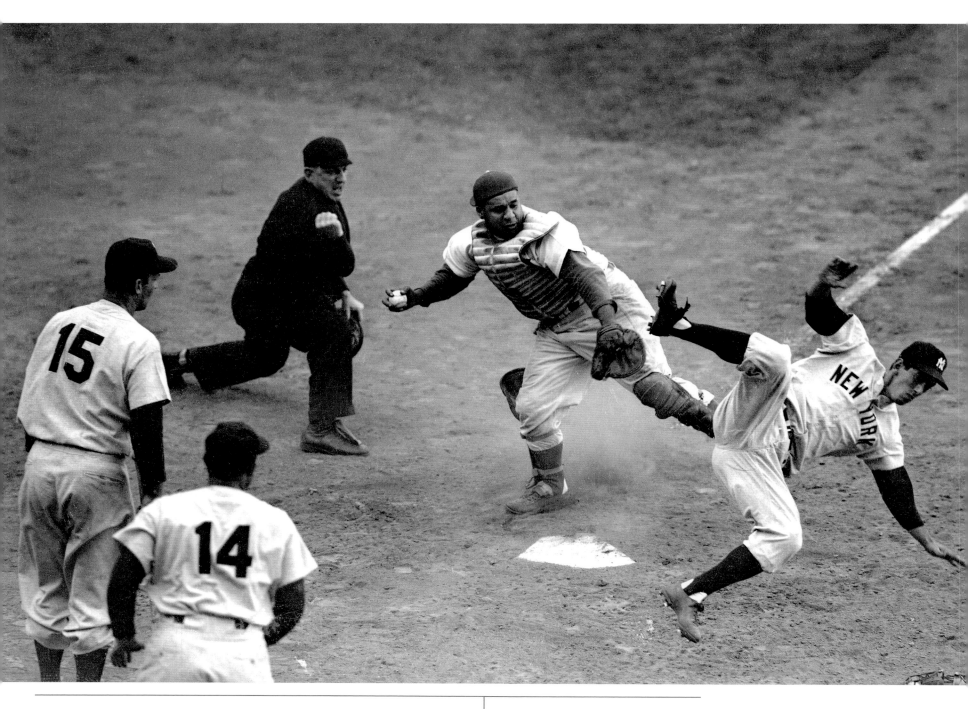

October 3, 1953

AND WHERE WAS BILLY GOING?

Dodger catcher Roy Campanella, his right shin guard twisted by collision at the plate, hangs on to ball after tagging Billy Martin for last out and sending him sprawling in ninth inning of fourth game at Ebbets Field. Ump Gore calls it. Martin tried to score from second on Mantle's bases-loaded single. Had he held at third, tying run would have come to bat and the Series standing MIGHT have been different today.

Charles Hoff

Martin batted .500 during the Series, with twelve hits, two home runs, and eight RBIs, and was great in the field—but this time he abruptly ended the two-out ninth-inning rally, and Game 4, with bad baserunning; he was out by fifteen feet.

October 3, 1953
IT'S GREAT TO BE A WINNER

Dodger catcher Roy Campanella, heading
for clubhouse, holds aloft ball he planted
on Billy Martin to register final out of
game. Gil Hodges (14), coach Herman, and
pitchers Meyer and Wade (46) complete
the happy group. Meyer's slated to pitch
today against Yank's Jim McDonald.
Seymour Wally

With the 7–3 victory, the Dodgers tied the Series. And Game 5 was also being played at home. Charlie Dressen actually decided to go with twenty-one-year-old Johnny Podres, but he had Russ "Mad Monk" Meyer (at 15–5, the Dodgers pitcher with the second-best season record) warming up right from the start. (The other pitcher here was Ben Wade, and the coach was Billy Herman, the onetime star second baseman for the Cubs.) With his own top starters used up, Stengel chose Jim "Hot Rod" McDonald, a nine-game winner (whose twenty-four career wins were scattered over nine seasons and five teams), to begin Game 5.

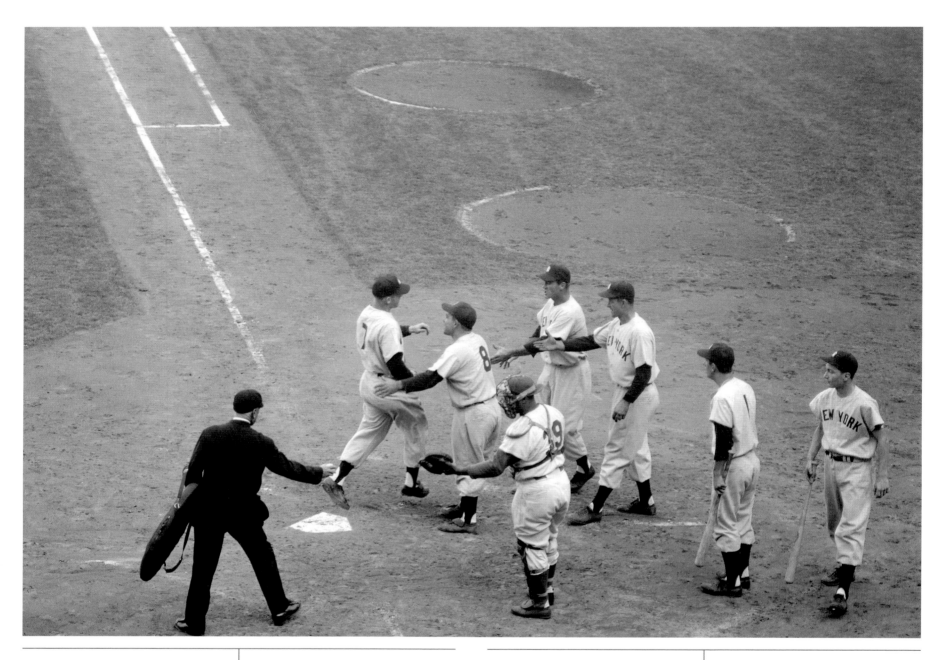

October 4, 1953
Mantle's greeted by Berra,
Bauer, Collins and Martin after
belting grand slam homer in third.
Fred Morgan

Although Gene Woodling opened the game with a home run off Podres (and then made a second-inning throw from left that caught Hodges on his way home), the third opened with a 1–1 tie. With two outs, Rizzuto scored on a Collins bouncer that took a bad hop past Hodges, and Podres then loaded the bases by hitting Bauer and walking Berra. In came Meyer to face Mantle, who had struck out in his last five at bats. But Mickey pounded the first pitch into the upper deck in left field, and suddenly the Yankees had a 6–1 lead.

October 4, 1953
Third baseman Gil McDougald has
Campanella's savage eighth inning smash
bounce off his shoulder and into left field
for a single. Gil, shaken up, stayed in
game and blasted a Joe Black pitch
into the left field seats.
Charles Hoff

Along with McDougald, Martin also hit a late-inning home run. Cox and Gilliam both homered during the game too, and the Dodgers had a four-run rally in the eighth against McDonald and Kuzava in relief, then added another in the ninth. But the Yankees also piled on five runs in the last three innings, so Mantle's third-inning grand slam proved to be the margin in the 11–7 Yankees win.

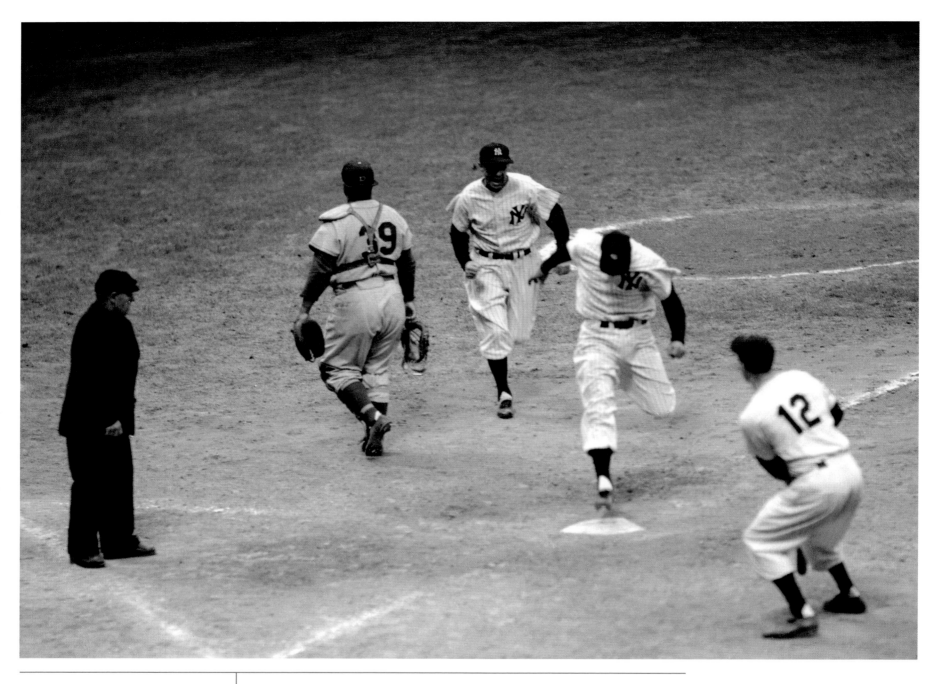

October 5, 1953
VICTORY STOMP
Yanks' Hank Bauer, trailed by Crosetti,
stomps on plate with run which ended
Series. Campanella walks away.
Tom Watson

The Yankees came to this moment after two runs in the first inning of Game 6 and another
in the second, while the Dodgers came back with a run in the sixth, against starter Whitey
Ford—and then tied the game, 3-3, with a walk and Carl Furillo's two-run homer against
reliever Allie Reynolds in the top of the ninth. There were 62,370 anxious fans at Yankee
Stadium on this cold, windy day. Then the Dodgers' Clem Labine, pitching in relief of Carl
Erskine, walked Hank Bauer, and Billy Cox couldn't handle Mantle's high chopper toward
third. And who brought home Hank Bauer, and with him the championship? None other than
Billy Martin, hitting a 1-1 fastball over second base.

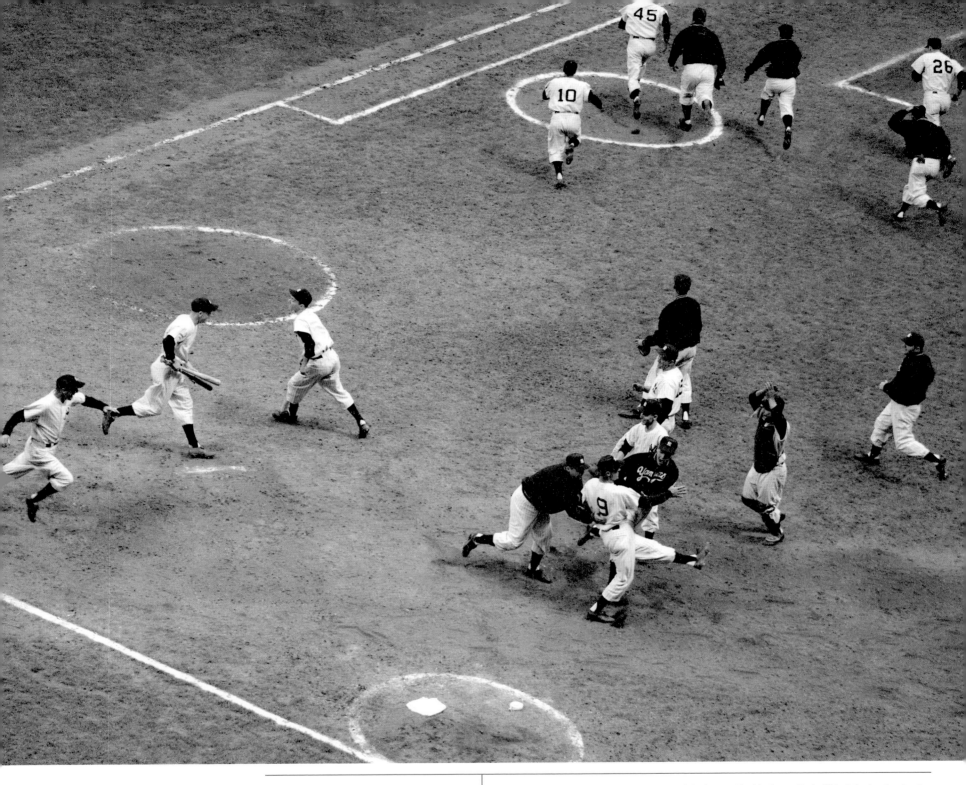

October 5, 1953
Hank is almost upended by the charge of
his enthusiastic mates. Bauer opened the
ninth with a walk, advanced on Mantle's
infield hit and raced home on Martin's
single to center.
Leroy Jakob

For the Dodgers, it was their second straight loss to the Yankees, their fifth defeat going back to 1941. Charlie Dressen—soon to be fired after three heartbreaking years as Dodgers manager—grumbled, "If I had had Newcombe, I could have won this." But the star pitcher of 1949–51 was still in his second year of military service. For the Yankees and Casey Stengel, it was *five* World Series crowns in a row—the first time that had ever happened, and a record that's still unmatched.

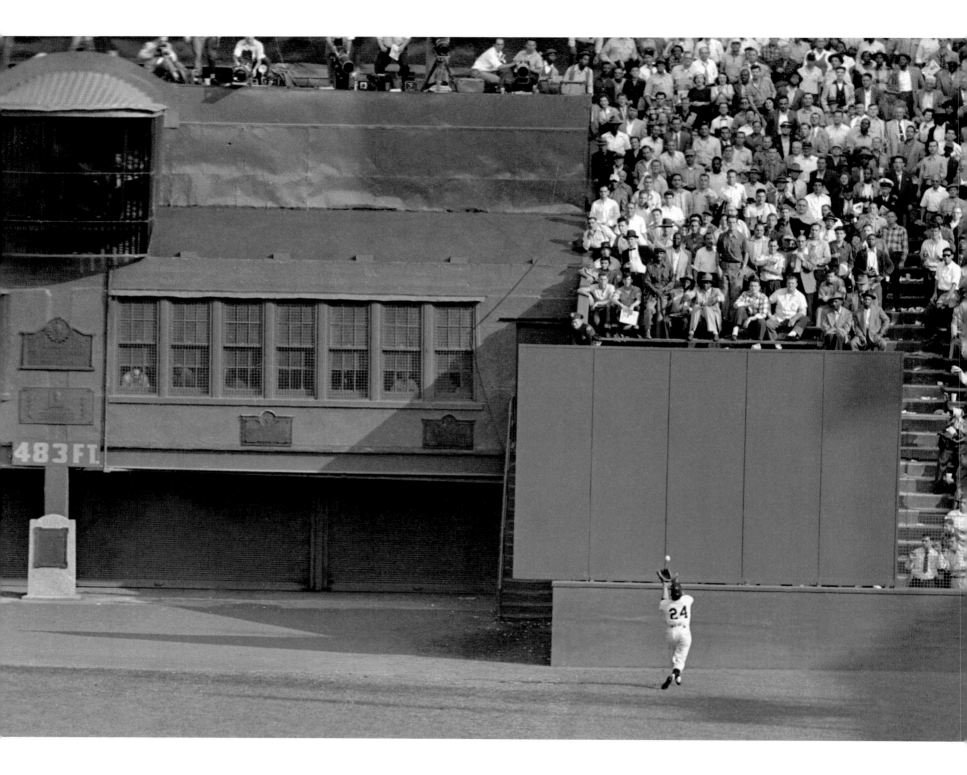

There is no reason to know the name Jim Rhodes, without whom the Giants wouldn't have been swimming in champagne after the 1954 World Series. He wasn't a star. He wasn't an everyday player. He wasn't able to match his one moment in the spotlight ever again. The fact is, he wasn't even called Jim Rhodes. How does Dusty Rhodes sound? If the curtain calls given players today were in use in 1954, Dusty Rhodes would have been popping out of the dugout with astonishing regularity. He batted a mere 164 times that year but managed to contribute fifteen home runs and fifty RBIs. And his best work came in the Series. The Giants finished twenty-seven games better than the previous year, edging out the Dodgers by five games. The Dodgers had a new manager, Walter Alston, who held down that job for twenty-three years. He had a lot to learn his rookie season, and it's generally agreed that the Giants' Leo Durocher out-managed him completely. It helped, too, that Willie Mays returned to the Giants after two years in the army. He led the league in hitting (beating out teammate Don Mueller) and slammed forty-one home runs. Bobby Thomson, the hero of 1951, was traded for Johnny Antonelli, a pitcher who had needed three years to win seventeen games for the Braves. He joined the Giants and won twenty-one. The great surprise of that season was the Yankees' failure to win their sixth straight pennant. They won the usual number of games, 103, but Cleveland did just a little better, 111. The first Series game matched Bob Lemon, the Indians' twenty-three-game winner, against Sal Maglie, who won fourteen. Cleveland jumped to a 2–0 lead in the first inning on Vic Wertz's triple. Wertz had two more hits off Maglie that day, but he's remembered for the hit that got away. The game was tied in the eighth when Cleveland led off with a walk and a single. With the left-handed-hitting Wertz up next, Durocher replaced Maglie with left-hander Don Liddle. The lefty's first pitch was a high fastball, and Wertz made solid contact. The ball flew into the deepest part of center field, and there was no doubt the two runners would score. But no, Mays wouldn't let that happen. He outflew the ball and, with his back to the plate, made what Cleveland manager Al Lopez would call "the greatest catch ever. I'm not even factoring in the pressure." After thanking Liddle for retiring the dangerous Wertz so expeditiously, Durocher replaced him with Marv Grissom, who got the next two outs. Wertz had one more chance, and he led off the tenth with a double. But the Indians couldn't bring him in. In the Giants' half of that inning, there were runners on first and second and Durocher sent up Rhodes, who had been used as a pinch hitter forty-five times that season, to bat for Monte Irvin. Rhodes sent a routine fly ball to right field—but there was nothing routine about that part of the Polo Grounds. The right-field wall was 257 feet from the plate, and Rhodes's fly was a solid 258. A three-run homer. The next day, in the Giants' 3–1 victory, Rhodes came off the bench to drive in two runs. In Game 3, his third-inning single gave the winning Giants two runs. The Giants won Game 4, but without a bit of help from Mr. Dusty Rhodes. Hey, nobody's perfect.

Fred Morgan's similar photo of the famous catch in Game 1 of the Series, between the Giants and the Indians, ran on the back page of some editions of the *Daily News,* along with the line "Catch in Time Saves 9." Other editions ran a four-shot sequence in the centerfold; the caption at left accompanied the second photo. The other captions: "1—Willie Mays races toward center field seats in pursuit of Vic Wertz' tremendous belt. Pictures were made with new sequence camera on 70mm film equipped with 20-inch lens and shooting 10 frames per second." "3—Mays is finally facing the infield again as he gets off a strong throw from deep center." "4—Willie completes an all-out effort by falling to the ground after his throw-in." Everyone talks about the magnificent catch, but Mays's memorable follow-up throw to second kept the Indians' Larry Doby there and preserved the eighth-inning tie—until the Giants took Game 1 in the tenth.

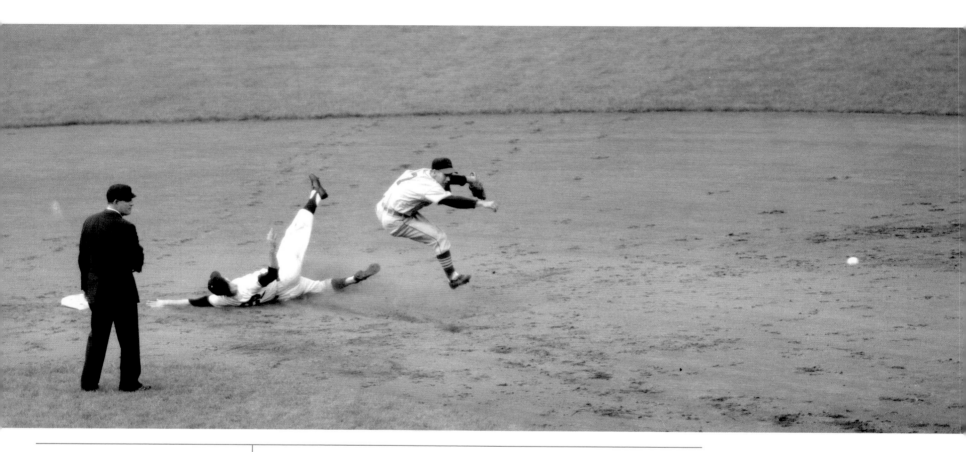

May 19, 1954
FLYING CARD

Shortstop Solly Hemus flies through the air as he avoids Don Mueller's late slide into second in 4th inning. Solly's toss to first doubled Henry Thompson, who had grounded to Schoendienst. Cards, behind Raschi, blanked Giants, 3-0.
Bill Meurer

Vic Raschi had been the Yankees' number one starter (going 98-42 in 1948-52). But his knees were going and his annual salary disputes were bitter, and after having a 13-6 season in 1953, he was sold in February to the Cardinals. Raschi retired two years later, with a 132-66 record. Mueller, the Giants' right fielder in 1950-57, batted .342 in 1954, just behind Willie Mays (back from military service, and on a tear—all season), while third baseman Hank Thompson hit twenty-six homers. Second baseman Red Schoendienst, for years a team leader with his bat and glove, and Hemus both later managed the Cardinals—the former (in 1965-76, with two brief returns later) far more successfully than the latter (1959 to mid-1961).

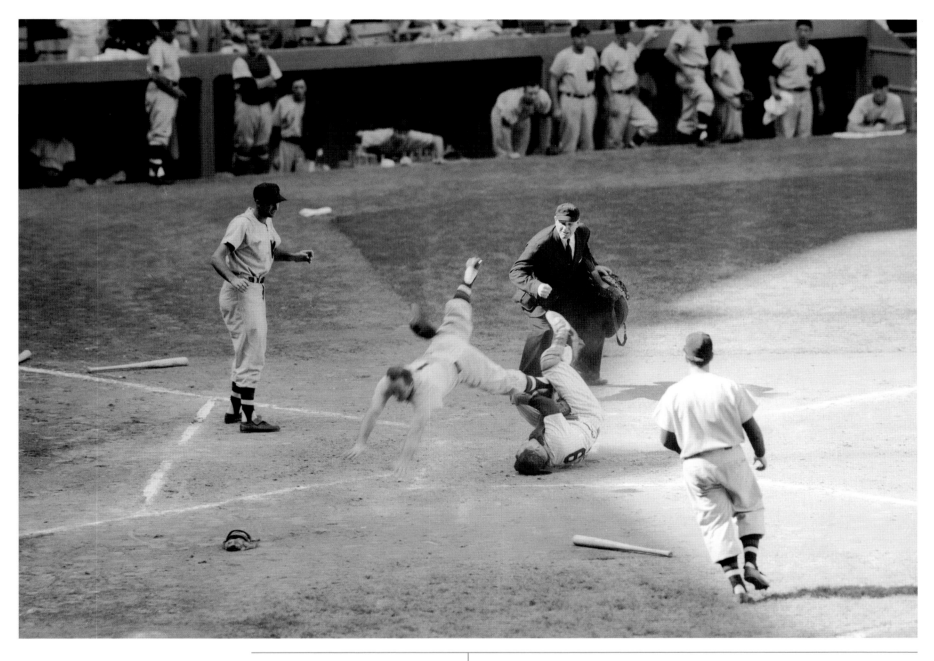

May 31, 1954
HOME SWEET HOME
Senators' Eddie Yost heads for a two-point
landing after bowling Yankee catcher
Charlie Silvera over in collision at home in
second inning of nightcap at Stadium.
Ump Rommel has fist clenched for out
signal. Yost tried to score from first on
Busby's double, but Woodling-Coleman-
Silvera relay cut him down.
Walter Kelleher

The Yankees split this doubleheader, losing 1–0, then winning 7–6 on a bases-full walk in the tenth after blowing a 6–1 lead. Third baseman Yost got on base a lot, but walking more than hitting; outfielder Jim Busby hit and stole to get his bases. The Senators had one World Series crown, back in 1924, and pennant titles in 1925 and 1933, but they usually finished in the second division and were sixth in 1954, forty-five games back. After 1960, they became the Minnesota Twins. This was Gene Woodling's last of six seasons with the Yankees; he broke his thumb on August 21, missed the rest of the year, and was traded to Baltimore. (He ended his career with the 1962 New York Mets.) Jerry Coleman returned from military service—which is what his fill-in at second base, Billy Martin, was doing in 1954–55. Silvera backed up Berra (who won his second MVP award).

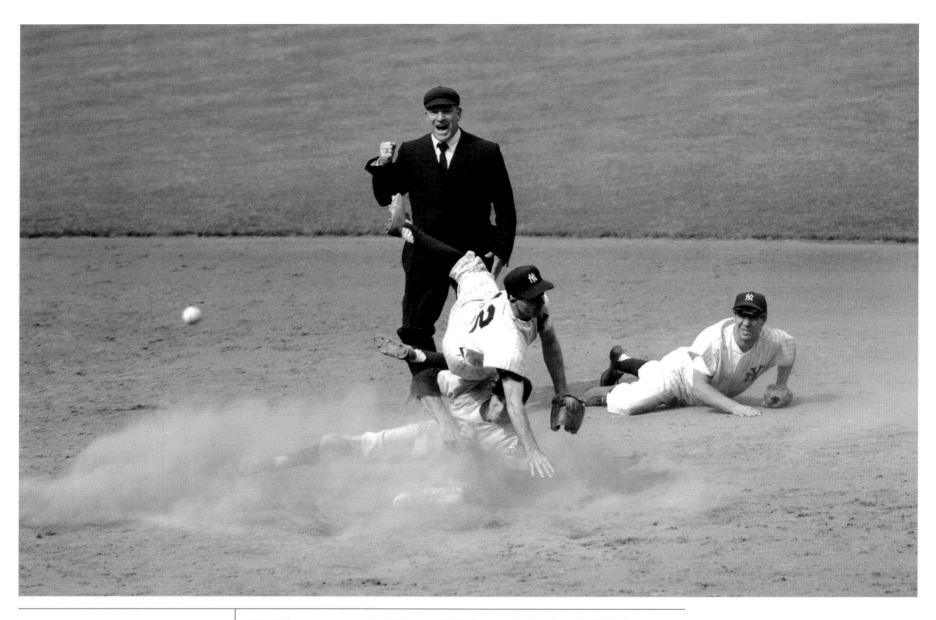

June 3, 1954
LO—(VERY LOW) THE POOR INDIAN
Yanks' Jerry Coleman falls on top of
George Strickland of Indians while
throwing to first base in effort to double
up Dale Mitchell in ninth inning. Phil
Rizzuto, who made diving stop of
Mitchell's grounder and flipped to
Coleman for the forceout of Strickland,
watches the action. Yanks beat Indians, 2-
1, at Stadium on Joe Collins' eighth inning
home run.
Charles Hoff

The Indians, runner-up to the Yankees in 1951–53, were their nemesis in 1954. The Yanks
had Rookie of the Year Bob Grim (20–6—though arm injuries later spoiled his career), Whitey
Ford (16–8), Allie Reynolds (injured and in his last season), Ed Lopat, and the bats of MVP
Yogi Berra and Mickey Mantle, but they couldn't match the Cleveland rotation of twenty-three-
game winners Early Wynn and Bob Lemon plus Mike Garcia, Art Houtteman, and Bob Feller,
along with batting champion Bobby Avila and sluggers Larry Doby and Al Rosen. The Indians
moved into first place on May 16 and then held all comers at bay, except for four days in
June. Strickland mainly contributed his glove at shortstop; Dale Mitchell, the former left
fielder but now primarily a pinch hitter, is the answer to two trivia questions: his homer on
September 18 clinched the pennant, and his strikeout as a pinch hitter for the 1956 Dodgers
ended the Don Larsen perfect game (and his own career). Rizzuto, who turned thirty-seven in
September, was losing range at shortstop and had his worst season at the plate (.195), just
four years after he was the MVP.

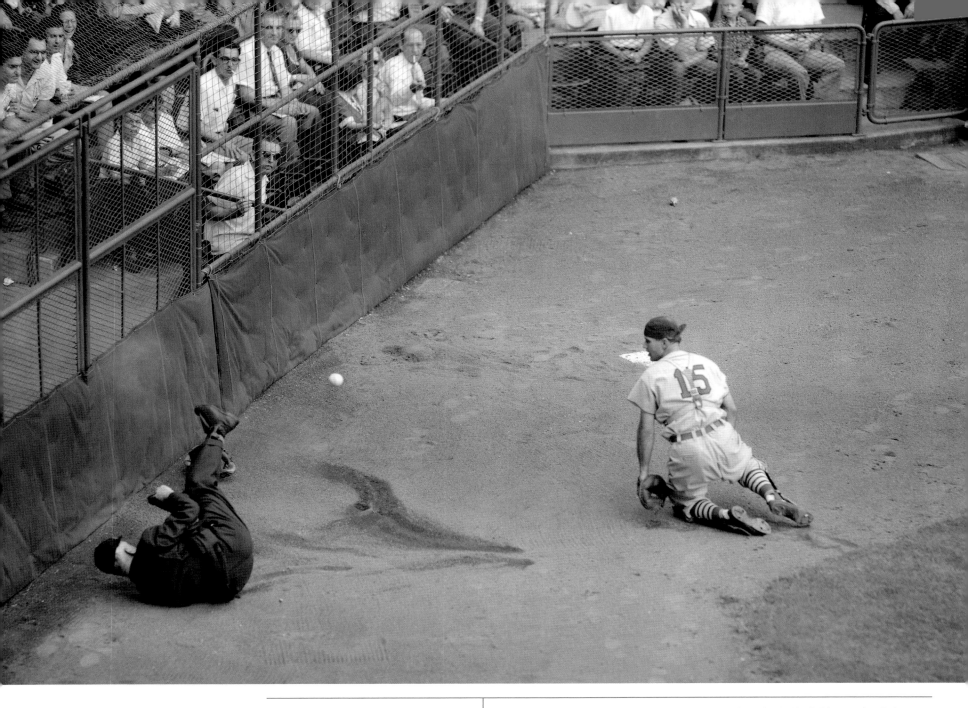

June 26, 1954

SPILLING GORE ALL OVER THE PLACE

Cardinal catcher Bill Sarni, down on one
knee, looks toward plate umpire Art Gore
who sprawls near screen in third inning at
Ebbets Field. Foul pop by Dodgers' Billy
Cox drops untouched. Sarni and Gore
collided as Sarni raced back in attempt to
make the grab and Gore went along to
make sure the catch was legal. Given
another chance, Cox singled.

Charles Hoff

The Dodgers won 7–6 in eleven innings on a bloop single by Jackie Robinson, after Duke
Snider's two-out homer tied the game in the ninth. Under their new manager, Walter Alston
(who lasted, on one-year contracts, through 1976, winning more than two thousand games,
seven pennant titles, and four World Series crowns), the Dodgers had fallen out of first place
on June 15 and were now one game behind the Giants. Sarni was a good catcher in 1954 to
mid-1956, when he and Red Schoendienst were part of a trade to the Giants for Alvin Dark,
Whitey Lockman, and other players; a heart attack during spring training in 1957 ended
Sarni's career. Cox had been the Dodgers' fixture at third base for seven years, but Don Hoak
replaced him in 1954. Cox and the aging Preacher Roe were traded to the Orioles in the off-
season, and both retired the next year.

June 30, 1954
Gal rooters take to their feet to exhort
heroes to greater efforts.
Frank Hurley

The fans went home happy: the Giants beat
the Dodgers 5–2, the second game of a
three-game sweep at the Polo Grounds.

July 6, 1954
MIXED EMOTIONS . . .
The Dodgers didn't start getting even in
Brooklyn last night. The script was the
same at Ebbets Field as it was at the Polo
Grounds last week when the Giants took
the Brooks to camp in a three-game sweep.
There were 33,616 fans on hand last night,
many of them Giant fans. They saw the
Jints win, 5-2. Dodger fans saw their team
drop 4½ lengths behind. THE NEWS fotos on
this page show how the fans felt about it.
Dodger fan James McLaughlin grits teeth
on tail-end of a rope.
John Duprey

This is one of six photos in the *Daily News*
centerfold on the game and fan reaction to
it. Home runs by Willie Mays, Monte Irvin,
and Alvin Dark gave the Giants another
5–2 win, behind the pitching of Sal Maglie
and Marv Grissom—who came on in relief
and, with bases loaded in the ninth, shut
down a potential Dodgers rally.

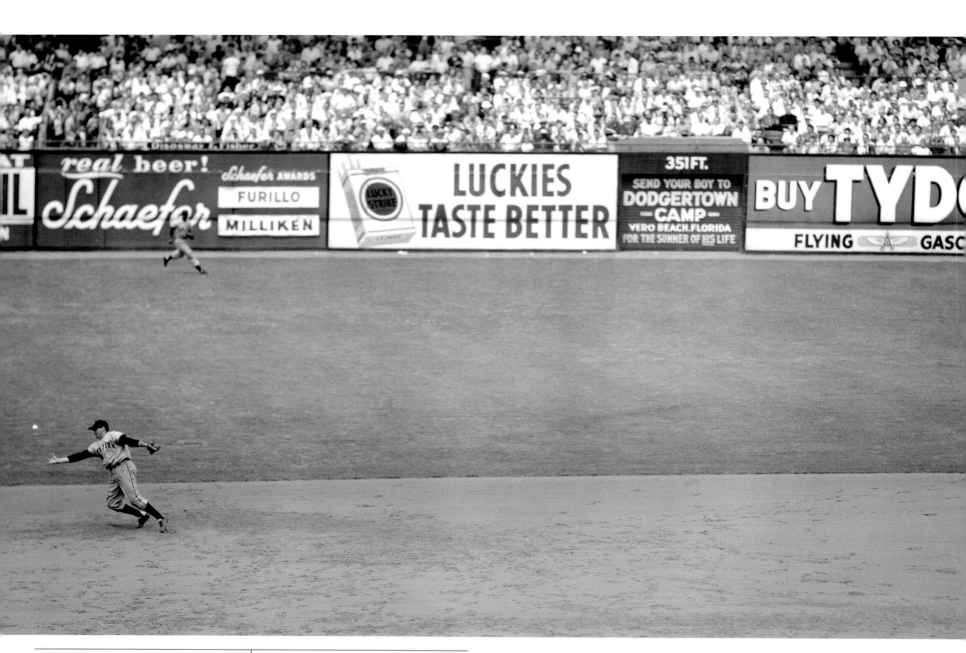

July 8, 1954
Giants shortstop Alvin Dark lunges for the ball after stopping Robinson's liner in 3d. It dropped, but he threw to second to nip Campanella.
Charles Hoff

The Giants won this game too, 11–2, and with it their second three-game sweep of the Dodgers in about a week. Brooklyn was now six and a half games back. The lopsided score came on two home runs by Willie Mays (who already had thirty) and one by Monte Irvin (his third in three days, and one of nineteen for the season). Whitey Lockman also homered and had two doubles, while Don Mueller had four straight hits. Dark, another Giants slugger, had twenty home runs in 1954, while the Dodgers' Campanella—in an off year—had nineteen.

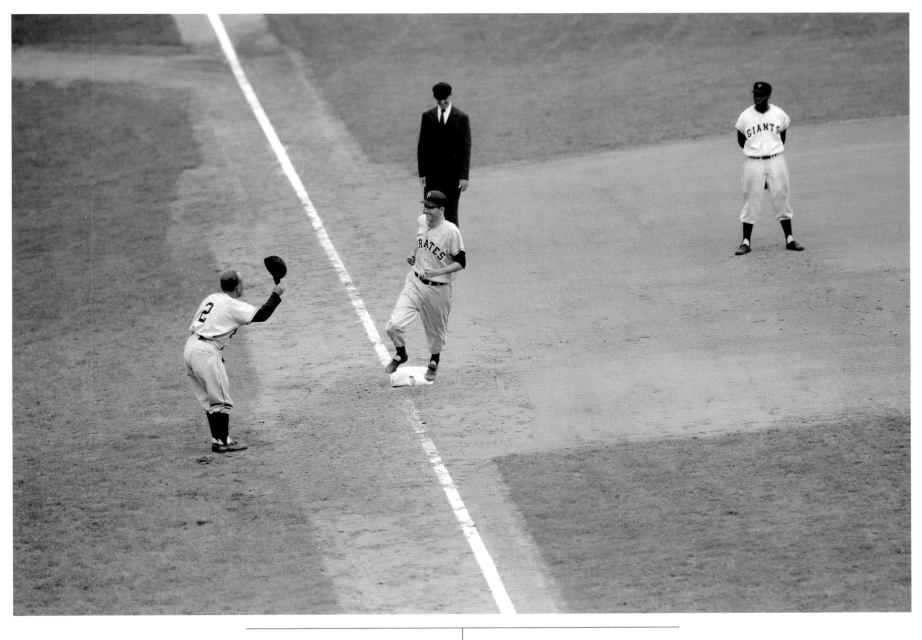

July 10, 1954
THE LID'S OFF
Pirate manager Fred Haney doffs his cap
and bows to his hurler, George O'Donnell,
as latter rounds third after hitting two-run
homer in the sixth inning.
Fred Morgan

The last-place "Bucs" battled back from a
seven-run deficit in the second inning—
including Alvin Dark's grand-slam home
run—and managed to beat a surprisingly
sloppy first-place Giants team, 10–7. The
Pirates were still twenty-nine games
behind, though, only eighty games into the
season, and they wound up forty-four
games out of first. O'Donnell was a rookie
right-hander, who came on in the fifth.
Haney later managed the Milwaukee Braves
to a world championship and two pennant
titles (1957–58).

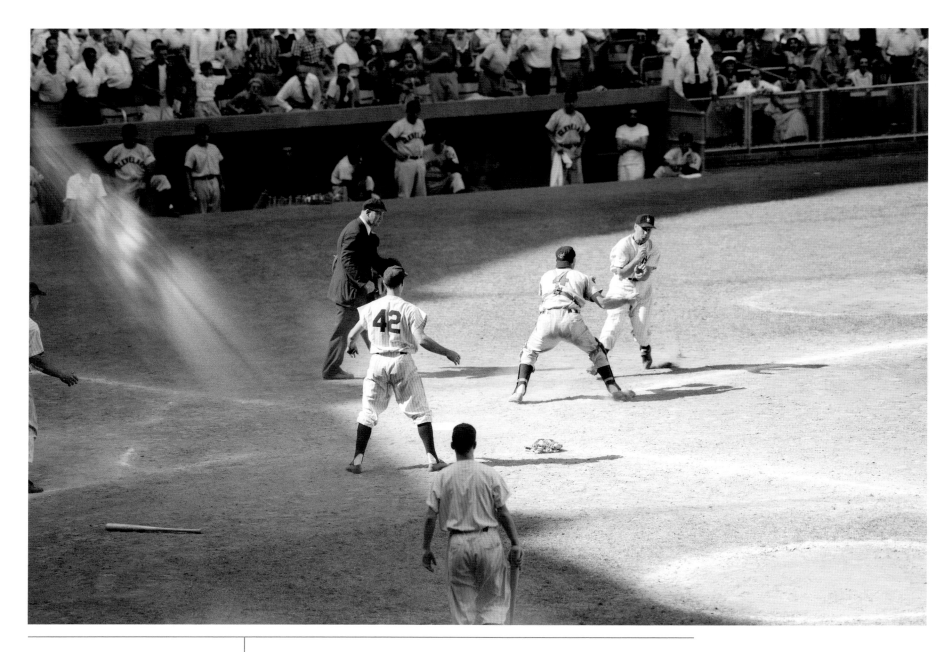

July 25, 1954

A ROUGH AFTERNOON AT HOME

Hegan clutches ball firmly as Slaughter
braces to ram Hegan in effort to score
leading run from first on Robinson's
bases-loaded, pinch-hit double in seventh.
Smith-Dente relay beat Slaughter who was
out when Hegan held ball despite crash.

Charles Hoff

That's Indians catcher Jim Hegan, left fielder Al Smith, and utility infielder Sam Dente, and Yankees newcomers Eddie Robinson and Enos "Country" Slaughter. The Yanks did tie the game on this play and won in the eleventh, 4–3, moving to just one and a half games behind Cleveland. But they started slipping, and the Indians pretty much ended their hopes with a doubleheader sweep on September 12, before a major-league-record crowd of 86,563 in Cleveland. The Yankees finished up with 103 wins—and still fell eight games short of the record-setting Indians. Robinson, a former slugger (including for Cleveland in 1948), went fifteen for forty-nine as a pinch hitter in 1954. Slaughter, the longtime star outfielder for the Cardinals, spent a year in New York. When he came back in mid-1956, from Kansas City, the Yankees made room on their roster by releasing Phil Rizzuto. Slaughter was a Hall of Famer, but the North Carolinian is infamous for trying to organize a Cardinals strike against Jackie Robinson in 1947 and then spiking him while sliding into second.

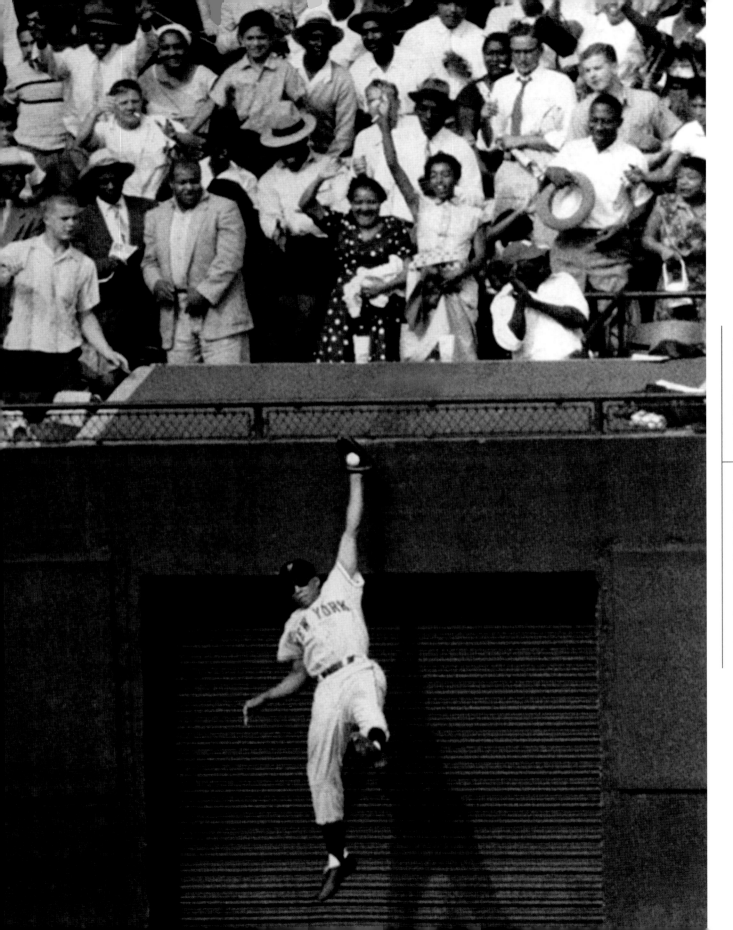

August 15, 1954

OUT FOR A SUNDAY DRIVE

The Giants' amazing Willie Mays amazes centerfield fans with leaping, one-handed catch of Duke Snider's long drive to exit gate in seventh inning. The Duke and Willie socked homers yesterday.
Charles Hoff

People who watched only the World Series didn't realize that Mays did this sort of thing often. This time the Dodgers beat the Giants, 9–4, at Ebbets Field, to pull within a half game of the Giants after a three-game sweep of their own, while the Giants were dropping seven of eight. (Then they won seven in a row.) This one was hardly a pitchers' duel: there were forty-four hits, twenty-five walks, and four solo home runs by the Giants. Snider had forty home runs for the season (while teammate Gil Hodges had forty-two—and each drove in 130 runs).

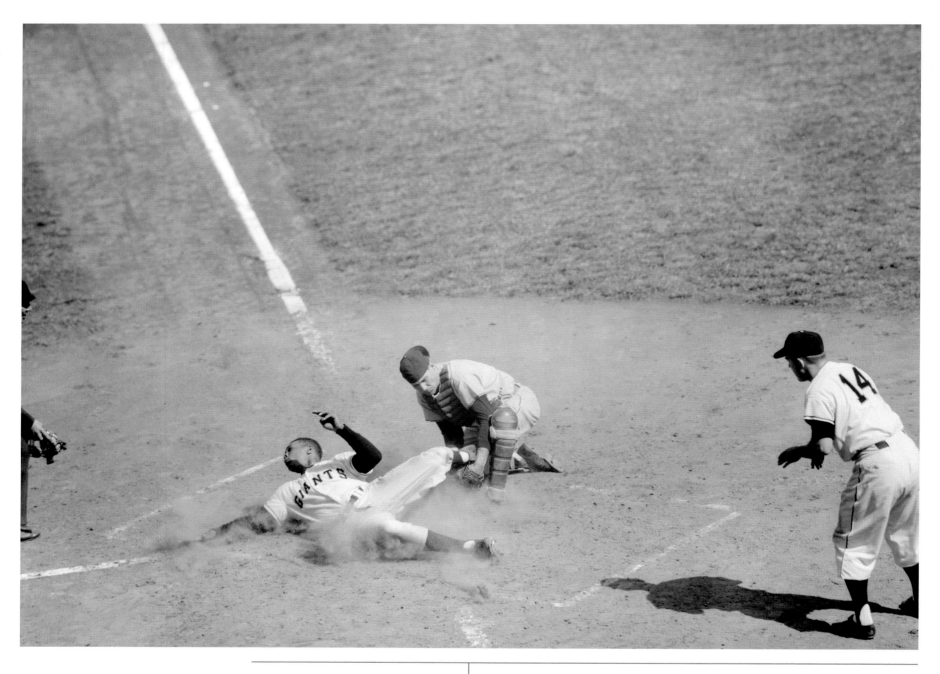

September 13, 1954
WHOA, WILLIE!
Cards' Bill Sarni tags out Willie Mays at
home in 3d at Polo Grounds. Ambitious
Willie tried to score from first on Don
Mueller's double to center. Giants won, 1-0.
Fred Morgan

Nevertheless, Mays doubled and scored the sole run in the first, and in the third he killed a Cardinals rally by catching a sinking liner at his knees and then doubling up Alex Grammas off first base. Mays was well on his way to his MVP award, with the league batting title (.345— won on the last day, over Snider and Mueller, when he went three for four) to go along with forty-one home runs and 110 RBIs. Despite the still-powerful Stan Musial, who led the dynasty of the early to mid-1940s, the Cards were about to end the season in sixth place, their worst finish in sixteen years—and it had been thirty years since they'd wound up as far back as twenty-five-games out of first.

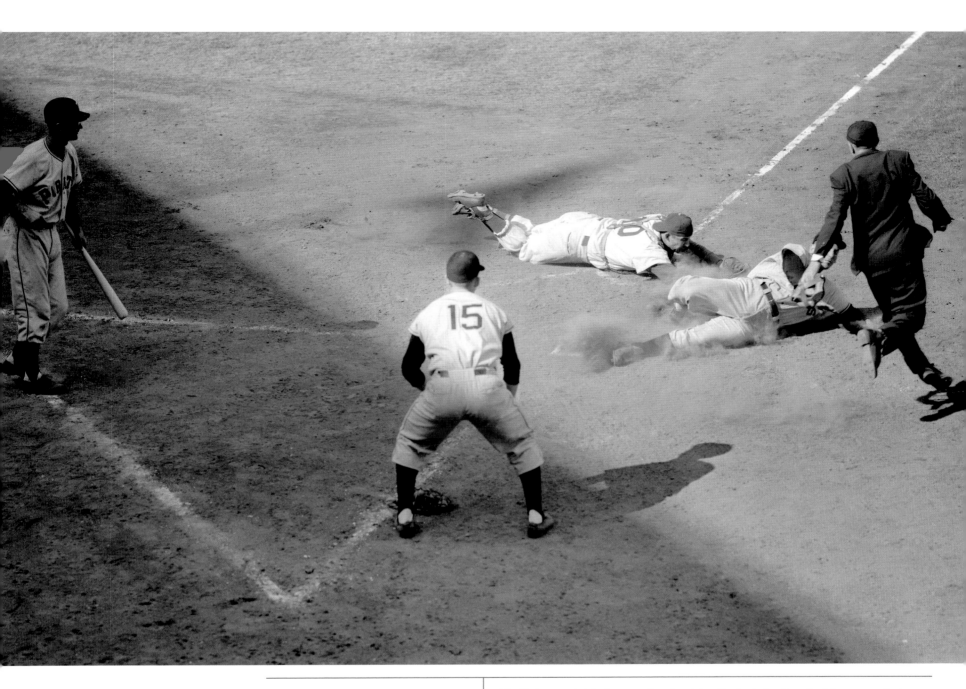

September 24, 1954
SEVENTH-INNING STRETCH
Brook catcher Rube Walker strains to
utmost to reach sliding Toby Atwell in 7th
at Ebbets Field. Atwell's fall-away slide got
him over safely as ump Pinelli attested.
Despite this Pirate score, Flock won, 6-5.
Leroy Jakob

The Dodgers ended their season two days later, five back despite a final four-game winning
streak. The two-time league champs still had a great team—but the Giants had Mays again.
They also had a new ace, Johnny Antonelli, acquired before the season from the Milwaukee
Braves for 1951 hero Bobby Thomson. He soon placated the angry Giants fans, going 21–7 to
lead the league in winning percentage, earned run average (2.30), and shutouts. Add those
two to a mix that included Ruben Gomez (17–9), Sal Maglie (14–6), reliever Hoyt Wilhelm
(12–4, with a 2.10 ERA), and the bats of Hank Thompson, Alvin Dark, Monte Irvin, and Don
Mueller, and you have a team that went from fifth place the year before, thirty-five games out,
to the pennant in 1954.

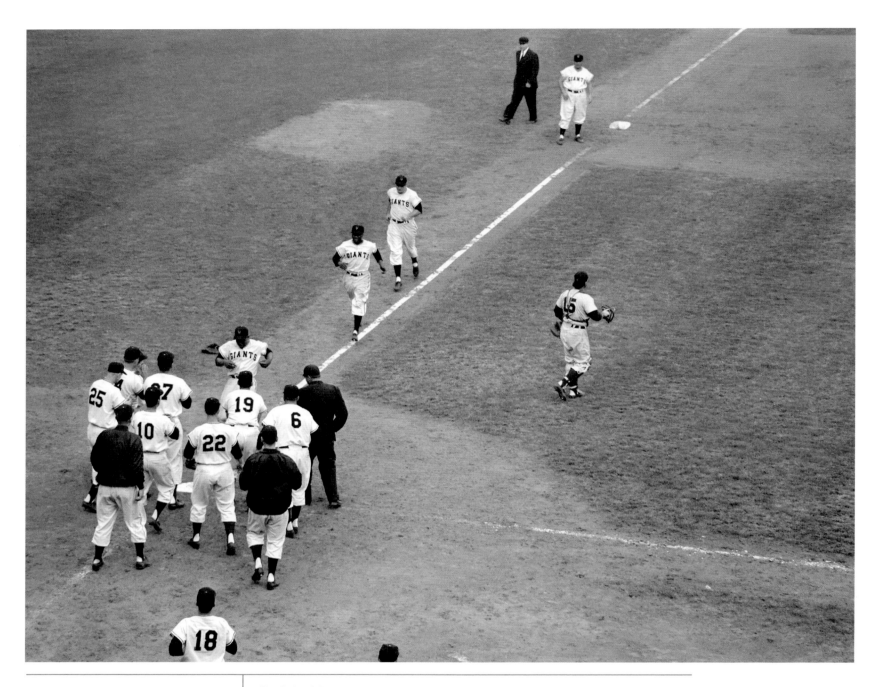

September 29, 1954
It's a happy road home for Giants' Mays,
Thompson and Dusty Rhodes (front to
back) as teammates swarm about dish
after Rhodes' Oriental-type homer iced '54
Series opener. It wouldn't have been a
homer in any other major league park.
Charles Payne

The fitting follow-up to the phenomenal Willie Mays catch (shown on page 126): the Game 1
clincher in the tenth inning by the *other* World Series hero, pinch hitter Dusty Rhodes.
Somehow it's appropriate that the first player trotting to home plate, in front of Hank
Thompson as well as Rhodes, is Willie Mays. The home run gave the Giants a 5–2 win over
the Indians.

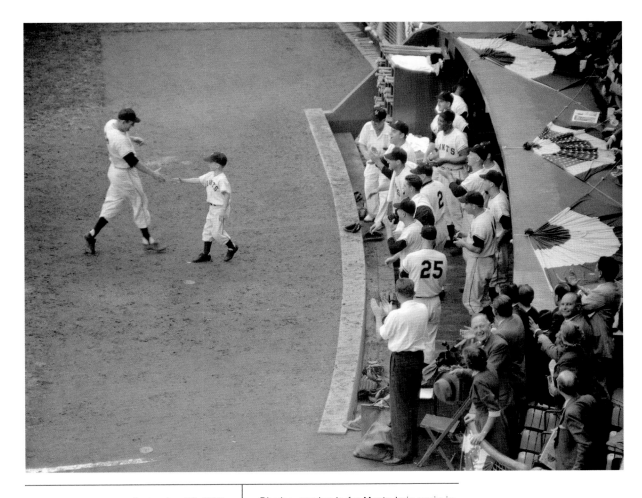

September 30, 1954
LITTLE THINGS MEAN A LOT

Chris Durocher, young son of the Giants' manager, is the first one out of the dugout to glad-hand Dusty Rhodes after he belted homer in seventh inning. For second straight day, Rhodes led Giants to victory over Cleveland Indians. Dusty also had run-producing single that paced Giants to 3-1 win.
Walter Kelleher

Rhodes, coming in for Monte Irvin again in Game 2, had tied the score in the fifth with a single that scored Mays and advanced Thompson. When Antonelli grounded out, Thompson came home with the go-ahead run. This insurance run by Rhodes landed on the right-field roof of the Polo Grounds.

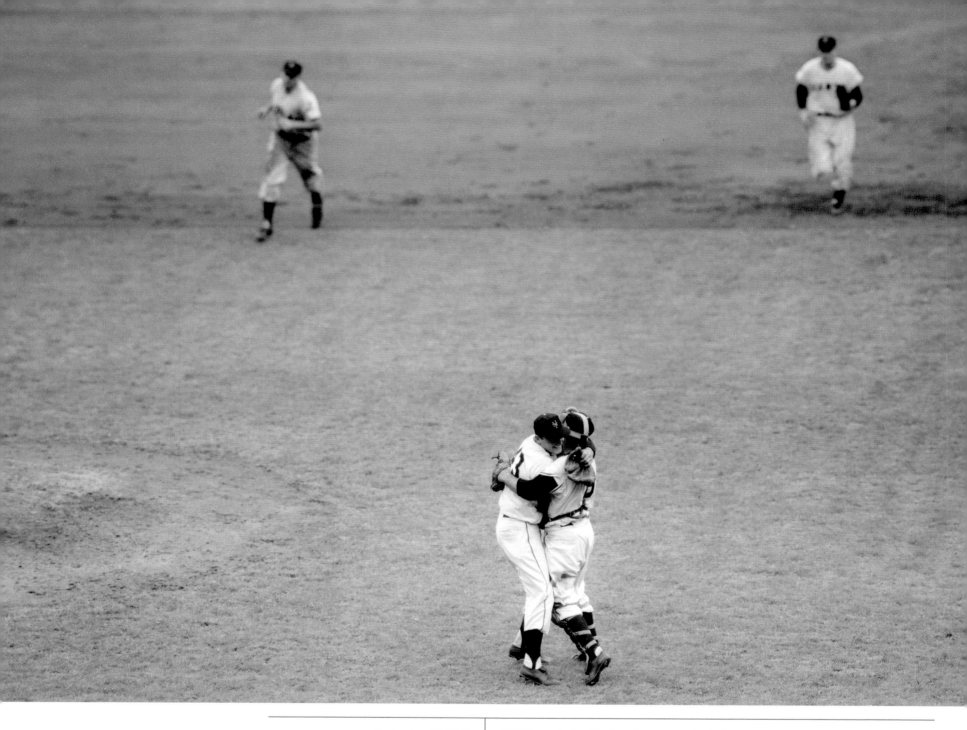

September 30, 1954
The game's over and catcher Wes Westrum
has a big hug ready for the smiling
winning pitcher, Johnny Antonelli.
Johnny fanned nine and walked six.
Fred Morgan

With the underdog Giants up two games, the Series then moved to Cleveland. In Game 3, the Giants scored six times before the Indians got a run, and Hoyt Wilhelm relieved Ruben Gomez in the eighth to get the last five outs. Indians manager Al Lopez used four pitchers and lost anyway, 6–2. On October 2, Bob Lemon returned on two days' rest to face nine-game winner Don Liddle. When Lemon loaded the bases in the fifth, with the Giants up 3–0, in came reliever Hal Newhouser, now an Indian after a Hall of Fame career with the Tigers. He walked in another run, Monte Irvin—hitting for himself for a change—singled in two more, and a seventh run came home before the inning ended. The Indians scored four times, but Wilhelm and Antonelli—who got the save—preserved the 7–4 win and the four-game sweep. For the first time since 1933, and for only the fifth—and last—time in their sixty-five years in New York, the Giants were world champions.

December 1, 1954
The New York Giants' Monte Irvin (left) hands liquor boxes to teammate Willie Mays in front of their Willmont Liquors Inc. store, located at 556 Pennsylvania Ave. in Brooklyn.
Nick Sorrentino

Mays was the league MVP, Irvin had been the RBI leader in 1951, and both Giants were well on their way to the Hall of Fame—but extra money came in handy in those days long before free-agent contracts. They were in business together for about a year; Irvin closed the store a while after Mays pulled out.

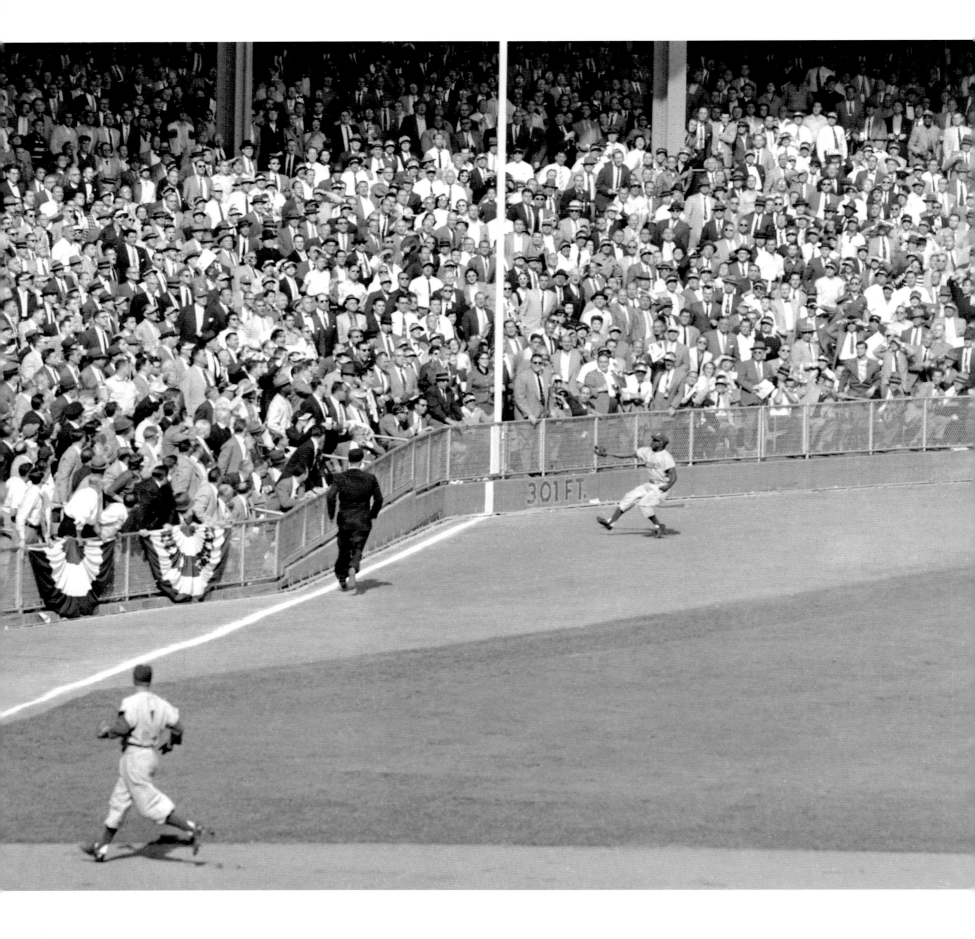

The first Brooklyn team to play in a major league, the 1872 Brooklyn Eckfords, were followed by the Brooklyn Atlantics, the Brooklyn Bridegrooms, the Brooklyn Gladiators, the Brooklyn Wonders, the Brooklyn Superbas, the Brooklyn Robins, and, finally, the Brooklyn Dodgers (short for Trolley-Dodgers, which was what their fans needed to do to reach the ball yard). What those teams had in common was their inability to win a championship. No World Series flag had ever flown over Brooklyn. The borough's most repeated sentence was "Wait till next year." They were known, affectionately, and not so affectionately, as the Bums. So when the 1955 Dodgers reached the World Series, you'd have to say they were due. Until you looked across the field and spotted the pinstripes on the other team. Which meant you'd be forced to add, Oh, no, not them, not again. The Yankees and Dodgers were meeting for the third time in four years, the fifth time in nine years. They were Yankee years, every one of them, even on those rare occasions when the Dodgers seemed to have the superior personnel. This was another of those years. The Dodgers had roared through their schedule. They won on Opening Day and the next nine games. Won twenty-two of their first twenty-four, and they were where they should have been at the end of the season, leading by thirteen and a half games. Enjoying the view from what their longtime announcer, Red Barber, used to call "the catbird seat." The Giants were never in the hunt. On September 25, Leo Durocher resigned, and the last three Giant outs of his eight-year stay came on a triple play. Casey Stengel found himself writing new names on the Yankees' lineup card. Eddie Lopat and Johnny Sain were traded, Allie Reynolds retired, Bob Turley and Don Larsen were the important new arms, and Tommy Byrne, back with the team after three forgettable years, contributed sixteen wins. Yogi Berra won his third MVP award, and his backup that year was Elston Howard, the first black to play for the Yankees—nine years after Jackie Robinson broke the color barrier. The Dodgers were getting older, but the Boys of Summer were still the core of that team. It was too soon for a nineteen-year-old rookie named Sandy Koufax to make a difference. Robinson stole home in the first game of the Series and then faded into the background. He batted only .182 and sat out the seventh game with a heel injury. On the Yankees' side, Mantle's aching left knee limited him to ten at bats. Still, the Yankees won the first two games, and Brooklyn fans couldn't have been optimistic. No team—certainly not the Trolley-Dodgers—had won a seven-game Series after dropping the first two. But when the action shifted back to Brooklyn, so did the smiles. Duke Snider had a three-run homer in Game 4 and two more homers in Game 5, and when they returned to the Bronx, the Dodgers were in charge, three games to two. And then it was 3–3, after Whitey Ford allowed only four hits and one run. Would the deciding game become another chance for the Dodgers to fail? Or would the world finally turn upside down on the Yankees? The Dodgers scored first: a run in the fourth and another in the sixth. That same inning, the Yankees came to life. Billy Martin walked, Gil McDougald beat out a bunt, and the next batter was the MVP. Berra sliced a fly ball toward the left-field line, the wrong field. Sandy Amoros, in left-center, was chasing after the ball, his glove outstretched. Miraculously, he caught up to it. His throw to the infield doubled up McDougald, and the rally was snuffed out. So were the Yankees. A day later, the entire front page of the Daily News was Leo O'Meallia's cartoon of a howling Dodger fan under the headline "WHO'S A BUM!" An exclamation point, at last.

October 4, 1955

Sandy Amoros goes racing into the left field corner to make a scintillating, one-hand grab of Yogi Berra's bid for an extra base hit in the sixth inning with two runners on base and nobody out. Ump John Flaherty is right there to make the call. Sandy, who had just gone into the game, said, "I guess I never made a better catch." But that didn't end it. Amoros made a quick recovery, fired to Pee Wee Reese and the shortstop's throw to Gil Hodges, already leaving the bag, retired the sliding Gil McDougald trying to return to first for a big double play. Martin remained on second and died there when Bauer grounded out.

Frank Hurley

The speedy Amoros had just been brought in as a defensive replacement for Junior Gilliam, who had started in left field but now shifted to his usual spot at second base, replacing the youngster Don Zimmer. Dana Mozley wrote in the Daily News that this was the "play that broke the Yankees' back" in the decisive Game 7 of the 1955 World Series between the Dodgers and the Yankees.

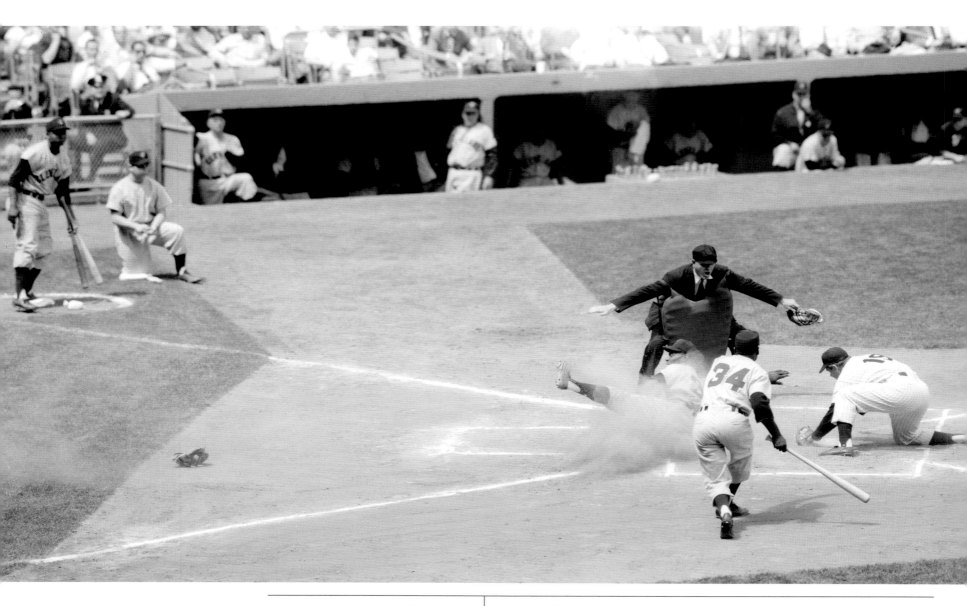

May 11, 1955
STAND UP AND CHEER!

Indians' Dave Pope, a cheering section of
one, roots teammate Al Smith home from
third on a wild pitch in the first inning of
the game at Yankee Stadium. Umpire Ed
Rommel ain't cheering. The unprejudiced
arbiter signals safe as hurler Bob Turley
makes a grab for the ball that Yogi Berra
retrieved too late. Turley, seeking his sixth
straight, was the loser, 4–3.

Charles Hoff

Turley and Don Larsen arrived after the 1954 season, in an unprecedented *eighteen*-player
trade that sent Gene Woodling—among many others—to the Baltimore Orioles. Larsen went
9–2, while Turley won 17 games. This wasn't one of Bullet Bob's gems: he gave up only three
hits and struck out eleven but also walked eight, threw a wild pitch, and hit a batter. As for
Yogi, he had twenty-seven home runs and 108 RBIs, and although he batted only .272, he hit
'em when they counted, so he earned his third Most Valuable Player award—all in a five-year
stretch. Smith hit twenty-two home runs for the Indians in 1955; Pope was part of a mid-June
trade to the Orioles for ex-Yankee Woodling and ex-Dodger Billy Cox. Cleveland won a
respectable ninety-three games but finished three behind the Yanks after a seesaw race—and
didn't get into the playoffs again until 1995. On the day of this game, the Yankees traded
away Johnny Sain and Enos Slaughter to the Athletics.

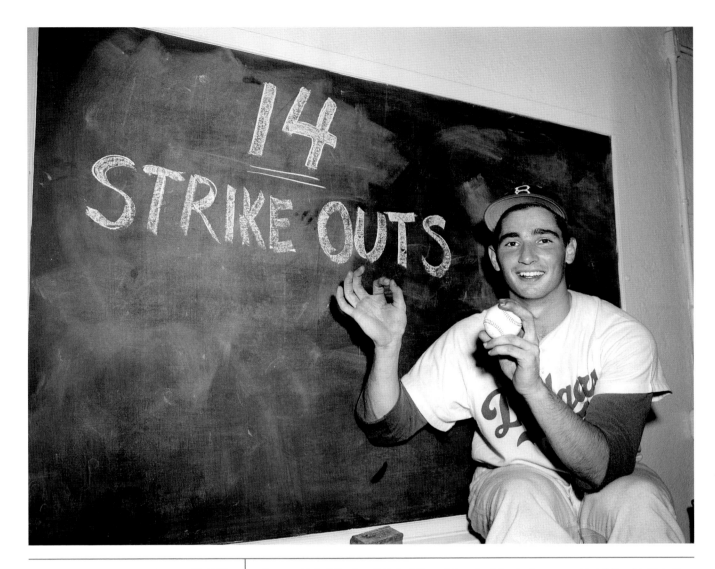

August 27, 1955
Sandy's 14 strikeouts was high for
the season.
Charles Hoff

It was a hint of the far-off Hall of Fame future for this nineteen-year-old rookie, who gave up only one hit in the first inning and one in the ninth for his first major-league win, 7–0, against the Braves (with the help of home runs by Carl Furillo and Jackie Robinson). In the *Daily News,* Dick Young called him "The bonus baby with the man-sized fast ball." Because of bonus-contract rules, he couldn't be sent down to the minors to learn his craft, so he usually just sat on the bench. (Some said he was too young and too wild, others that anti-Semitism was also a factor.) When he did get into a game, it was usually as a reliever; he made his debut on June 24, in Milwaukee. In his first start, on July 6 in Pittsburgh, he left the game in the fifth with the score tied—and was out for three weeks with a sore back. But the Dodgers' staff had a lot of sore arms, and Walter Alston decided to give Koufax another start after seeing him throw eight straight strikes in a recent game. He had three more starts, in September, and finished his first season 2–2, with a 3.02 earned run average.

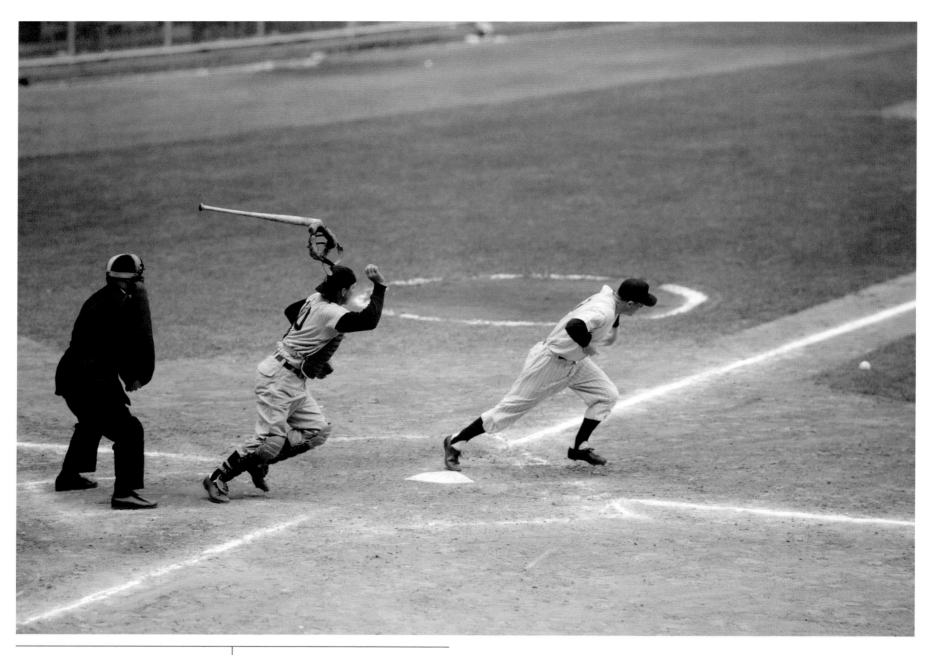

September 9, 1955
GAME'S UP IN THE AIR
Yanks' McDougald streaks for 1st after laying down perfect bunt in 4th. His bat and catcher Lollar's mask fly through the air together.
Tom Watson

Then Berra walked, Mantle struck out, and Joe Collins hit a three-run home run. With another homer as well, Collins accounted for four of the five runs in the 5–4 win over the White Sox, which put the Yankees into a tie for first with Cleveland. Onetime Yankee Sherm Lollar was with Chicago for a decade. On April 23, he had two hits in one inning—then did it again, something only two major leaguers had done before— and his two home runs and five RBIs were part of the Sox's 29–6 shellacking of the Kansas City Athletics. Chicago finished in third place, five games out of first.

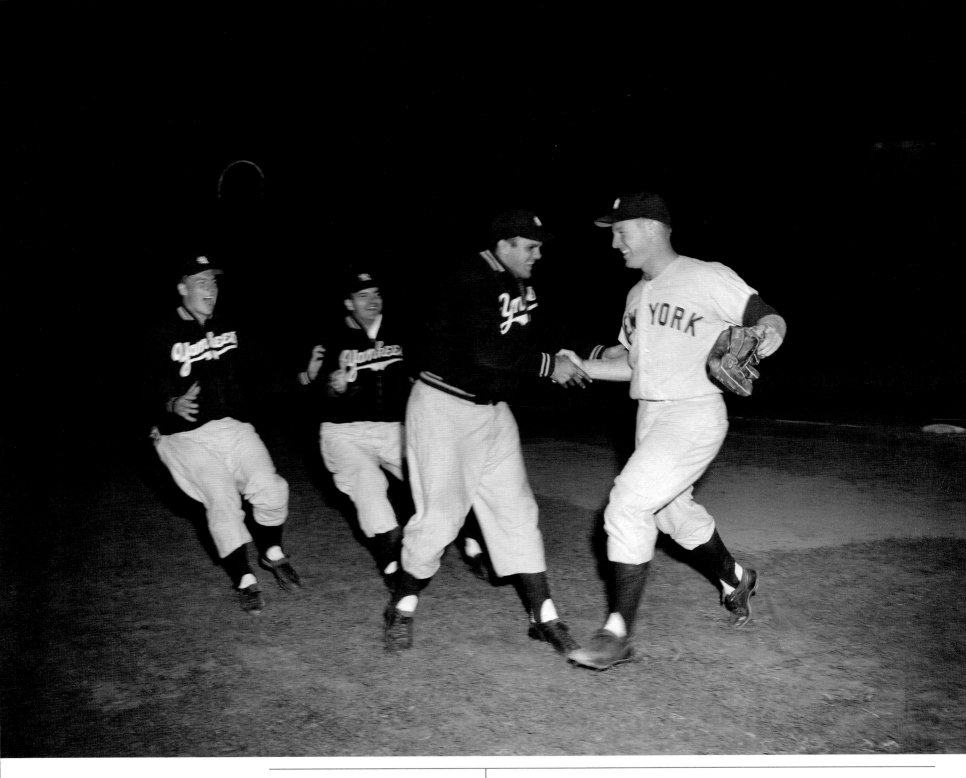

September 23, 1955
Charles Hoff

To congratulations from Bill "Moose" Skowron and other teammates, number one starter Whitey Ford leaves the mound after the last pitch of the pennant-clinching 3–2 defeat of the Red Sox. Boston had won the opener of the doubleheader and loaded the bases in the seventh, when Ford came on in relief of Don Larsen and pitched a double-play ball to Ted Williams. The *Daily News* noted that the first photographs of the victory in Boston—the Yankees' sixth flag in seven years—were taken at 11:10 P.M. and reached the newspaper office in New York two and a half hours later.

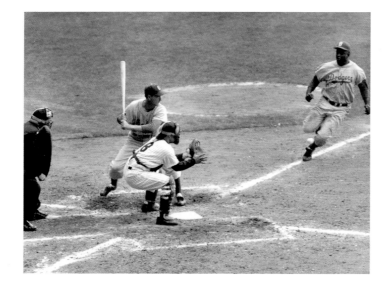

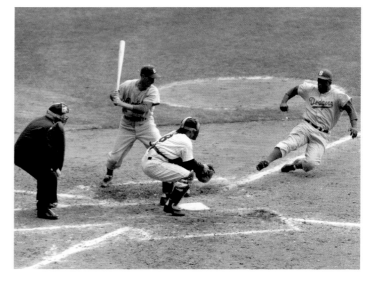

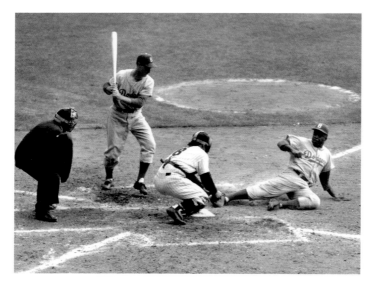

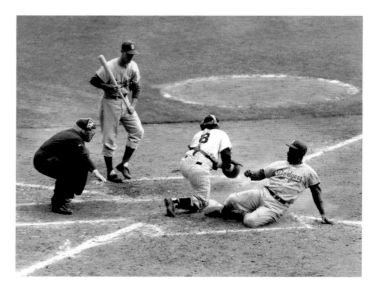

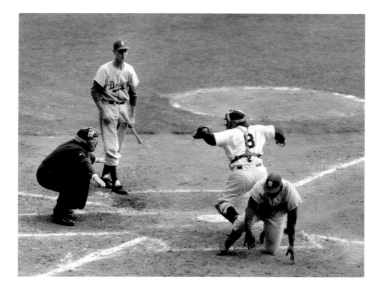

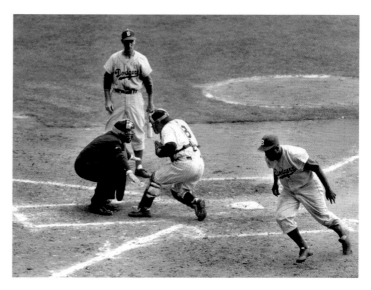

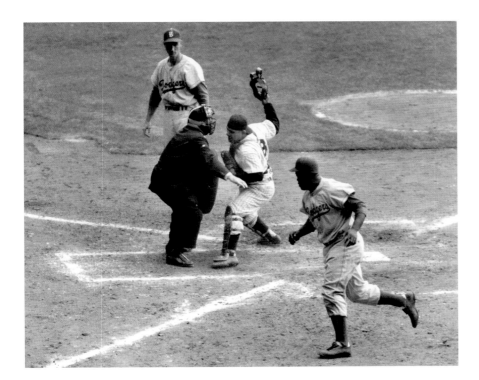

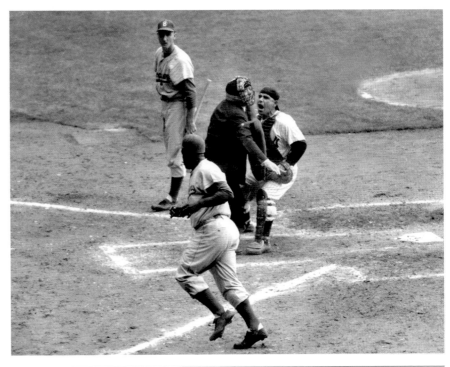

September 28, 1955
YOGI HAS IT OUT

Jackie Robinson, with two out in the eighth inning and the Dodgers trailing, 6-4, in the Series opener at the Stadium, tries to steal home. Frank Kellert, the batter, steps aside as Whitey Ford pitches low. Yogi Berra puts his mitt in front of the plate in Robby's path. It's close. Ump Bill Summers, behind Berra, calls Robby safe. Berra calls Summers a lot of things. The camera seems to agree with Yogi.

Frank Hurley

In his article in the *Daily News,* Joe Trimble called Robinson "gray, fat and 36"—but the disputed steal made it a one-run game. However, Bob Grim relieved Ford and held off the Dodgers in the ninth. In the end, home runs by Furillo and Snider couldn't match Joe Collins's two homers (and three RBIs) and a two-run shot by backup catcher-outfielder Elston Howard—the first black to play on the Yankees. Game 1 went to the Yankees, 6–5.

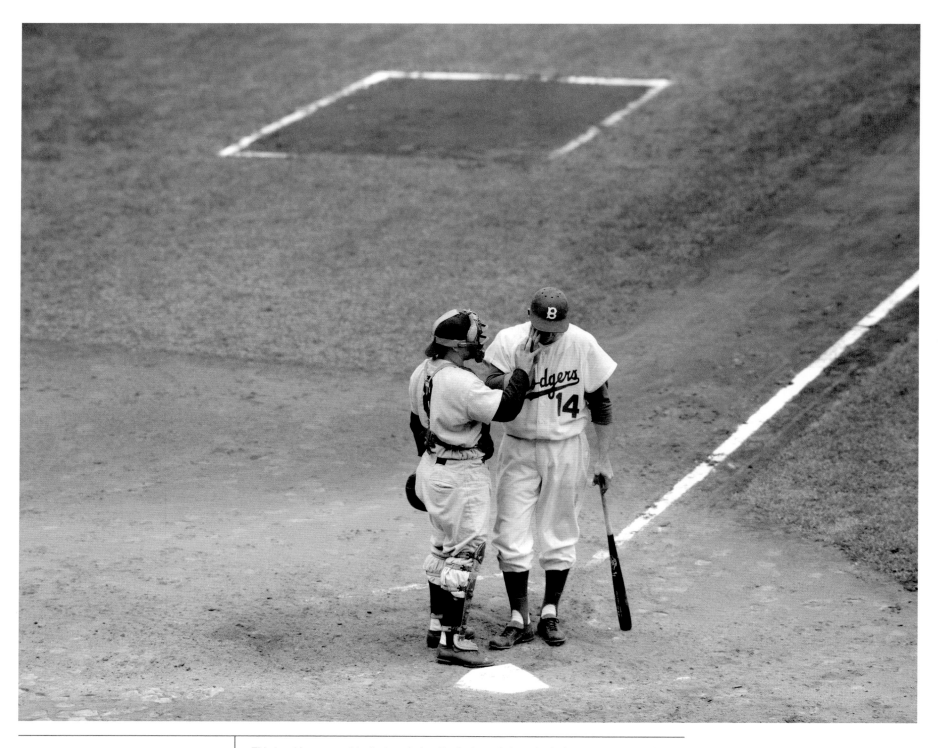

October 1, 1955

YOGI FEELS FOR HIM

Yanks' Yogi Berra puts his hand to
Gil Hodges' face after the Brook first
sacker was hit by foul off his own bat
in 2nd. Gil stayed in the game to
blast two singles and homer.

Charles Hoff

This touching moment took place *before* the Dodgers tied up the Series at two games apiece.
The Yankees had won Game 2, 4–2 (Tommy Byrne over Billy Loes), with all four runs coming
in the fourth inning. However, slugger Hank Bauer pulled a muscle trying to steal second; like
the injured Mantle, he then spent most of his time on the bench. At Ebbets Field, Snider and
Campanella led the Dodgers on a tear, with thirty-four hits, seven home runs, and twenty-one
runs by the team over the three games there. In Game 3, Johnny Podres—on his twenty-third
birthday—and the Dodgers beat Bob Turley and the Yankees, 8–3.

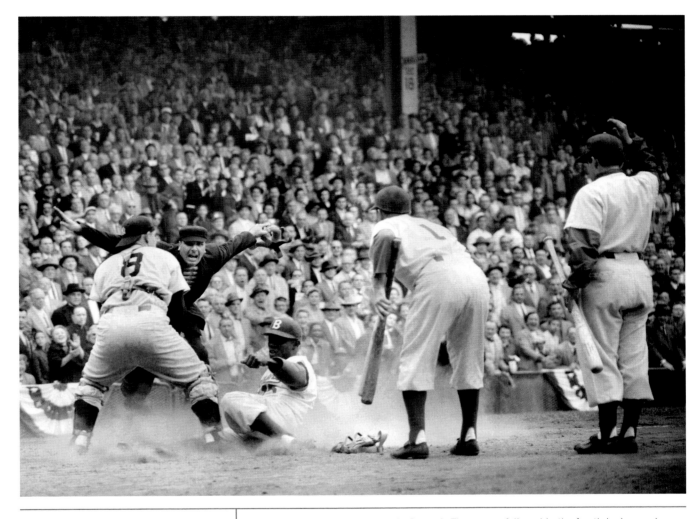

October 1, 1955
HAPPY HOME-COMING

Flock's Sandy Amoros slides over the plate on Gilliam's 3d-frame double. Yogi Berra stands astride the plate with the late throw from Elston Howard. Ump Frank Dascoli gives an emphatic "safe" signal.
Bill Meurer

This was the Dodgers' first run in Game 4. Three more followed in the fourth inning, and another three in the fifth. Although McDougald homered for the Yankees (as Mantle had in Game 3—one of only two hits by the injured slugger, in ten Series at bats), the Dodgers won again, 8–5, with Clem Labine beating Don Larsen. The Yankees' starter came out in the fifth, just before Snider's three-run homer off reliever Johnny Kucks, a rookie.

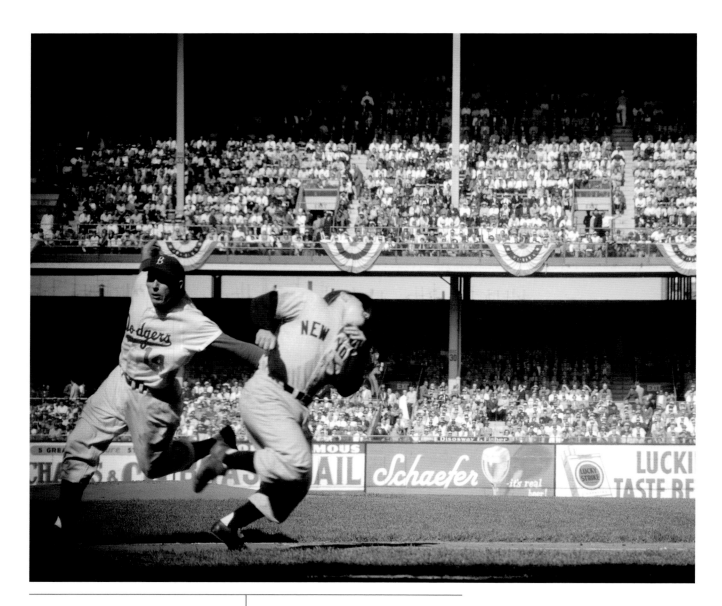

October 2, 1955
Gil Hodges lunges to tag Yogi Berra as the Yankee backstop tries to squirm out of the way on his first-inning roller. Yogi bashed a homer and single in losing cause.
Bill Meurer

By the fifth inning of Game 5, the Dodgers had built a 4–1 lead on two home runs by Snider and one by Amoros. Backup outfielder Bob Cerv pinch-hit a home run for the Yankees in the seventh.

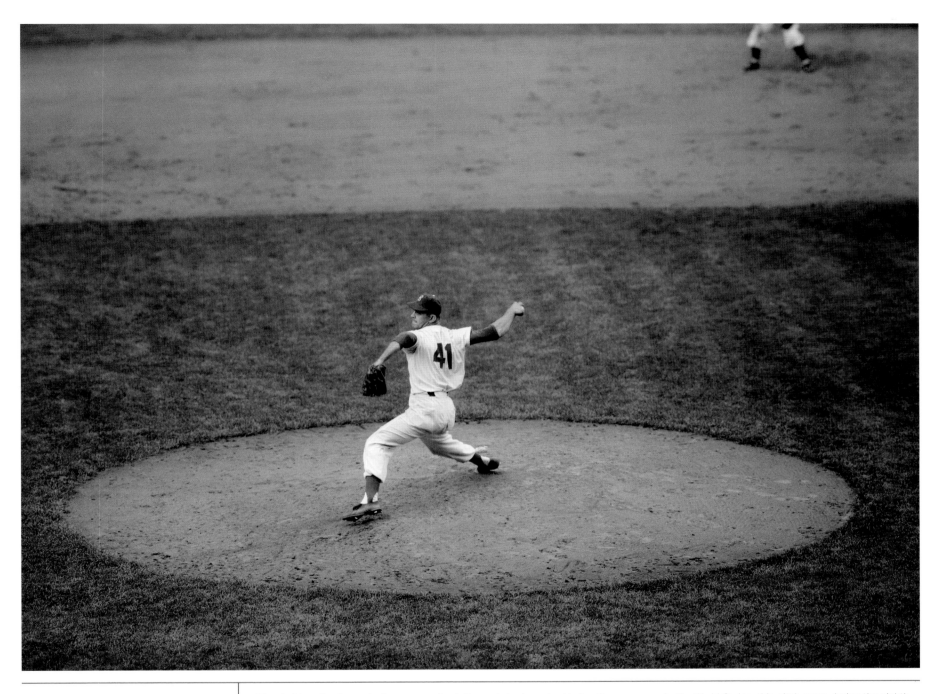

October 2, 1955
Charles Hoff

Clem Labine, the Game 4 winner, came back the next day to make his fourth appearance in the World Series; this pitch came during the eighth inning, when Yogi got a home run. But the Dodgers also added a run in the eighth, and the final score was 5–3, with rookie five-game winner Roger Craig getting the credit and Game 1 saver Bob Grim taking the loss. A record World Series crowd at Ebbets Field—36,796 fans—saw the Dodgers take the lead, three games to two. Game 6 was back in the Bronx. Moose Skowron belted a three-shot blast, and before the first inning was over the Yankees had scored five times. The Dodgers' starter was eight-game winner Karl Spooner, who had struck out fifteen in his major-league debut in September 1954—then struck out twelve more, four days later. But he injured his arm in spring training in 1955. In Game 6, he lasted only one-third of an inning. Spooner took the loss, and he never appeared in another major-league game.

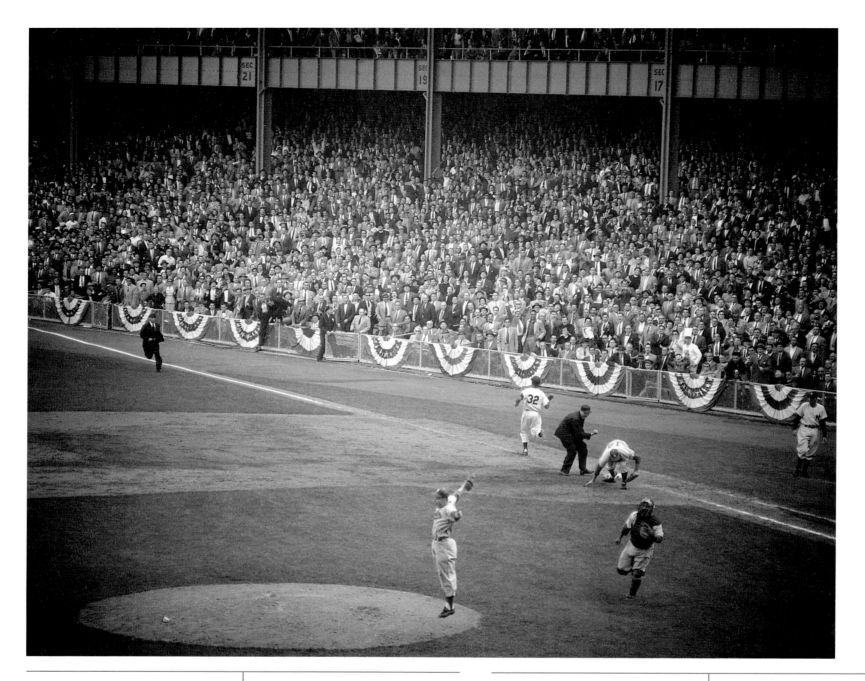

October 4, 1955
As Elston Howard (32) is retired for last out
of series. Podres leaps for joy at mound.
Charles Payne

Game 3 winner Johnny Podres was in Game 7
from beginning to end. The Yankees starter
was Game 2 winner Tommy Byrne. The thirty-
five-year-old was back with the Yankees, where
he'd started, after a four-year exile, and his
16–5 record led the league in winning
percentage. In Game 7, he pitched another
five-hitter—but this time it wasn't enough.

October 4, 1955
The electric tension snaps, and Hoak
(left), Podres and Campy converge to
whoop up the 2–0 win.
Frank Hurley

The Dodgers scored in the fourth inning
when Campy doubled and Hodges singled
him home. In the sixth, Reese, Snider, and
Furillo loaded the bases, and Hodges's sac-
rifice fly off fresh reliever Bob Grim
brought in the second—and final—run of
the game before Grim ended the rally.
Podres scattered eight hits and two walks,
but the Yankees couldn't bring anyone
home. The closest they came was Berra's
fly ball to Sandy Amoros in the sixth
(see page 144).

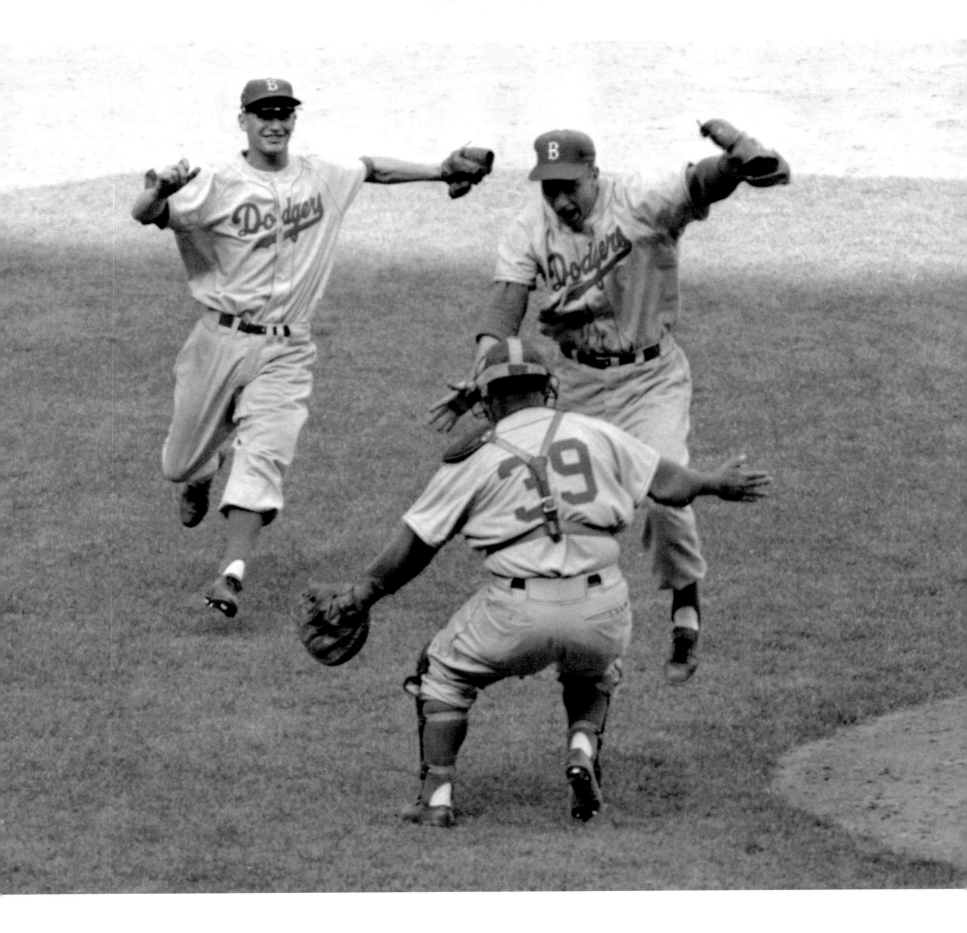

October 4, 1955
WOTTA DAY!

All messed up from "beating" taken from teammates on field and in dressing room after game, Johnny Podres catches breath after the most hectic day in his 23 years. His second complete World Series game and the clincher a shutout. That's livin'.

Wally Seymour

The caption accompanied a similar clubhouse close-up, shot by Al Pucci. The sixth try was the charm: the Brooklyn Dodgers—also-rans against the Yankees in 1941, 1947, 1949, 1952, and 1953 (along with World Series losses in 1916 and 1920)—were finally the world champions. And they became the first team since the 1921 Giants (in a best-of-nine setup) to win the World Series after losing the first two games.

October 4, 1955
Dodger fans do some wild celebrating on
Flatbush Ave., near Dekalb.
Paul Bernius

The page 3 headline over the photo was "Brooklyn Pinches Itself, Goes Crazy." Art Smith's article on the reaction began, "Everything was crazy in Brooklyn last night. . . . Saloonkeepers gave away booze to guys they never saw before. . . . Candy store owners played the big treat to neighborhood kids who'd been robbing them for years. . . . Women kissed neighbors they wouldn't be caught dead talking to. . . . Never before had Brooklyn, that borough of perennial October gloom, gone so joyously screwy, so hysterically daffy, so ecstatically nuts. . . . Because that, at long last, was Next Year!" Smith described paper and bags of water being hurled out of office-building windows, and he added, "And then, as churchbells clanged all over town and whistles along the waterfront boomed and shrilled, streams of delirious humans, or reasonable facsimiles, poured into Brooklyn's streets." The celebrating lasted through the night.

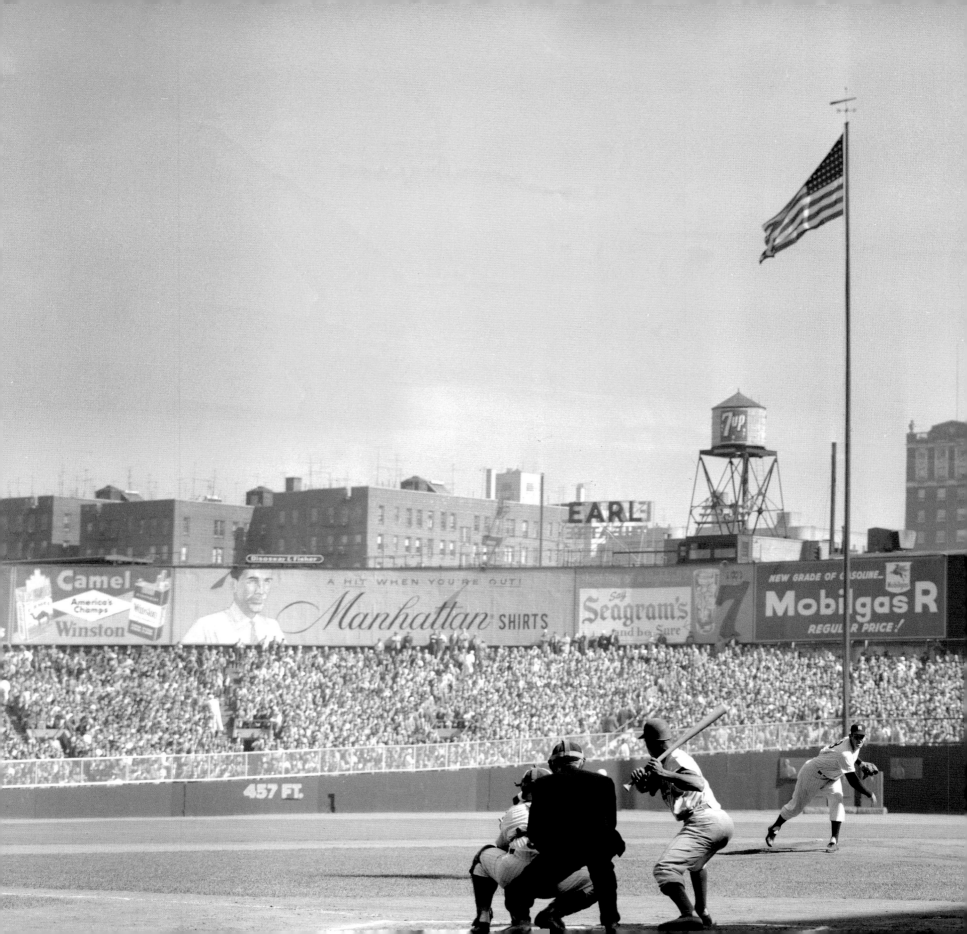

Do not—repeat—do not make the Yankees angry. Do not take away their October celebrations. Do not expect them to walk off into the sunset. The Yankees represented the American League in seven World Series from 1943 to 1953 and were nothing but successful. If they had kept up that dominating sort of thing, baseball might as well have stored all the bats in a broom closet and turned off the stadium lights, and October excitement would have consisted of watching the leaves change color. But the Yankees couldn't win the pennant in 1954. A year later, they lost the World Series. So 1956 was their angry year. They won seven of their first eight games and moved into first place in mid-May, never to leave. Mickey Mantle's stock, improving each year, exploded. He won the Triple Crown (.353, fifty-two homers, 130 RBIs) and crashed another of those home runs people still talk about. On May 30, swinging against Washington's Pedro Ramos, Mantle's astounding poke kept rising until it slammed against the right-field facade, the last piece of real estate that would keep a ball from leaving Yankee Stadium. Another Washington pitcher, the splendid Camilo Pascual, shouldn't have been surprised. He pitched against the Yankees in seven games that year and lost them all. Mantle's fiftieth home run came with two weeks left in the season and clinched a pennant race that was always a runaway. Whitey Ford, Mantle's after-hours pal, won nineteen games, and his earned run average was the lowest in the league. One great Yankee wouldn't have considered it a successful season: Phil Rizzuto, thirty-eight, was released on Old-Timers Day. Curiously, the town's other superstar, Willie Mays, put up some of the least impressive of his New York numbers. So it was hardly a surprise when the Giants, world champions only two years earlier, finished a mere seven games out of last place. The Dodgers, on the other hand, kept winning. They beat out the Braves and Reds, in a down-to-the-end struggle, receiving significant help from an old enemy, pitcher Sal Maglie, who had battled them for so long with the Giants. He won thirteen, tossed a no-hitter, and kept winning in the Series opener. The Yankees led the next game by six runs, but the Dodgers took that one too. The pitcher responsible for giving away that lead was Don Larsen, who, after the Yankees had tied the Series, returned to start Game 5. Nine innings later, Larsen was still on the mound, three outs away from a perfect game. Carl Furillo led off with a fly ball to right. Roy Campanella's second swing produced a grounder to second. Dale Mitchell, pinch-hitting, watches ball one and then strike one. He swings and misses, and fouls one off. The next pitch, with Mitchell's bat still on his shoulder, completes the perfect game. Somehow, the Dodgers bounced back the next day when Clem Labine, who started only three games that season, won 1–0 in ten innings. Game 7 isn't the one anybody remembers. Nine runners crossed the plate, and every one of them was wearing pinstripes. Just like old times.

The caption accompanied Charles Hoff's profile shot of the same moment. In Game 5 of the World Series against the Dodgers, it took Larsen only ninety-seven pitches, starting with this one against Junior Gilliam (who went down on a called third strike), to make history. Game 1 winner Sal Maglie—who had thrown a no-hitter on September 25—was just a little less perfect, giving up five hits and two runs, including an RBI single by Bauer and Mantle's third homer of the Series. Mantle also caught Hodges's sinking line drive in the fifth, and third baseman Andy Carey and shortstop Gil McDougald made fine defensive plays too. The famous final strike—for the last of seven strikeouts—was called by umpire Babe Pinelli, a veteran working his last game behind the plate. A crowd of 64,519 followed every pitch. Even in the regular season, perfection hadn't been achieved since April 1922—but for a World Series game, before or since, Don Larsen's day is unique.

April 17, 1956
IN BROOKLYN, EVERYBODY IS A FLAG-WAVER
In Ebbets Field, Dodger captain Pee Wee Reese and manager
Walt Alston (right) lovingly unfurl banner emblematic of World Series victory.
Flag was raised with appropriate ceremonies, but Phils provided
a discordant note by winning, 8-6.
Al Pucci

Opening Day began with a parade for the first-time world champions, along Flatbush Avenue in Brooklyn. Starter Don Newcombe gave up five runs in the third inning, but he went on to become the league's MVP, with a league-leading won-lost record of 27–7. He also won the first Cy Young Award, then given out to a single pitcher in the majors. One of the players making a major-league debut in the game was the Dodgers' future pitching star Don Drysdale, who went 5–5 in his rookie season. In the fourth inning, Junior Gilliam got an inside-the-park home run—which Dick Young called "a real rarity in this confined plot"—when the ball took a "weird hop" away from the Phillies' Richie Ashburn in left-center field.

May 26, 1956
ACCIDENT PRONE
Willie Mays lies on ground after being hit
over eye by thrown ball during pre-game
practice at PG. Hank Thompson comforts
Mays as Wayne Terwilliger (cap in hand)
stands by. Injury isn't considered serious.
Charles Hoff

The *Daily News* noted that Mays was "meandering between Daryl Spencer, the thrower, and Al Dark as they played catch." He reluctantly sat out the game, applying ice wrapped in a towel, as the Giants lost to the Dodgers, 6–0. Mays went on to hit thirty-six home runs for the season and was the league leader in stolen bases, with forty. On the other hand, first-year manager Bill Rigney led the Giants to a sixth-place finish, twenty-six games out of first. In mid-June, longtime shortstop Alvin Dark, a future manager of the Giants (and other teams), was sent to the Cardinals as part of a big trade, and Spencer replaced him at short.

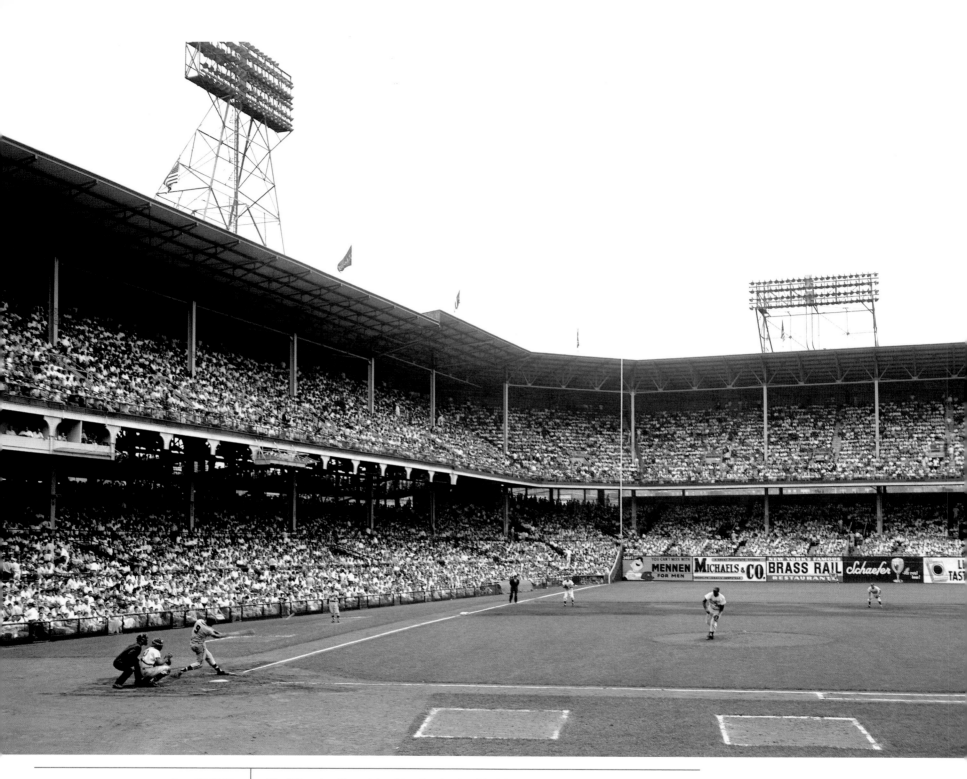

June 17, 1956
Walter Kelleher

The Milwaukee Braves' Joe Adcock unleashes his third home run in a doubleheader against the Dodgers at Ebbets Field, in the second inning of the second game. On Fred Haney's first day as manager, the Braves won both games, 5–4 and 3–1. The second homer by Adcock—an often-injured, often-platooned power hitter who slugged thirty-eight for the Braves in 1956—was "an unprecedented drive onto the roof of the double-decked left stands," as Dick Young observed, and it broke a tie in the ninth opening of the opener. In Haney's four years at the helm, the Braves finished second twice, won the pennant twice, and became world champions once.

September 26, 1956
Richie Ashburn leaps high against the
right field fence trying to collar Snider's
drive in first. But the ball hit above
Richie's outstretched glove and scooted
away from Valo (15). Duke got inside-the-
park homer.
Charles Hoff

After the ball (under the large "O" in the Bulova sign) eluded Ashburn and right fielder Elmer
Valo, left fielder Del Ennis chased it down and fired home, but not in time. Snider hit another
home run and a double, but the fifth-place Phillies won anyway, 7–3, and the Dodgers were
still a game behind the Braves. The Dodgers won only by defeating the seventh-place Pirates
in all of their last three games; they didn't clinch the pennant—by one game—until the last
day, when two homers each by Sandy Amoros and Duke Snider helped the team beat the
Bucs, 8–6.

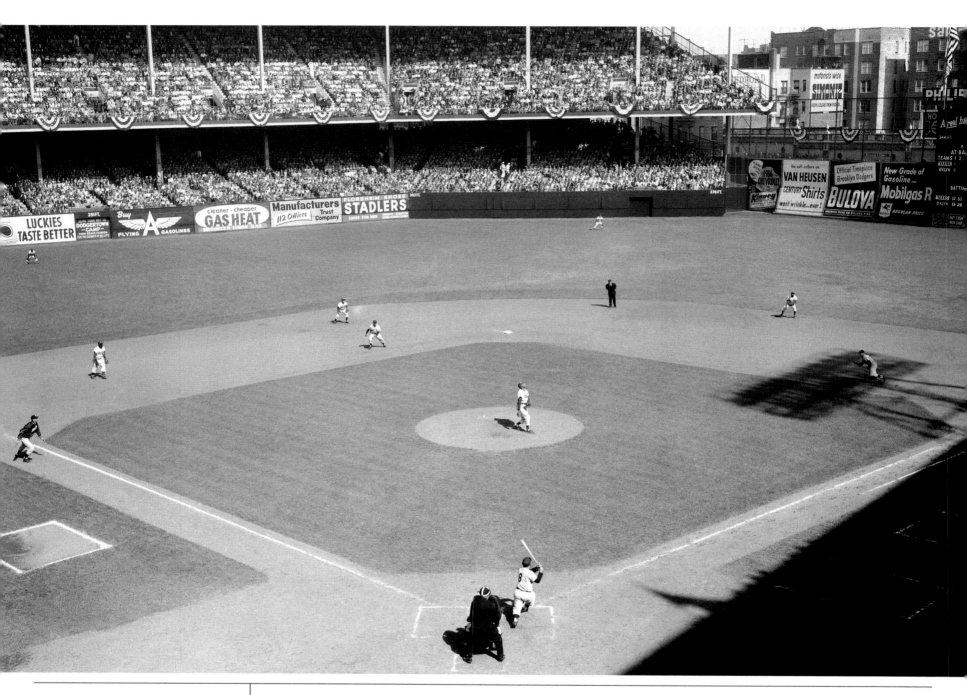

October 5, 1956
The big moment for the Yankees arrives in
second inning as Yogi Berra follows
through after swatting grand slam homer,
the fifth in World Series history.
Ed Peters

Don Larsen was off third (not far from Jackie Robinson, in his tenth and final season), Enos Slaughter (who had been given Phil Rizzuto's spot on the roster) had the lead off second (near Pee Wee Reese), and 1956 Triple Crown winner Mickey Mantle was moving from first (toward Junior Gilliam) as Berra knocked Don Newcombe out of Game 2 with this shot at Ebbets Field. This gave Yogi four of his record-setting ten RBIs in the World Series. Larsen was also wild, however, and he came out as the Dodgers were countering with six runs in the bottom of the second to tie the score.

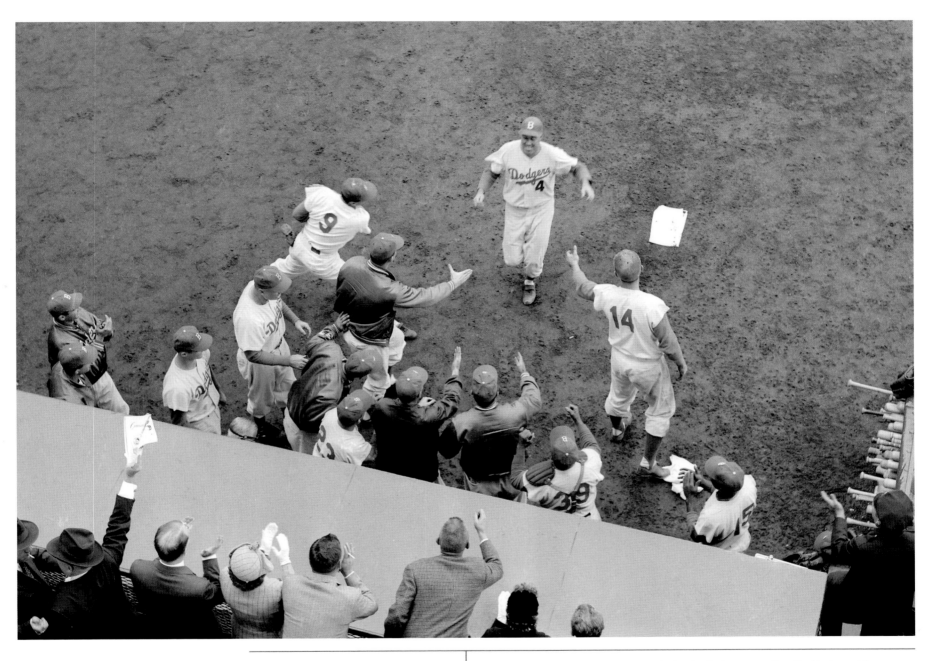

October 5, 1956
Duke Snider's a happy guy as he's mobbed
by mates after three-run homer (off lefty
Byrne) tied score at 6-6.
Charles Hoff

Berra's Game 2 grand slam seemed to ignite the Dodgers more than the Yankees. After the eleven-run second inning (by the two teams), the Yanks scored only twice more, with Don Bessent pitching seven innings of relief to get the win, while the home team faced five Yankees relievers and picked up seven more runs over four innings. The 13–8 final score gave the defending champions a two-game lead (they'd won the opener 6–3).

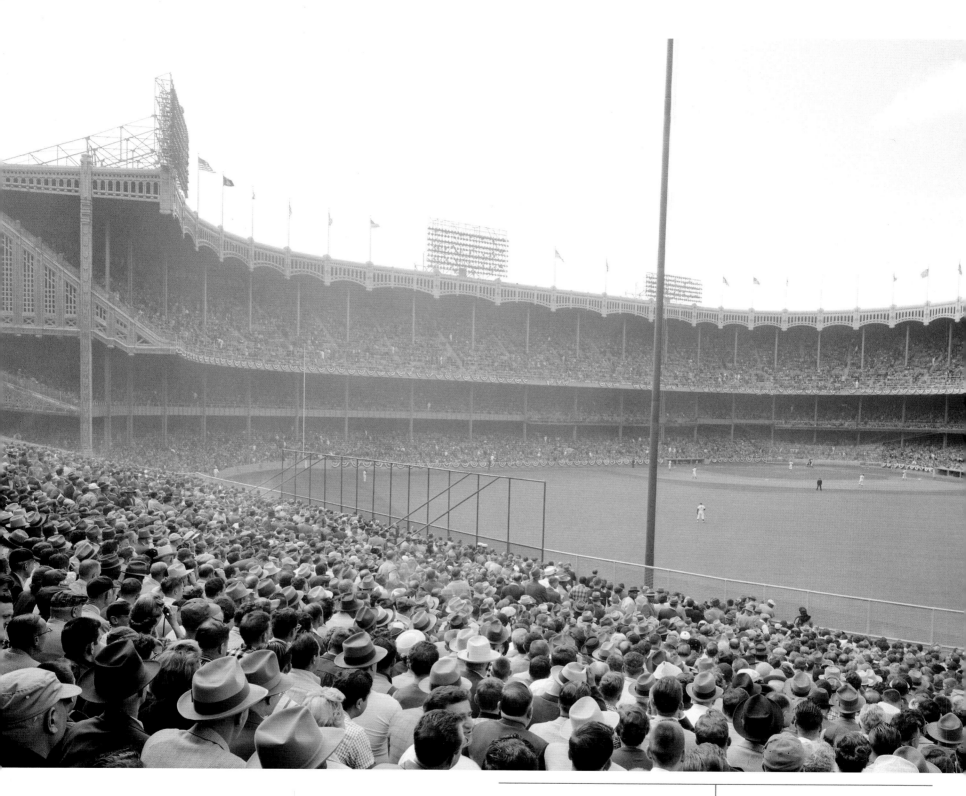

October 6, 1956
View from center field bleachers points
out tremendous gathering. 73,977 fans,
largest crowd in New York since World
Series game in 1947.
Al Pucci

Game 1 loser Whitey Ford was back on two
days' rest, facing Roger Craig for Game 3
instead of Sal Maglie. This time only
Yankees—Martin and Slaughter—homered.

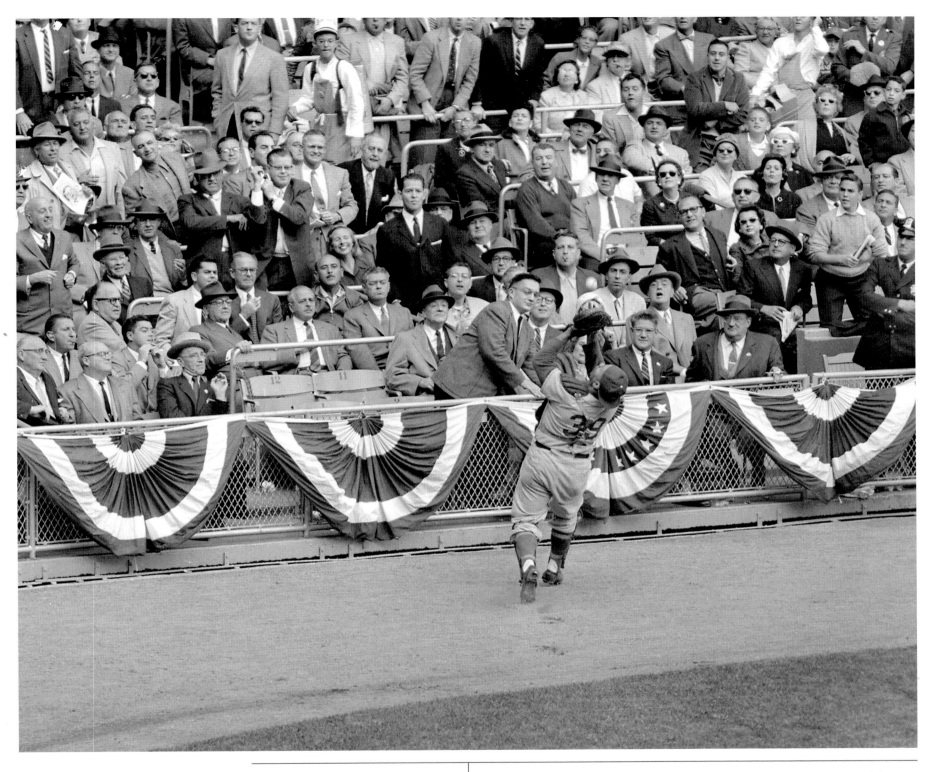

October 6, 1956
Campanella snares Mickey Mantle's foul
pop in third with approval of Dodger
president Walter O'Malley (right, front)
and Brooklyn Borough President John
Cashmore (behind O'Malley).
Frank Hurley

Game 3 remained in a 1–1 tie until the sixth inning, when the Dodgers got a run and the forty-year-old Slaughter—the oldest player in the Series and, in the first three games, the hottest hitter—responded with a three-run homer. Each team managed one more run, for a 5–3 outcome and the Yankees' first victory in the Series. Ford scattered eight hits in his complete-game win.

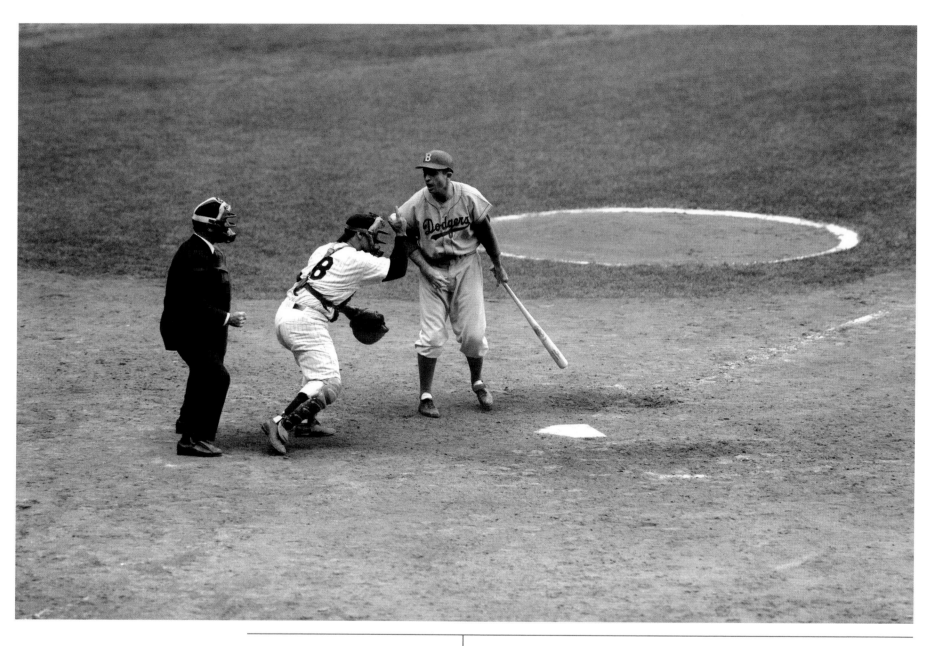

October 7, 1956
"What-a-at did you say? ? ?" is Randy
Jackson's expression as he turns on Ump
Napp as latter called him out on strikes in
9th with bags loaded. Berra waves ball
triumphantly.
Charles Hoff

Tom Sturdivant (16–8 in his second season) got the next Yankees win with a six-hitter in Game 4, evening the Series. The home runs came from Mantle and Bauer. In the ninth, with the Yankees up 6–1, Robinson doubled and came home when Campanella singled after Amoros and Furillo walked. With one out and the tying run at the plate, Stengel walked to the mound, but he left in his starter. Sturdivant took care of Jackson, a pinch hitter, with a high fastball and then got Junior Gilliam to hit a soft fly ball to Mantle, ending the game. Carl Erskine, who had pitched a no-hitter in May, took the loss. (For Game 5, see page 161.)

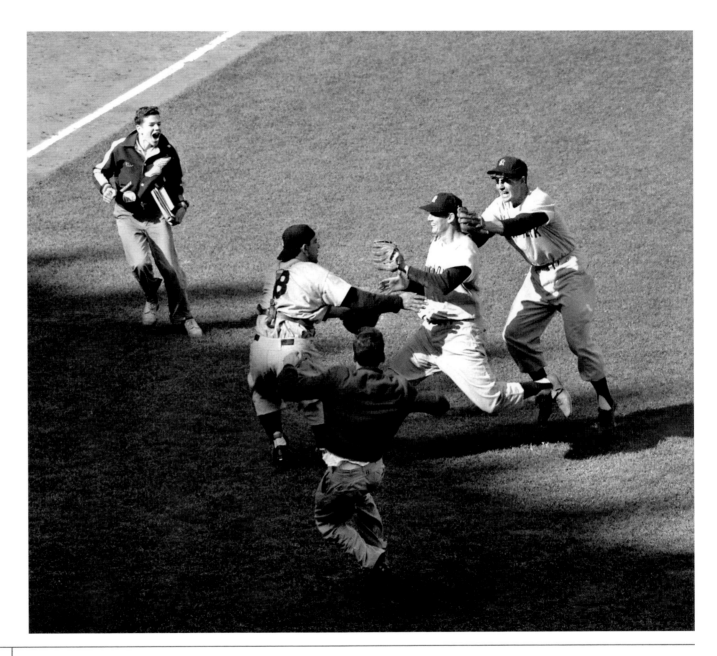

The caption accompanied a similar photo of Berra (8), Kucks (center), and others celebrating after winning Game 7. The Yankees got to this moment after the Dodgers, playing back at Ebbets Field, stayed alive in Game 6—and evened the Series—when Jackie Robinson singled home the sole run of the game, in the tenth inning. (Two months later, O'Malley sold his contract to the Giants, and Robby decided he'd rather retire.) Bob Turley gave up only four hits but took the loss; Labine got the win. All six Series games had been won by the home team. And the finale was also in Brooklyn. But Kucks (an eighteen-game winner, who tailed off badly after 1956 and was traded to the Athletics in early 1959) pitched a three-hit shutout. And the Bronx Bombers went on a rampage: Berra had two two-run homers and Elston Howard had a solo shot to knock Don Newcombe out of the game, and Moose Skowron capped it off with a grand slam off Roger Craig in the seventh. With this 9–0 massacre, the Yankees recaptured the World Series crown.

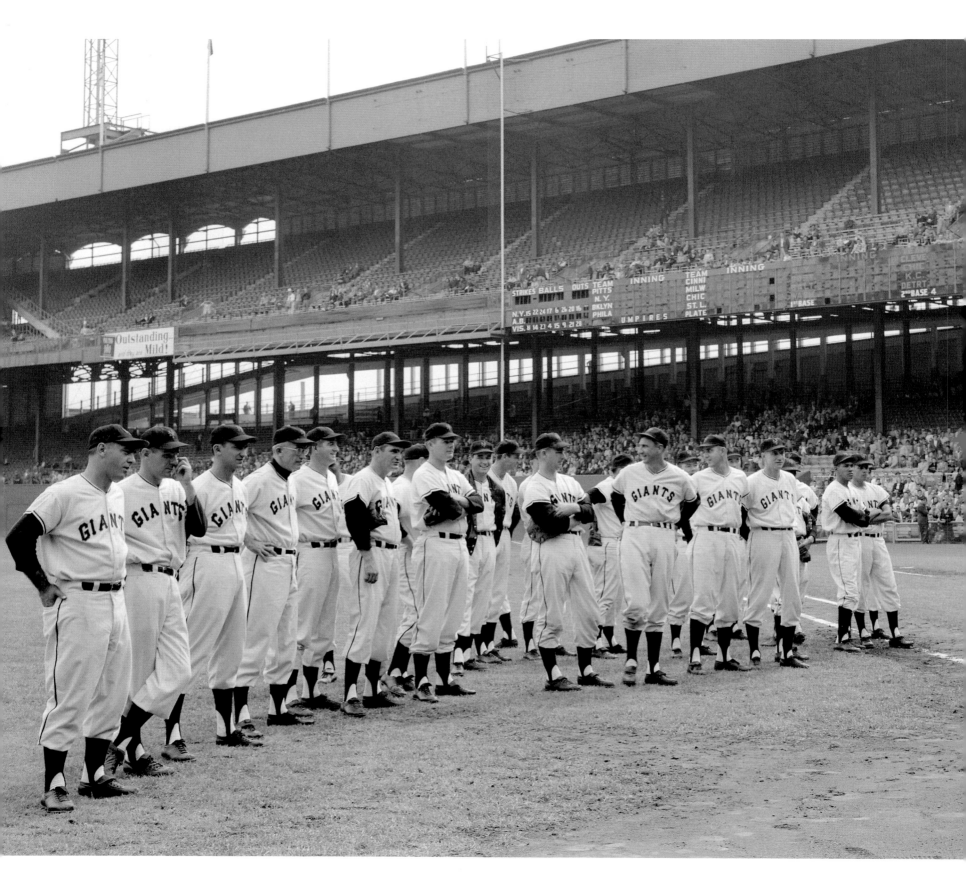

Brooklyn without the Dodgers? The Polo Grounds without the Giants? It happened the instant the clock struck 12 on the 1957 season. A year earlier, nobody had paid much attention when Walter O'Malley, the Dodgers' owner, moved seven of his team's games out of Brooklyn and into the minor-league stadium at Jersey City. O'Malley kept saying he needed a new ballpark for Brooklyn, and he even volunteered to pay all the bills for the right location. But the local politicians, like wide receivers heading out-of-bounds, were dragging their feet. There were new promises, hopeful headlines, but very little movement. The offers from Los Angeles—anything you want, Walter, old buddy, old pal—were mighty attractive. The Yankees stayed on the sidelines, winning as usual. The first week in June, the White Sox were six games in front of the Yanks. Three weeks later, the Bronx team was in first to stay. Mickey Mantle had a second straight MVP year, and the new double-play combination, Tony Kubek and Bobby Richardson, made impressive debuts. Whitey Ford, hampered by a shoulder injury, won only eleven games, but five other pitchers won ten or more. The Dodgers had more than geography problems. Their longtime stars—Jackie Robinson, Pee Wee Reese, Roy Campanella, Carl Furillo, and Don Newcombe—were wearing down. The twenty-year-old Don Drysdale was their most reliable starter, winning seventeen, and Sandy Koufax, still learning, was beginning to get regular work. The Giants' season was another flat time. Willie Mays, who batted .333, was about the only reason to make the trip to the Polo Grounds. On September 29, Dusty Rhodes, the hero of the 1954 Series, made the last out, and the Giants were all through playing in New York. San Francisco, here they come. Only 11,606 spectators can honestly say they paid their way in. Five days earlier, in front of 6,702, the Dodgers had closed Ebbets Field by beating Pittsburgh. The World Series turned out to be another right hand to New York's chin. The National League team, the Milwaukee Braves, four years removed from their Boston roots, weren't supposed to give the Yankees much trouble, even though Hank Aaron led the league in home runs and RBIs, Eddie Mathews added more power, and their ace, Warren Spahn, won his usual twenty-one games. Spahn, who led off the Series, his first since 1948, was overshadowed by teammate Lew Burdette, who began his career in the Yankees' minor-league system. After Ford beat Spahn with a five-hitter, it was Burdette's turn to win. He was nicked for single runs in the second and third innings but then, incredibly, would spend his next twenty-four innings giving up no runs at all. The Yankees won Game 3 in Milwaukee and pushed across a tenth-inning run to take the lead in Game 4. The series was going as expected—another half inning and the Yanks would be in front three games to one—until Tommy Byrne threw a pitch to Milwaukee's Nippy Jones that sailed to the backstop. The umpire, Augie Donatelli, called it a ball, but Jones insisted the baseball had hit his shoe. He showed the ump a black smudge on the ball and claimed it was shoe polish. Donatelli changed his call to hit by pitch. A double sent Nippy home, tying the score, and Mathews followed with a game-winning home run. Burdette edged Ford, 1–0, the next day, and after the Yankees came back to take Game 6, it was Burdette again in the finale. Casey Stengel's choice, Don Larsen, the perfect man, couldn't get out of the third inning. Burdette, pitching on two days' rest, threw another shutout. And the World Series flag, for the first time since 1948, was flying in a city other than New York. The city's golden time was over, but it sure was fun while it lasted.

It didn't matter, but the Pirates won the game, 9–1; Johnny Antonelli—who had won twenty-one games in 1954 and twenty in 1956, took the loss and finished the season 12–18. For the second straight year, the Giants wound up twenty-six games out of first. Except for that championship season back in '54, attendance at Giants games had steadily fallen from nearly 1.6 million in 1947 to well below 700,000 in 1956 and 1957. The story in Brooklyn was nearly as bleak—going from 1.8 million to stagnation at just over 1 million. (The Yankees were also way down from pre-television annual figures of more than 2 million in 1947–50, but they were holding firm at about 1.5 million fans a year in 1953–57.) And so the Giants and the Dodgers abandoned New York City for the promise of California.

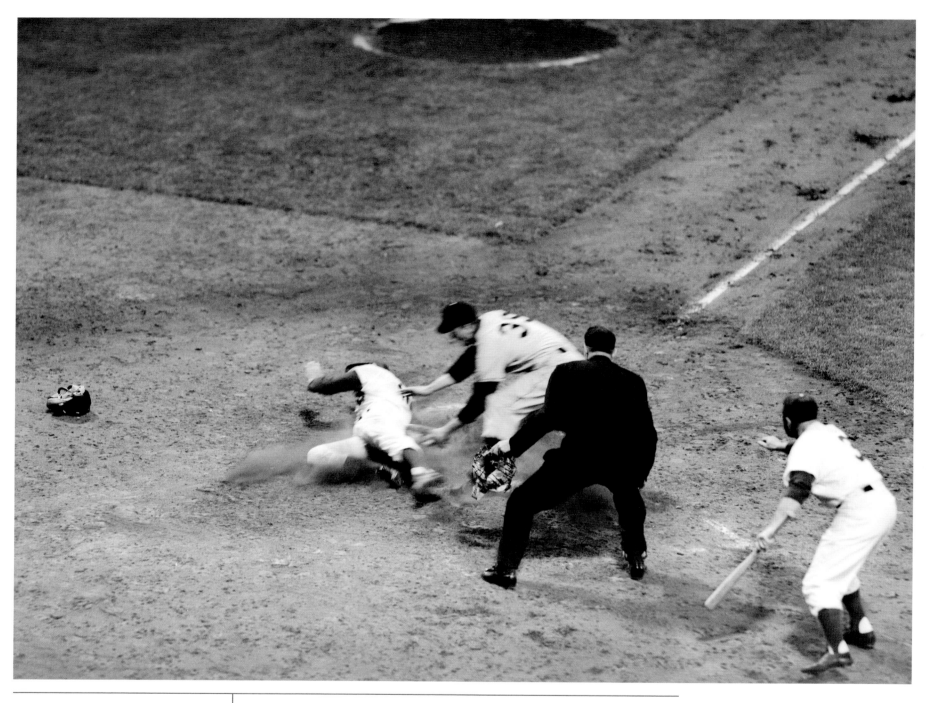

April 24, 1957
MEAN STREAK

Dodgers' Hodges streaks into plate to score Bums' fourth and deciding—as it turned out—run in the 4th at EF. Giant pitcher Barclay, covering plate on a passed ball, is too late with tag. Brooks won, 4-3.

Charles Hoff

Curt Barclay, a 9–9 pitcher for the year, started against Sandy Koufax (5–4) in the first game that the two teams played against each other in their last season in New York. During the season, Gil Hodges hit twenty-seven home runs, second behind Duke Snider, but production from Reese, Gilliam, Furillo, and Campanella fell sharply from the year before, and Newcombe—27-7 in 1956—went 11-12. The new ace was Don Drysdale, with a 17–9 record; Johnny Podres had twelve wins and his 2.66 ERA led the league, as did Clem Labine's seventeen saves.

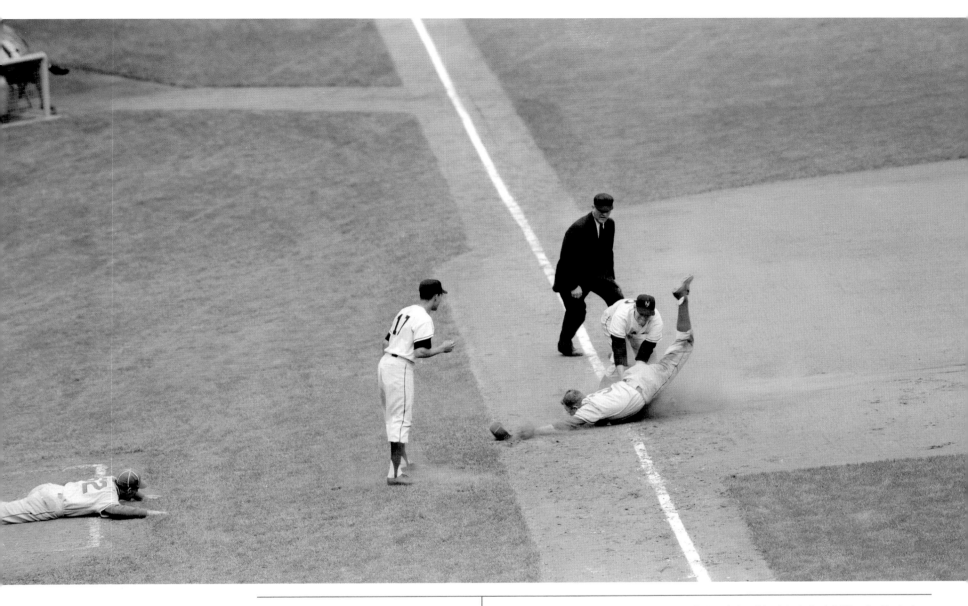

May 6, 1957
CUBBY HOLE

The Cubs' Jim Bolger digs out some Polo Grounds real estate as he slides safely into third on a teammate's hit in 6th inning. Virgil makes futile tag. Chicago rapped Giants, 6-2.

Seymour Wally

The futility of Ozzie Virgil's tag attempt on Bolger (who did a lot of pinch-hitting for the last-place Cubs) was indicative of the Giants' season. They were already in sixth place, having dropped there only sixteen games into the season, and they never moved up more than one spot. Willie Mays hit .333 with thirty-five home runs, and led the league with thirty-eight stolen bases; Hank Sauer contributed twenty-six homers; and that was pretty much it for offense. Ruben Gomez (15–13) was the only regular starter who won more games than he lost.

DESERTING US?

Dodger prexy Walter O'Malley (left) and Giant boss Horace Stoneham leave LaGuardia Field for NL meeting in Chi yesterday, where they received permission to shift franchises to Coast—"if they want to make a change."
Tom Gallagher

The Chicago meeting of National League club owners lasted four hours. The two from New York complained about their dwindling attendance, lack of parking facilities, and antiquated ballparks. (The Polo Grounds dated back to 1889, and Ebbets Field to 1913.) Although there was talk for most of the season of somehow providing each of them with a new, more appealing home, O'Malley and Stoneham were clearly keen on heading west—and officials in Los Angeles and San Francisco, respectively, were just as intent on welcoming them.

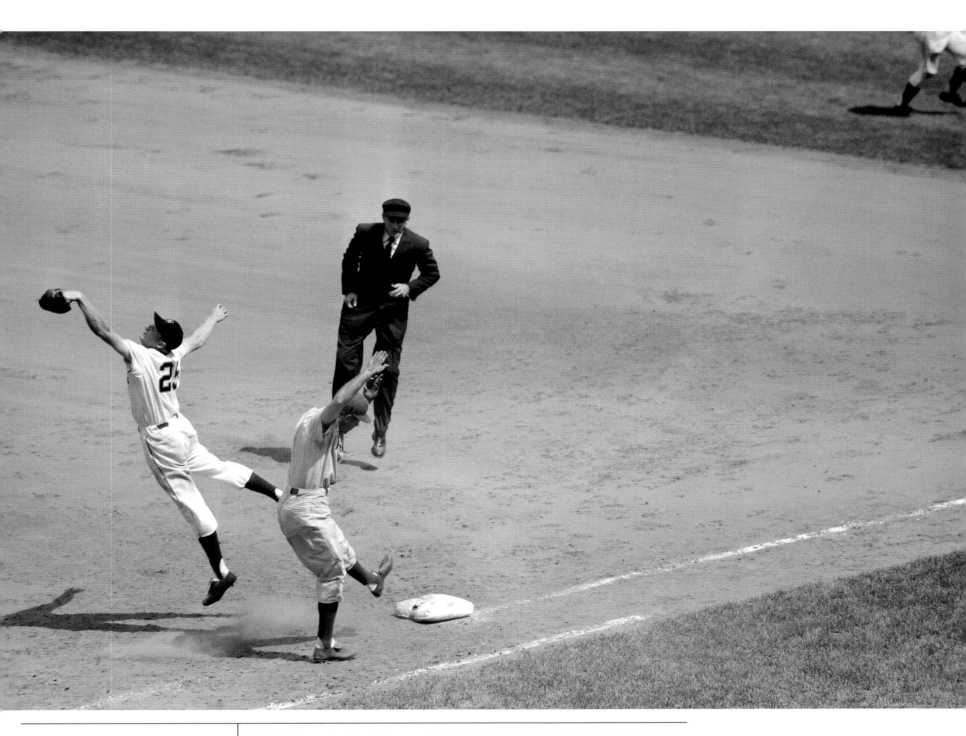

May 30, 1957
THROWN FOR LOSS

Phils' Hamner throw up his arms to
protect his head as Rodgers' wild peg gets
by Lockman in 9th of 1st. Hamner
went to 2d.
Charles Hoff

The Phillies went on to win the game, 2–1, in the tenth inning, though Giants starter Ruben Gomez had pitched a one-hitter—a game-tying home run—for nine innings. The Giants took the second game of the doubleheader, 8–1. The Giants brought back their longtime first baseman, Whitey Lockman, after a half-season exile with the Cardinals, in a preseason trade that included sending reliever Hoyt Wilhelm to the Cards. Andre Rodgers—a onetime cricket player from the Bahamas—and Granville "Granny" Hamner were utility infielders, and Hamner also pitched on occasion.

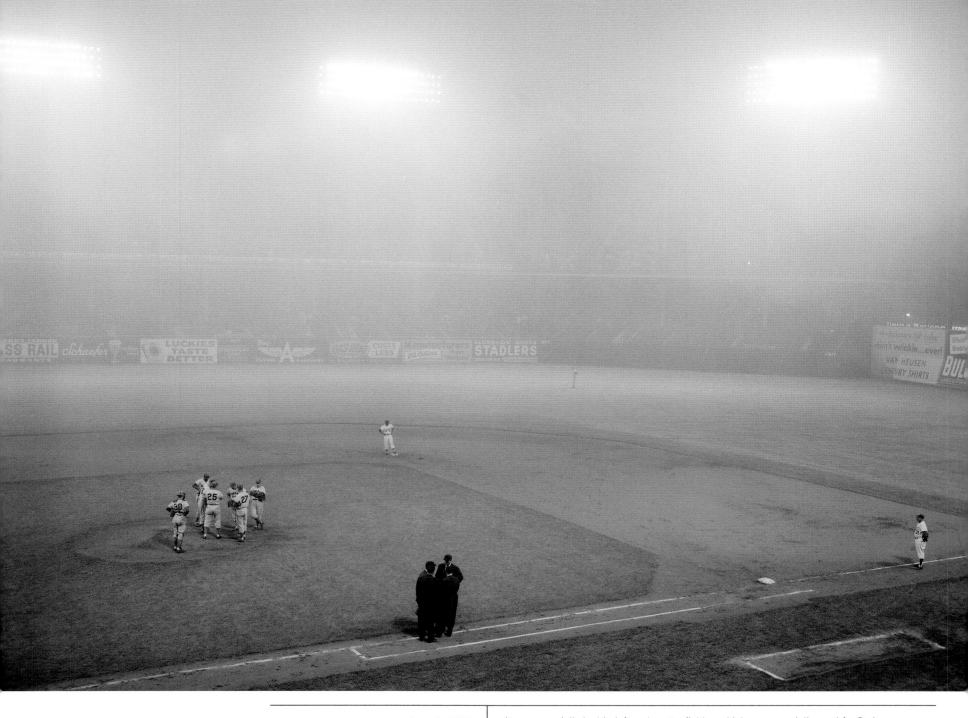

June 6, 1957
Because of fog in the park, bottom of second inning with Hodges and Neal on base, umpires called game. A fly ball by Neal had been lost in the outfield. Dodgers were winning 1-0. Pix shows the left field stands shrouded in fog.
Charles Hoff

It was especially bad in left and center fields—which was especially good for Dodgers shortstop Charlie Neal, whose double deserved an assist from the fog. (Pee Wee Reese—in his next-to-last season—moved over to third.) After a wait of nearly an hour and a half in the hope it would clear, the game against the Cubs became the first ever called on account of fog. Dick Young wrote, "The fog came in, not on little cat's feet, but in big, billowy gusts, like cigar smoke being blown from one of Walter O'Malley's cigars; from a whole box of them."

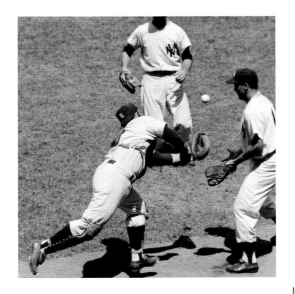

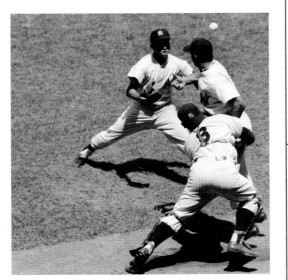

June 29, 1957

SLIPPERY

In the opening inning at the Stadium yesterday, Bob Cerv raised a pop foul that Yogi Berra, Bill Skowron and Bobby Shantz converged on. Yogi got his mitt on it, but the ball bounced loose and caromed off Skowron. Shantz finally caught it.
Frank Hurley

The Yankees, down five runs early in the game, won 7–6 in the tenth, handing the Athletics their ninth loss in a row. The perennially hopeless A's—never better than sixth place or nineteen games out of first in their thirteen years in Kansas City—finished in seventh, thirty-eight and a half games out, in 1957. Berra's average was down nearly fifty points, but he and Skowron were still belting home runs. Shantz, whose 11–5 season was his best of four in New York, had come over from the A's as part of a preseason, multiplayer deal that also gave the Yankees pitcher Art Ditmar and their future defensive star at third base, Clete Boyer. The day after this game, the Yankees moved into first place for good.

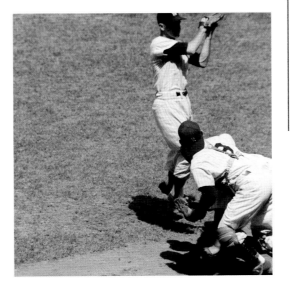

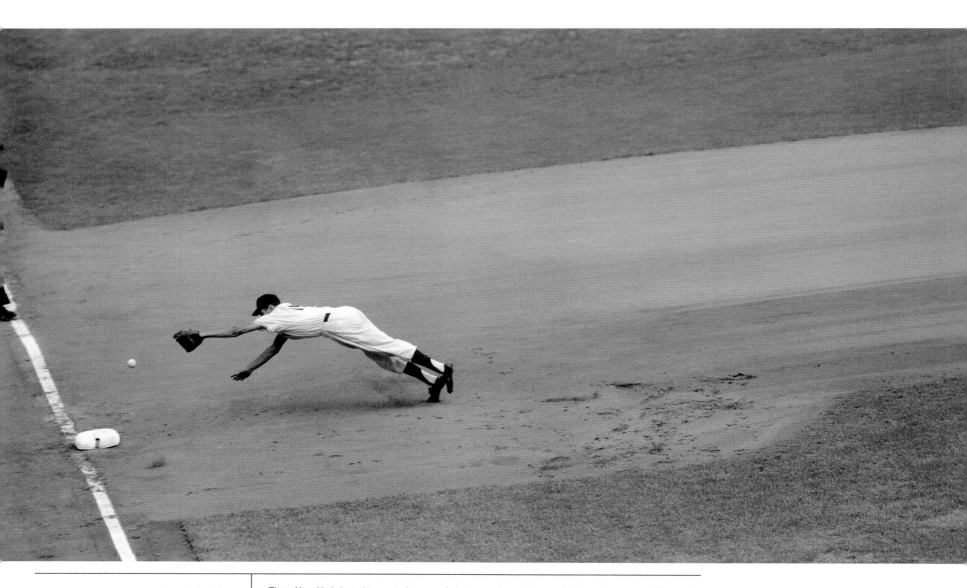

August 11, 1957
LEAVES DIVE EMPTYHANDED
Giants' Eddie Bressoud dives in vain for
Richie Ashburn's drive past 3d in 1st
inning of opener at PG. It went for a
double. Giants won, 5-0.
Charles Hoff

Then New York lost the second game of the home doubleheader to the Phillies, 2-0. Bressoud filled in for Daryl Spencer at shortstop after Alvin Dark was traded to the Cardinals in 1956. Ashburn, a leader of the 1950 Whiz Kids, usually whacked singles—enough to win two batting titles and wind up in the Hall of Fame—and he continued to play outstanding center field for Philadelphia until 1960. The Phillies finished the 1957 season eight games ahead of the Giants but still back in fifth place.

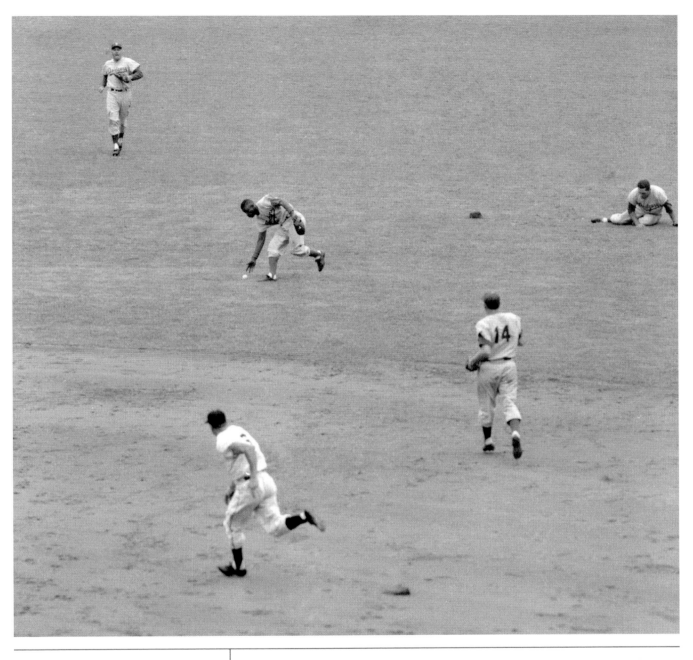

September 7, 1957

**IT'S A HIT AND FURILLO'S
STRUCK BY THE FACT**

Gilliam chases ball; Sauer heads for 2d.

Frank Hurley

This is the fifth shot in a back-page sequence of seven, showing Carl Furillo down as three other Dodgers head for the ball. Furillo actually caught Hank Sauer's lazy fly to right field in the fifth—but then he and Junior Gilliam collided, "and when they fell so did the ball." The second baseman got up first and retrieved the ball, but not in time to get the runner. However, Sauer was one of eleven Giants stranded during the 5–4 Dodgers win. Willie Mays hit a home run, but so did Furillo and Duke Snider—a three-run shot—in this next-to-last game played by the two teams at the Polo Grounds. Six days earlier, they had played their last game together at Ebbets Field; the Giants took that one, 7–5.

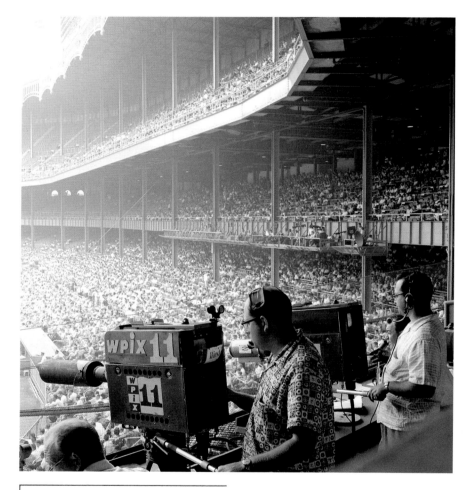

September 14, 1957
Cameraman Bob Rogow (left) and Phil
Valastro picture the play from behind
home. With three other strategically
spotted lensmen on the job, the entire
park is covered.
David McLane

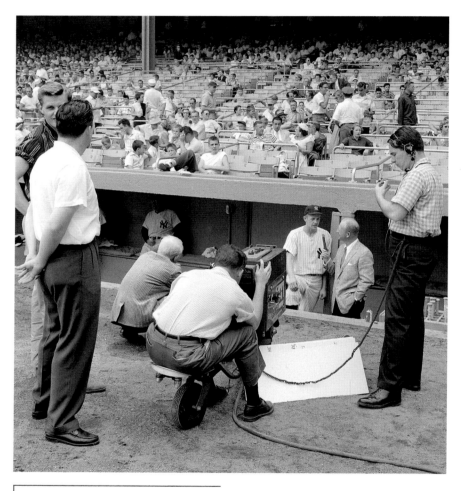

September 14, 1957
Bruce Oyen rolls into focus on Red Barber
and rookie infielder Jerry Lumpe as a
dugout interview gets under way.
David McLane

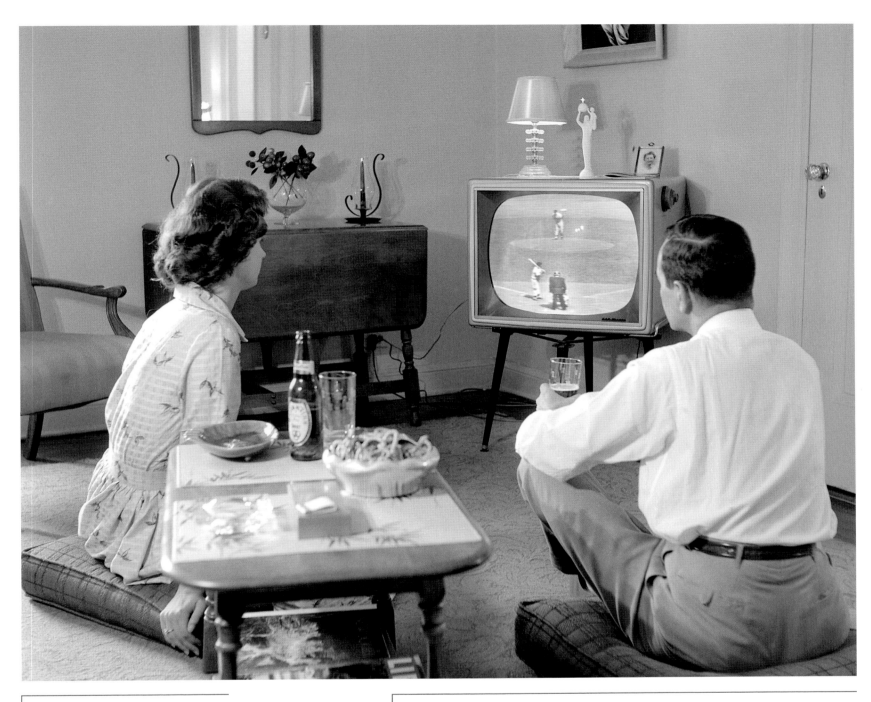

September 14, 1957
Sitting comfortably in living room, couple
enjoy fruit of work done by Murphy crew.
David McLane

These photos are among eight appearing in the
Sunday New York News Coloroto Magazine on
September 15 as part of a three-page feature
by Pete Coutros, headlined "Staying on the
ball." The article describes how "Sports chief
Jack Murphy"—who "directs operations [from]
the nether regions under the stands"—and his
crew of twenty use five cameras to cover the
games at Yankee Stadium. On the initial two-
page spread is a boxed sidebar:

The case for televised baseball:
1) Closeup view of the action.
2) No red-necked loudmouth yapping down
 your neck.
3) It keeps you home with the darling
 missus and kiddies.
The case against televised baseball:
1) How you gonna beat being at the park?
2) You watch whatever you want to watch.
3) It's an escape from the old battle-axe
 and the brats.

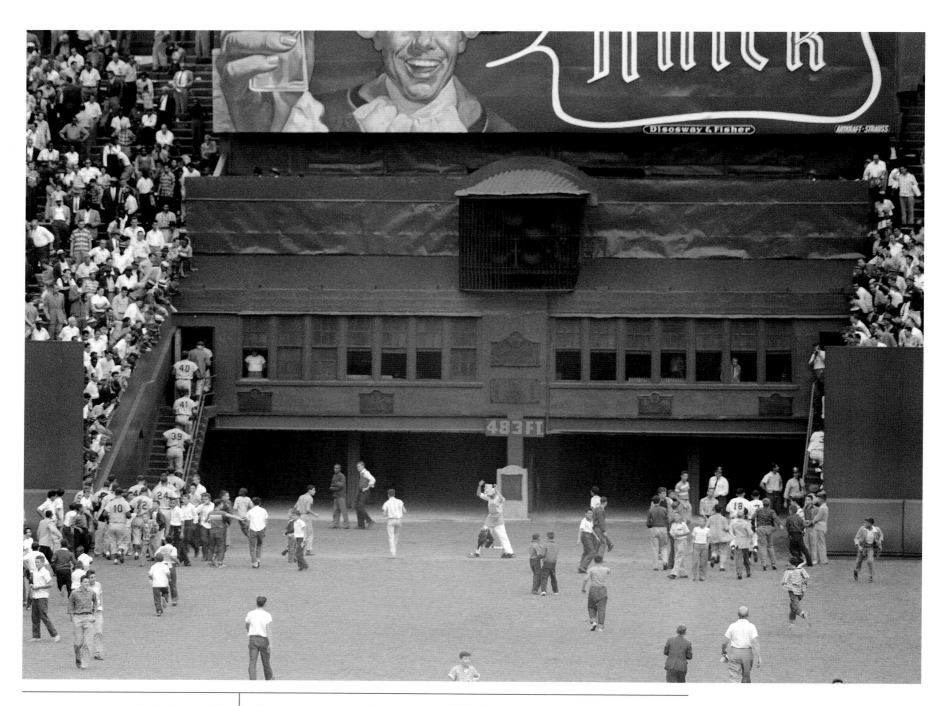

September 8, 1957

SCENE FOR THE LAST TIME

Dodger and Giant players file into PG clubhouse for last time together, ending age old rivalry yesterday.

Charles Hoff

The cross-town rivalry had begun back in 1890, when the six-year-old Brooklyn Bridegrooms (among other names) moved from the American Association to the National League, the home since 1883 of the New York Giants (originally also called the Gothams). And now it was over. The Giants won, 3–2, with a two-run homer by Sauer beating a solo shot by Gilliam. Barclay got the win, Marv Grissom the save, and Drysdale the loss. The *Daily News* reported that Garry Schumacher, the Giants' publicity supervisor, looked out at the 22,376 fans and said, "Five years from now, if all the people who'll say they were at the Polo Grounds for the last Giant-Dodger game were here we would never have had to go to Frisco." In the main article, Jim McCulley wrote, "And so came to an end baseball's greatest show—Brooklyn Dodgers vs. New York Giants. Baseball marches on—to the Golden West."

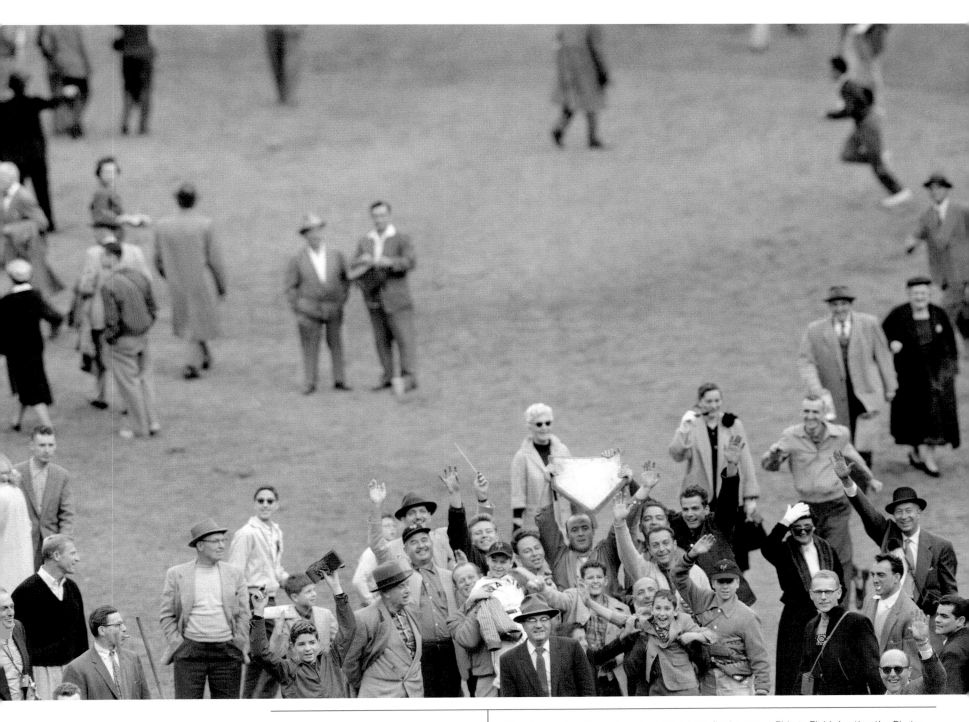

September 29, 1957
**OLDTIMERS AND FANS CAP CLOSING DAY
AT POLO GROUNDS**
Frenzied fans rushed PG clubhouse
to cheer heroes at close of game as
one souvenir hunter proudly shows
off home plate.
Charles Hoff

Five days earlier, the Dodgers had played the final game at Ebbets Field, beating the Pirates 2–0, before ending their season on the road. Danny McDevitt got the win, and Gil Hodges had the very last RBI in Brooklyn. Now it was the Giants' turn. They lost to the same Pirates (who finished in a last-place tie with the Cubs). Willie Mays received a standing ovation, and Sal Maglie and Carl Hubbell were cheered the loudest of all the former Giants introduced to the crowd before the game—including former first baseman and manager Jack Doyle, at eighty-six the oldest living Giant. When owner Horace Stoneham's name was mentioned, he was "loudly booed." And Mrs. John J. McGraw, widow of the team's longtime manager (1902–32), broke down and cried.

October 2, 1957
The silhouette of Joe DiMaggio is outlined against the playing field as the former Yankee great watches Yanks win opener.
Phil Greitzer

Casey Stengel's team clinched its eighth pennant in nine years on September 24. Mantle was the MVP again (with a third time in 1962). Tom Sturdivant (who had a sore arm in 1958 and was sent to the Athletics the following year) had sixteen wins again and only six losses. And Tony Kubek, playing outfield, shortstop, and third before settling down at short for eight years, was named Rookie of the Year. On a sad note, Gil McDougald's line drive smashed into Indians pitcher Herb Score's eye on May 7; neither player was ever the same again. And nine days later, a birthday party for Billy Martin ended in the infamous fight with drunken customers at the Copacabana Club. Several Yankees were fined—and General Manager George Weiss exiled the scrappy Martin, Stengel's favorite, to the A's a month later. Martin didn't return until 1975, as the Yankees' equally scrappy manager. Meanwhile, the World Series was the final blow to New York City in 1957. The dominant factor for the Milwaukee Braves, in Games 2, 5, and 7, was Lew Burdette—the first pitcher to win two Series shutouts since 1905 and three complete games since 1920. And so, for only the fourth time in eleven years, the Yankees had to do without the World Series crown—until they reclaimed it from the Braves in 1958.

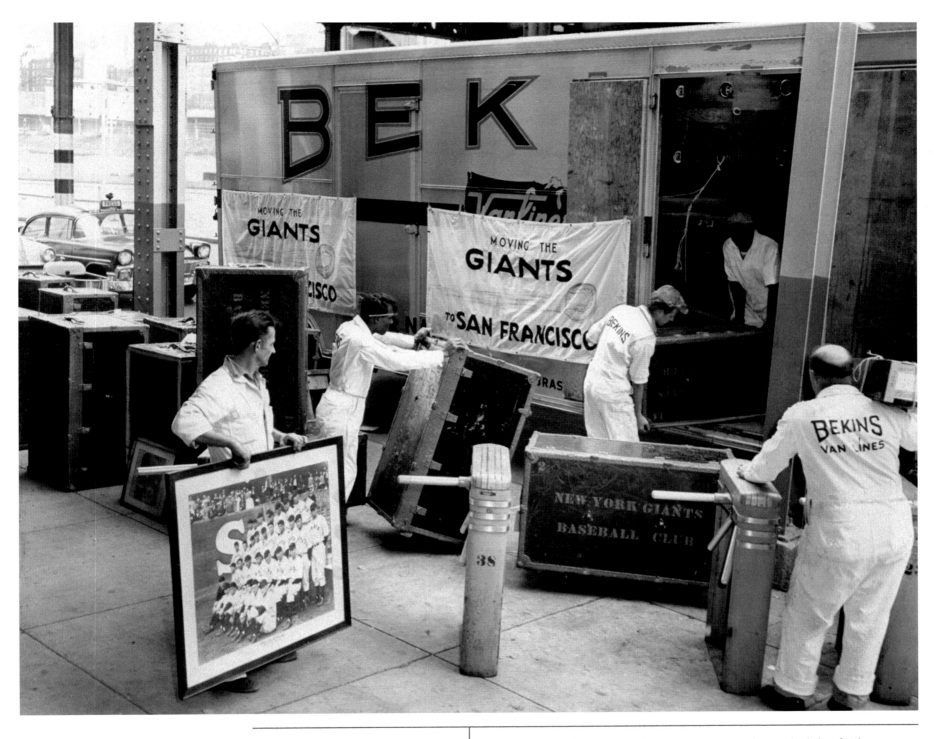

Fifteen turnstiles, office equipment, and framed photographs were loaded up for the cross-country ride to Seals Stadium, the Giants' temporary home while Candlestick Park went up. (Uniforms, bats, and balls were sent to the club's spring-training camp in Phoenix.) This was the anticlimactic ending to sixty-nine years of baseball at the Polo Grounds, and the beginnings of the new San Francisco Giants (who reclaimed the pennant by 1962, only to lose the World Series—to the New York Yankees). Dick Young's article ended: "It was shortly before noon when the sidewalk was clear. The truck took off with a grunt. The last remaining part of the Giants had left the Polo Grounds. The structure stood there, empty, grim, waiting to die."

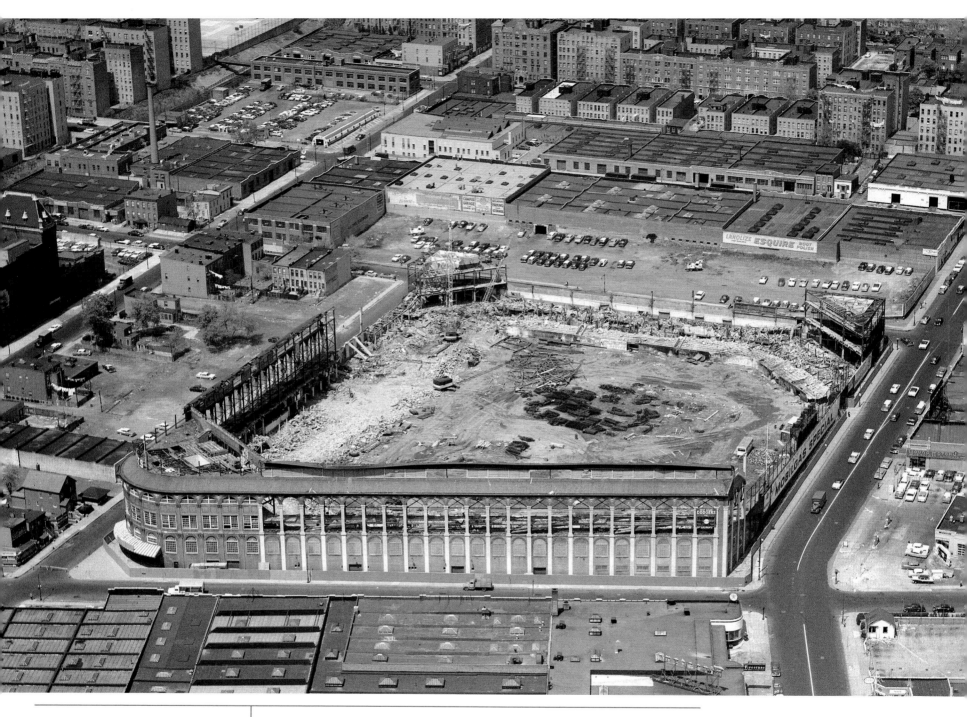

May 5, 1960
Ebbets Field, home of the Brooklyn Dodgers, being demolished.

By the time forty-five years of history at Ebbets Field came crashing down, the Los Angeles Dodgers were already establishing themselves as a perennial contender, winning the World Series in 1959 (and even going on to beat the New York Yankees for the championship in 1963). Meanwhile, it would be 1962 before the National League had another team in New York: the New York Mets. Back in Brooklyn, even today, it may not be safe to mention Walter O'Malley's name around old-timers and die-hard baseball fans. After all, especially in 1947–57, nobody died as hard—or lived as ecstatically, for one glorious season—as the fans of Dem Bums, the Brooklyn Dodgers.

Claus Guglberger

Between 1947 and 1957, *New York Daily News* photographers fed New York's insatiable appetite for baseball with photos that captured the daily drama that was the New York Yankees, New York Giants, and Brooklyn Dodgers. From April to October, *News* readers were treated to double-page photo spreads, not only of Mantle, Snider, and Mays while their stars shone brightest, but also of infield acrobatics, just-out-of-reach liners, and, of course, the slide into home plate. The photographers' skill and instincts, combined with a mastery of their cameras—which in some cases they helped to develop—created some of the most thrilling sports photography of the decade.

While the trusty Speed Graphic was suitable for capturing occasional field action, or a "candid" locker-room portrait, the two cameras intended to record the spontaneous action were the three-foot-long, seventy-pound Big Bertha and the Hulcher 70mm sequence camera. An early version of the Big Bertha (the origins of the name are a mystery, but a mobile long-range howitzer used during World War I might have been the inspiration) made its first appearance during the 1920 World Series between the Brooklyn Superbas and the Cleveland Indians. Lou Walker, a *Daily News* photographer, adapted a five-by-seven-inch Graflex camera by fitting it with a twenty-four-inch lens instead of the usual seven-inch, effectively creating an early telephoto lens. From a position in the Ebbets Field stands, Walker was able to photograph plays at all four bases. The resulting negatives permitted excellent enlargements that appeared in the next day's paper as a double-page spread.

By the 1940s, five-by-seven Graflex cameras fitted with twenty-eight-inch and forty-inch lenses—roughly equivalent to 160mm and 230mm lenses by today's 35mm standard—were typical for most city papers. Awkward to use, the Berthas employed five-by-seven film magazines that required the photographers to load twelve sheets of film into individual narrow compartments, or septums.

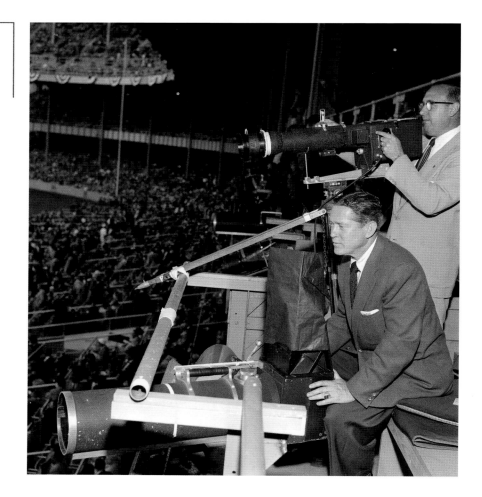

Charles Hoff (seated) operates the Big Bertha, while Frank Hurley aims his Hulcher during Game 2 of the 1955 World Series, between the Brooklyn Dodgers and the New York Yankees.

Because of their size, Berthas were bolted along the mezzanine level and made to swivel, allowing them to follow every play. Operating one took a level of hand-eye coordination not unlike that of a batter facing Whitey Ford. In addition to anticipating the action on the field, the photographer had to drop the shutter, slide the septum, pull the mirror, and release the shutter—all for one exposure. Focusing was accomplished by moving and locking a "stick shift" to preset points—outfield, first base/home, or second base/third base—marked by tape along the camera. The reward for all this manual labor? A finely honed sense of when to release the shutter. During regular-season games, photographers took an average of a mere twenty-four pictures each game.

The Hulcher 70mm SLR sequence camera had entirely different origins. Initially designed and built to photograph missile launches (a good choice, considering the era's "long-ball" style of baseball) for a precursor to the National Aeronautics and Space Administration, the camera was loaded with one-hundred-foot rolls of film and outfitted with 600mm lenses, and it could capture the action at ten frames per second. Introduced in the early 1950s, it was adapted for baseball, boxing, and football coverage by *Daily News* photographer Frank Hurley, who worked directly with the camera's inventor, Charles Hulcher. The film could be shot in ten-to-twenty-foot clips, allowing the photographer to cut the negative during a game and send it off with a motorcycle messenger to be processed at the studio and published in time for the early (5 A.M.) "bulldog" edition. Willie Mays's famous over-the-shoulder catch off Vic Wertz (page 126) and Sandy Amoros's catch off Yogi Berra (page 144) were both made with the Hulcher sequence camera.

One measure of an archive's strength is its depth. From Miksis to Mantle, Ebbets Field to Yankee Stadium, a staff of up to ten covering the World Series—two each (one high and one low) at first, third, and home, one at second, one in the outfield, a photo coordinator, plus a messenger—and an "if it moves, you shoot it" philosophy, *Daily News* photographers were expert at getting the picture. This is evident in the now iconic action photographs as well as "quieter" images such as Charles Hoff's photo of Yogi Berra touching Gil Hodges's face after Hodges was hit by a foul off his own bat (page 152), or Nick Petersen's photo of Chicago Cub Wayne Terwilliger hung up between first and second (page 58).

Of course, by the end of 1957 the Dodgers and Giants had left New York, and the Yankees were the only baseball in town. By the 1960s, the 35mm SLR and advances in film and motor drives would replace the slower Bertha and more delicate Hulcher, bringing an end to the "big rigs." Television gradually replaced newspapers as the primary source of baseball news and scores, and the "golden age" of New York baseball disappeared along with the cameras that had captured it.

ACKNOWLEDGMENTS

This book owes thanks to many. I would especially like to thank the following: Eric Meskauskas, Director of Photography at the *Daily News*, whose support made this book possible. Dolores Morrison, Assistant Director of Photography, whose input was invaluable throughout the entire process. Abrams editor Eric Himmel, for his exceptional patience and guidance. Richard Slovak, for leaving no stone unturned and covering all the bases! Dan Farrell, for sharing his experiences as a *Daily News* photographer; Betty Hulcher and Richard N. Hill of the Charles Hulcher Camera Company, for assistance in deciphering the Hulcher camera; and writer Jacques Menasche, who helped pull it together. In addition, I would like to thank Charles Ruppman, Nikhil Rele, Angela Troisi, Faigi Rosenthal, and the library staff for research assistance. And, finally, Marla, for everything else.

SOURCES

The following sources were helpful in preparing the annotations:

Baseball Encyclopedia. 10th ed. (New York: Macmillan, 1996).

Frommer, Harvey. *New York City Baseball: The Last Golden Age: 1947–1957* (New York: Macmillan, 1980).

Gallagher, Mark. *Day by Day in New York Yankees History* (New York: Leisure Press, 1983).

———. *The Yankee Encyclopedia* (Champaign, Ill.: Sagamore Publishing, 1996).

Golenbeck, Peter. *Dynasty: The New York Yankees, 1949–1964* (Englewood Cliffs, N.J.: Prentice-Hall, 1975).

Kahn, Roger. *The Era: 1947–1957, When the Yankees, the Giants, and the Dodgers Ruled the World* (New York: Ticknor & Fields, 1993).

Lorimer, Lawrence, with the National Baseball Hall of Fame and Museum. *The National Baseball Hall of Fame and Museum Baseball Desk Reference.* London, New York: DK Publishing, 2002).

Marshall, William. *Baseball's Pivotal Era, 1945–1951* (Lexington: The University Press of Kentucky, 1999).

Peary, Danny, ed. *We Played the Game: 65 Players Remember Baseball's Greatest Era, 1947–1964* (New York: Hyperion, 1994).

Ward, Geoffrey C., and Ken Burns. *Baseball: An Illustrated History* (New York: Alfred A. Knopf, 1994).

Wolpin, Stewart. *Bums No More! The Championship Season of the 1955 Brooklyn Dodgers* (New York: Harkavy Press and St. Martin's Press, 1995).

www.baseballlibrary.com.

And coverage of the games by the *New York Daily News.*

Editor: Richard Slovak
Designer: Tsang Seymour Design
Production: Jane Searle

Library of Congress Cataloging-in-Publication Data

Ziegel, Vic.
 Summer in the city: New York baseball, 1947-1957 / Vic Ziegel; photographs from the New York Daily News edited by Claus Guglberger ; annotations by Richard Slovak.
 p. cm.
 Includes bibliographical references (p.) and index.
 ISBN 0-8109-4342-5
 1. Brooklyn Dodgers (Baseball team)—History—20th century. 2. New York Giants (Baseball team)—History—20th century.
3. New York Yankees (Baseball team)—History—20th century. 4. Brooklyn Dodgers (Baseball team)—History—20th century—Pictorial works. 5. New York Giants (Baseball team)—History—20th century—Pictorial works. 6. New York Yankees (Baseball team)—History—20th century—Pictorial works. I. Guglberger, Claus. II. Daily news (New York, N.Y.: 1920) III. Title.

 GV875.B7Z54 2004
 796.357'64'097471—dc22

2003025595

The New York Daily News Archive is the largest searchable online database of photographs in the world. Consisting of current color photographs as well as historic images edited from more than six million prints and negative, the Daily News Photo Archive is the most comprehensive visual resource for the history of twentieth-century New York. It may be accessed on the World Wide Web at http://www.dailynewspix.com.

Printed and bound in Singapore
10 9 8 7 6 5 4 3 2 1

Harry N. Abrams, Inc.
100 Fifth Avenue
New York, N.Y. 10011
www.abramsbooks.com

Abrams is a subsidiary of